NAPLES

IN FLIGHT OVER THE CITY AND CAMPANIA

WHITE STAR PUBLISHERS

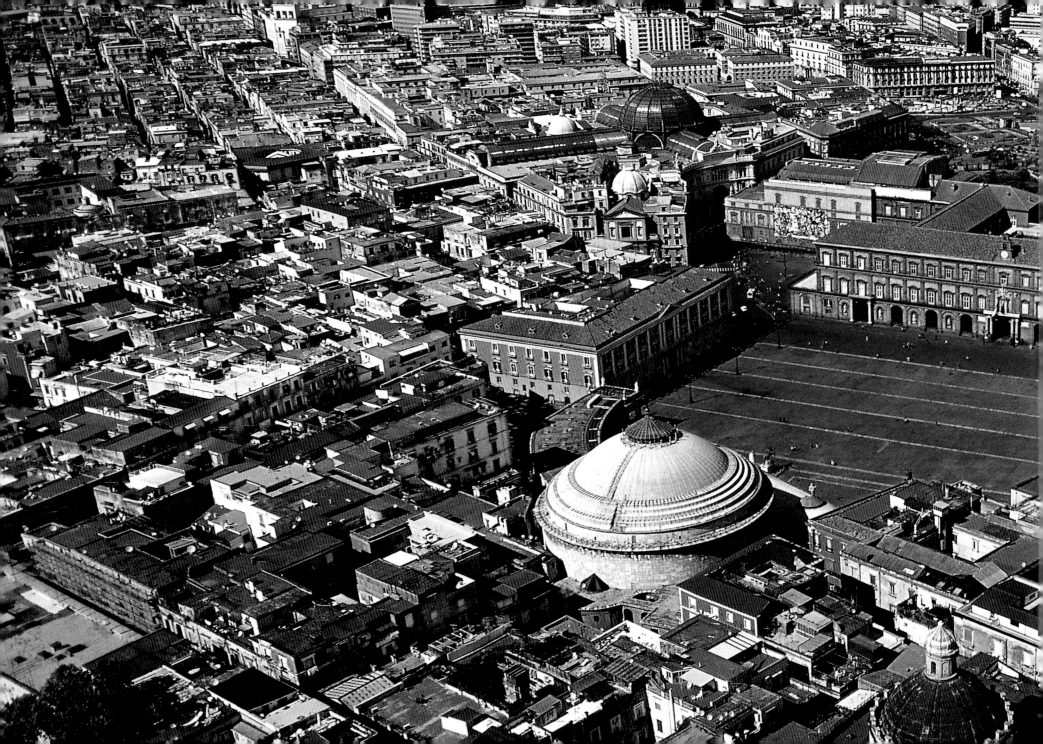

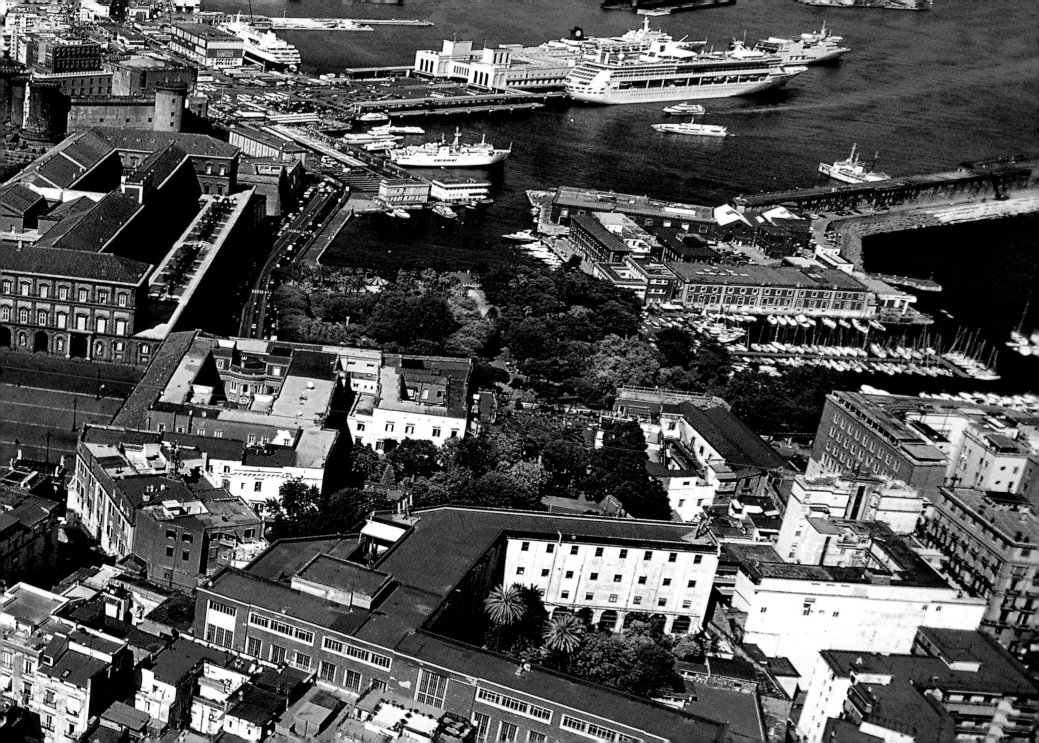

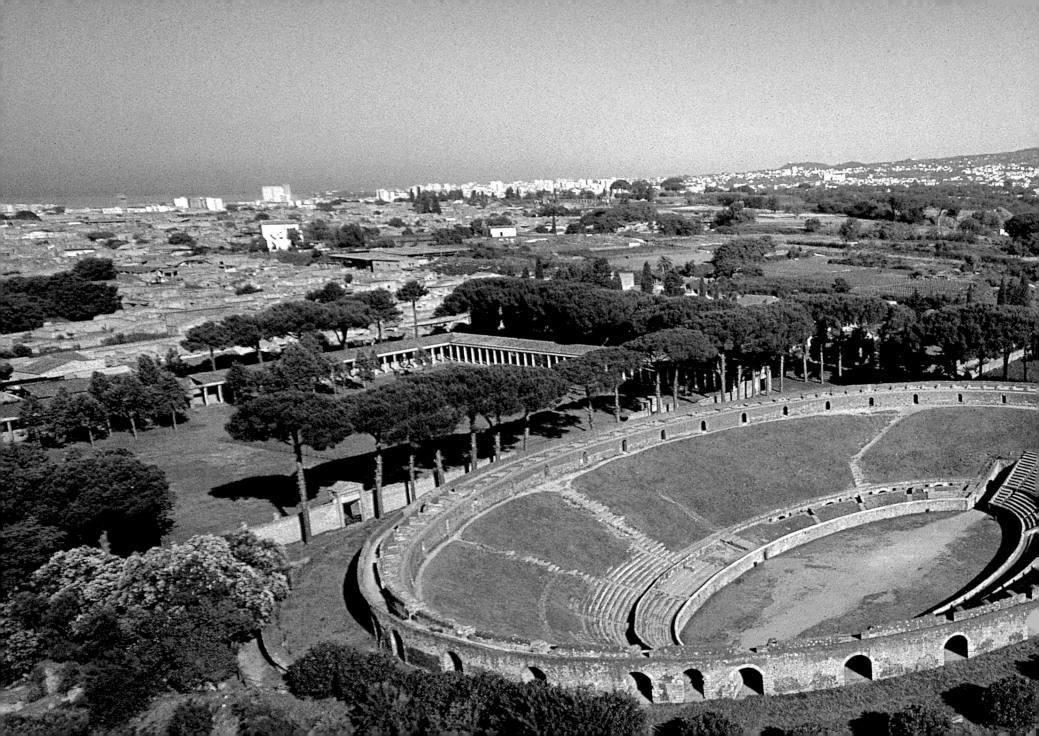

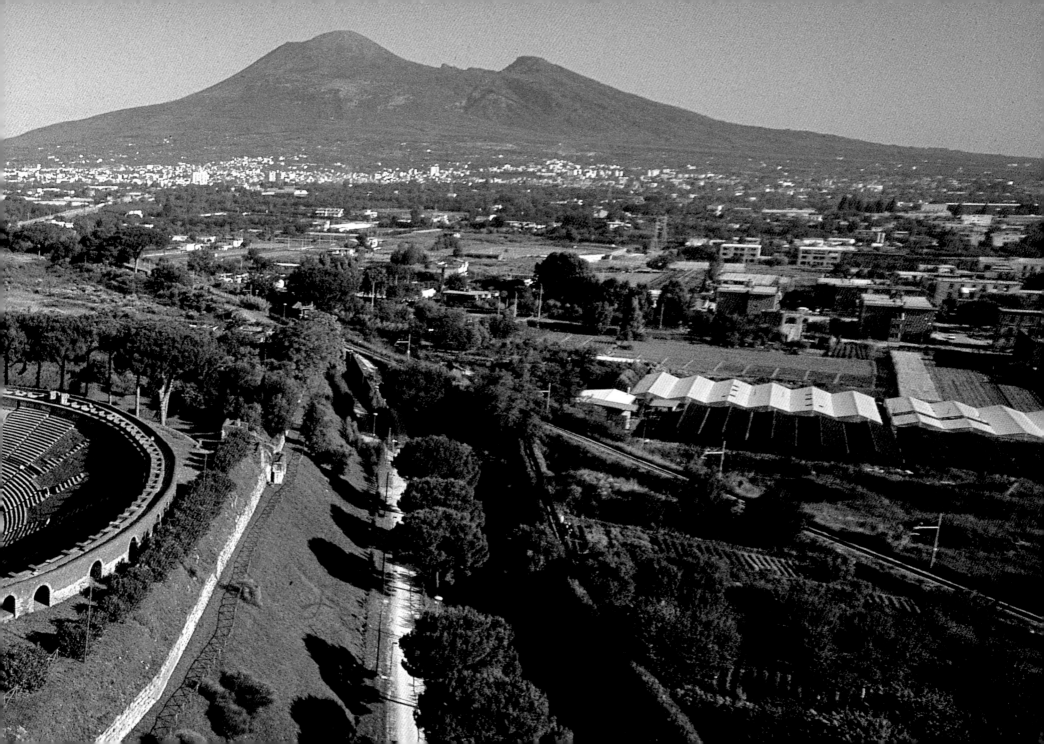

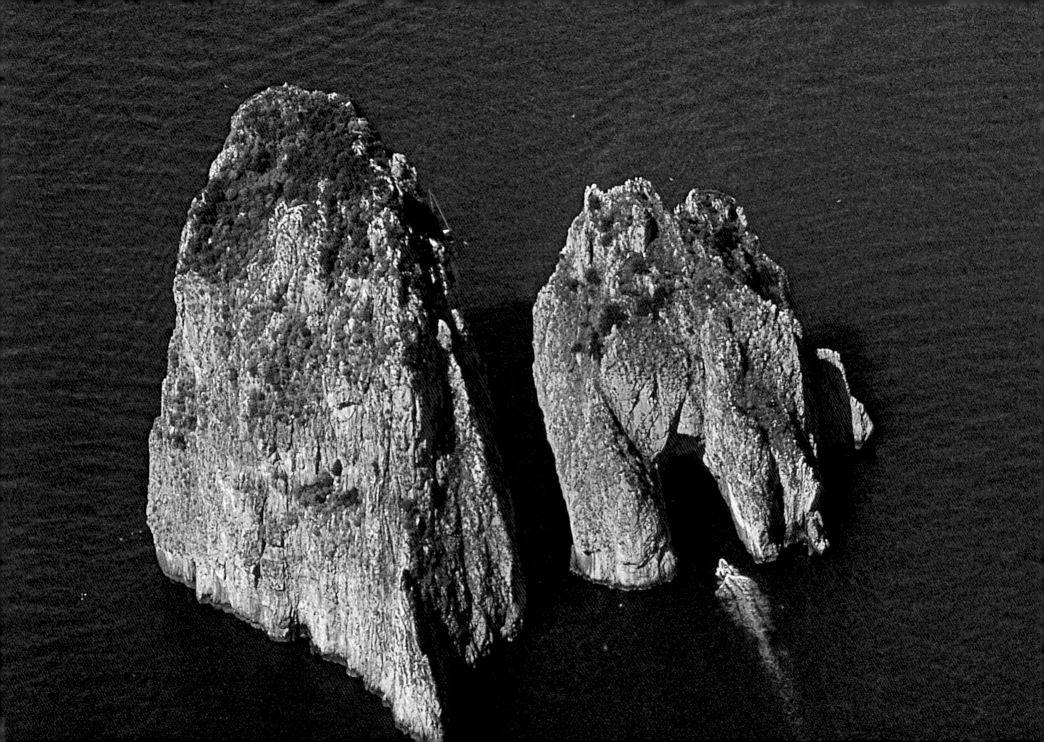

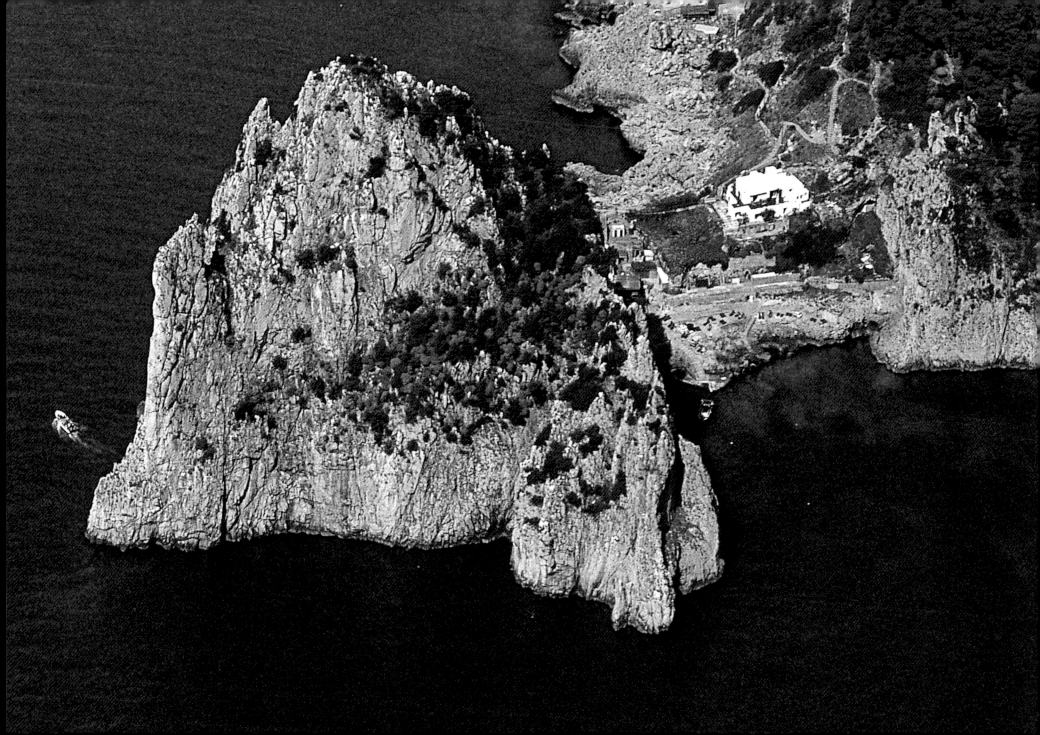

NAPLES

IN FLIGHT OVER THE CITY AND CAMPANIA

PHOTOGRAPHS
Antonio Attini
Marcello Bertinetti

TEXT
Raffaella Piovan

Contents

6-7 Capri (Naples) has three Stacks: the first, joined to the coast, is called Stella (Star) and is 358 ft (109 m) high. The outermost one is called Scopolo (or Outer Stack) and is 340 ft (104 m) high. At the center, the Middle Stack which is 267 ft (81 m) high.

8 A view of the island of Ischia: and the Aragonese bridge which connects the islet on which the castle stands (AD 1441).

9 Castel dell'Ovo (Egg Castle) (Naples) stands on the ancient islet of Megaride. It is said that there lies an egg in the castle placed there by Virgil.

2-3 Plebiscito Square in Naples is one of the most famous in Italy: we can recognize San Francesco da Paola from behind and Palazzo Reale in front.

4-5 Pompeii's amphitheater (Naples) was the backdrop, in AD 59, to a sensational fight between Pompeians and Nucerians which brought on a 10-year suspension in performances.

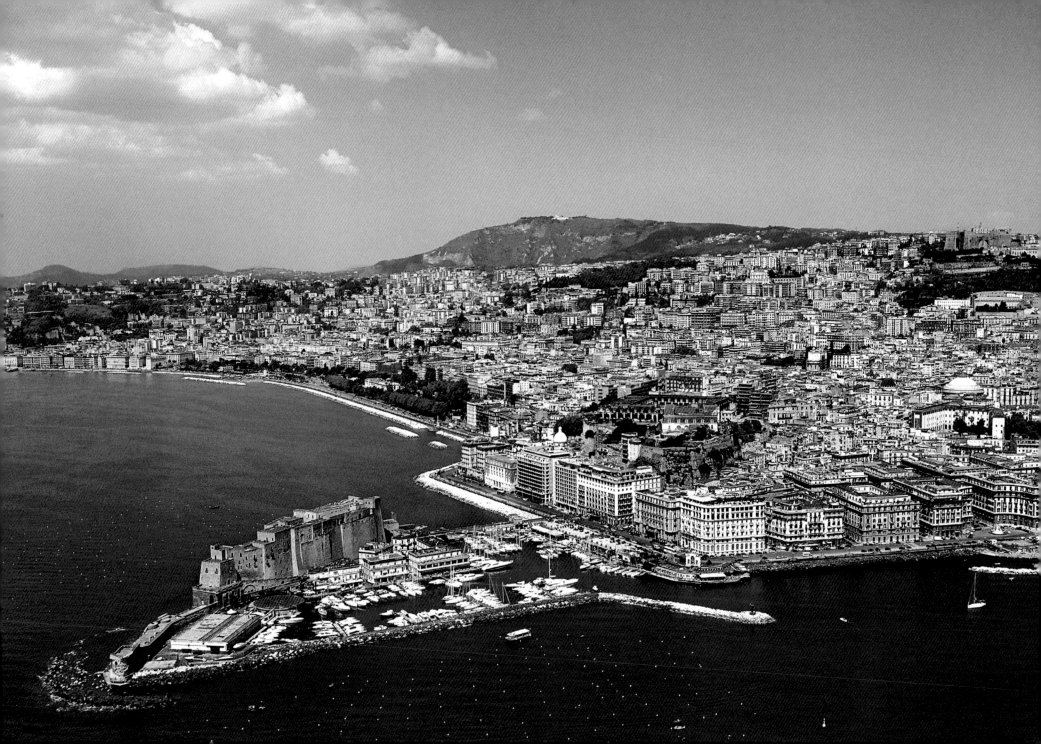

From high above it is green and blue, with touches of red and golden flashes of sacred cupolas or temple columns. Campania (from Kampanon, Campus, Ager Campanus) is one of the most bountiful Italian regions, as regards to scenery and history, because it has been forever felix (or lucky) as the ancient used to describe it. The land is fertile due to its volcanic nature, with the uneven coast of the Flegrean Fields at the Gulf of Policastro, an uninterrupted trail of hidden coves, grottos, islands, bays and gulfs. Precious land to conquer.

Thus her stories are many and riveting like those of an adventure story. It has been inhabited ever since remote times and archeology has written hundreds of pages on this territory.

At first it was the Stone Age people but then there were the Etruscans within and the Greeks on the coast. And the gods also arrived in Campania, those divinities which first used to live freely with humans and then, after the wedding of Cadmo and Armonia, withdrew in a universe of the mind and the heart. An epochal revolution occurred with the spread of the Greek alphabet, with those small signs which formed, with vowels and consonants, a "model carved in a silence which does not hush up."

The oldest inscribed Greek vase was found, in fact, off the island of Ischia (Pithecusa): it is Nestor's Cup, which dates back to the 8th century BC, upon which the words "...but who drinks from this cup, immediately will be taken with the desire for love for Aphrodite of the beautiful crown," can be read, a direct reference to Homer's Iliad. Civilization, religion and pottery, therefore, signify progress, commerce and the spread of news through designs and inscriptions to the remotest parts of the Mediterranean basin.

All this had a remarkable impact on the people of the region, expanding in every direction and creating the basis of the destiny of Etruria, of Lazio and the future Rome. Later, again by the Hellenic, were founded Cumae (750 BC), with the cave of the Sybil, the priestess of Apollo which predicted the future and Parthenope (680 BC), the embryo of Neapolis (470 BC).

11 The Amalfitan Coast is seen from Ravello's promontory, with its terraces of lemon orchards; in the distance one can see Minori (the first) and Maiori with its white sandy beach.

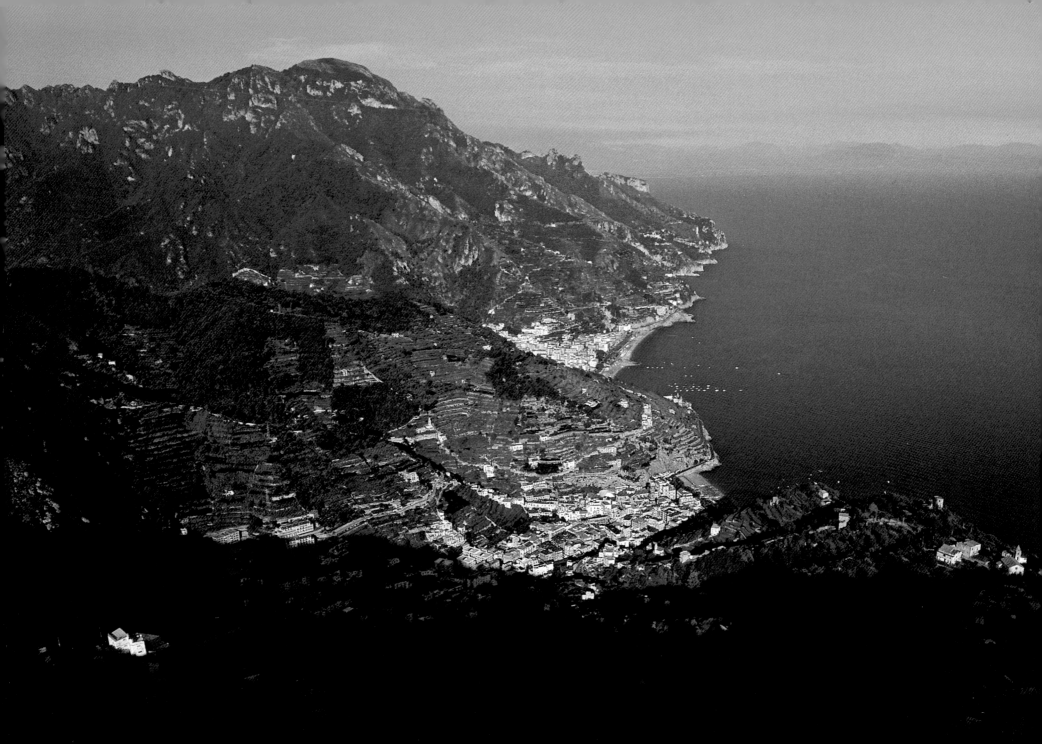

The refugees of Samo built Puteoli (Pozzuoli), the Sybarite Poseidonia (Paestum) and the Focesi Velia (Elea), immortal for its school of philosophy near Capo Palinuro where, according to the 5th canto of the Eeneid, the Enea's helmsman drowned ("...the god was above him...and the helm and the helmsman fell in the sea. Palinurus screamed but no one heard him"). And if the coastal area became more outlined in urban centers, leaving traces which can be perfectly noticed with aerial photography (amply used to detect archeological sites covered by the ground), the hinterland also grew in culture and

wealth. A city for all, Capua, Etruscan and very powerful, born in the 9th century, whose name will resonate throughout history many times.

But fertility generates greed: Greeks and Etruscans inevitably fought (the Greeks won in Cumae in two epic battles) to the full advantage of the Samnites, which came from north and east. They were overwhelming, so much so that no urban center was exempted from their influence, and the unification of the three populations even generated the first real people from Campania, the Osci, with their own language and cus-

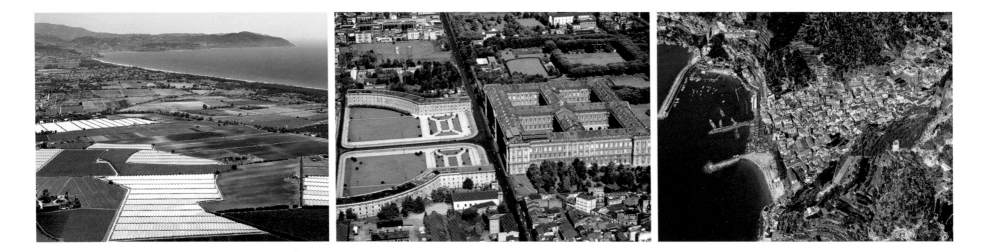

12 left All of Campania's coastal territory is intensely cultivated and its products pass to the fruit and vegetable markets all over Europe.

toms, very much tied to the land. The domination of Rome arrived subsequently which swept everything like a flooding torrent: the wars against the Samnites were two (in the second, in 321 BC, the Romans suffered the defeat of the Caudine Forks: they entered into a narrow gorge and were trapped) and the rest is history. The coastal cities never completely lost their Hellenic flavor and atmosphere but they became deeply Roman: Campania, after other wars and bloodbaths, deportations and forced assignations of lands to veterans, became a vacation resort, with culture and a great beauty. Magnificent villas rose as well as easy flowing streets, amphitheaters and theaters, bridges and aqueducts: it was a marvelous place, of which many traces can still be seen today, including those of the eruptions of Vesuvius.

In AD 88 the Latin poet Statius wrote: "When the plants will grow again and will make this desert green again, will the future generations be able to believe that swallowed cities and populations lie beneath their feet and that the countryside of their ancestors has disappeared in a sea of fire?." With the decline of the empire, the region suffered the same destiny: the swamps invaded the fields, malaria arrived and, finally, the barbarian invasions.

The following story is too complicated to be discussed now: it is enough to remember that this had always been a strongly contended region and that, with the start of the 9th century, the Normans made it an integral part of a modern and efficient monarchy, a real model for all of Europe. However, when the Vespers were fought in Sicily (1282–1302), such form of government started to lose its power, in favor of feudalism, with serious consequences for everyone. The Swabians and the Angevins took over and the capital was brought from Salerno to Naples. Then there were the Aragon and in the 18th century the reform of the Bourbon started and the Kingdom of Naples, later called "of the two Sicilies," returned to autonomy after the Spanish subjugation.

In this period the turmoil was very frequent and it culminated in 1860 with the fall of the reign under the hands of Garibaldi and his expedition. On 22 October of the same year the south became part of the Kingdom of Italy.

12 center The Palace of Caserta was designed by Luigi Vanvitelli who took Versailles as an example both for the palace's structure and for its surrounding gardens. The works started in 1752 and were finished by his son Carlo.

12 right Amalfi (Salerno), the oldest of the Marine Republics that enchanted the travelers of the time with its opulence and wealth.

The importance of Campania for Italian history is therefore enormous. With its maritime traffic (beside Naples, the power of the Marine Republic of Amalfi must not be forgotten) and the continuous changes at the apex of power, its soul grew strong, but malleable, managing to adapt itself to each new situation without losing its own distinctive traits.

Looking at it in its totality, from a bird's eye view, the stratifications of its various eras appear clear, where at times the oldest building materials have been reutilized to build new structures, from walls to churches.

The settlements of the so-called Vesuvian sites (Pompeii, Herculaneum, Stabia, Oplontis and Boscoreale), are evident, such as Paestum's Plain of the Temples, the shining ceramic cathedral domes which dot the Amalfitan coast, the green and white of the Palace of Caserta, the rivers like the Sele, the islands: Capri and its stacks, Procida, Ischia with the thermal spas. The immense expanse of Naples and the inner reliefs, from the Matese to the Sannio, from Irpinia to Cilento. A mosaic of absolutely inextricable traditions, culture and customs, which has brought the region to what it is today; full of thousand year old contradictions and gestures, complex and fantastic at the same time.

15 Marina San Francesco in Sorrento, Naples, owes its name to the church and the cloister of Saint Francis which is used today for concerts and shows.

18-19 Vesuvius' peak is immortalized in every painting which evokes the beauty of Naples and of its coasts.

20-21 Marina di Corricella on the island of Procida (Naples) offers striking scenery of colorful fishermen's cottages.

22-23 In Arabic-Sicilian style, the enchanted village of Ravello (Salerno) shows us the Duomo and to the right the entrance to the enchanting Villa Rufolo.

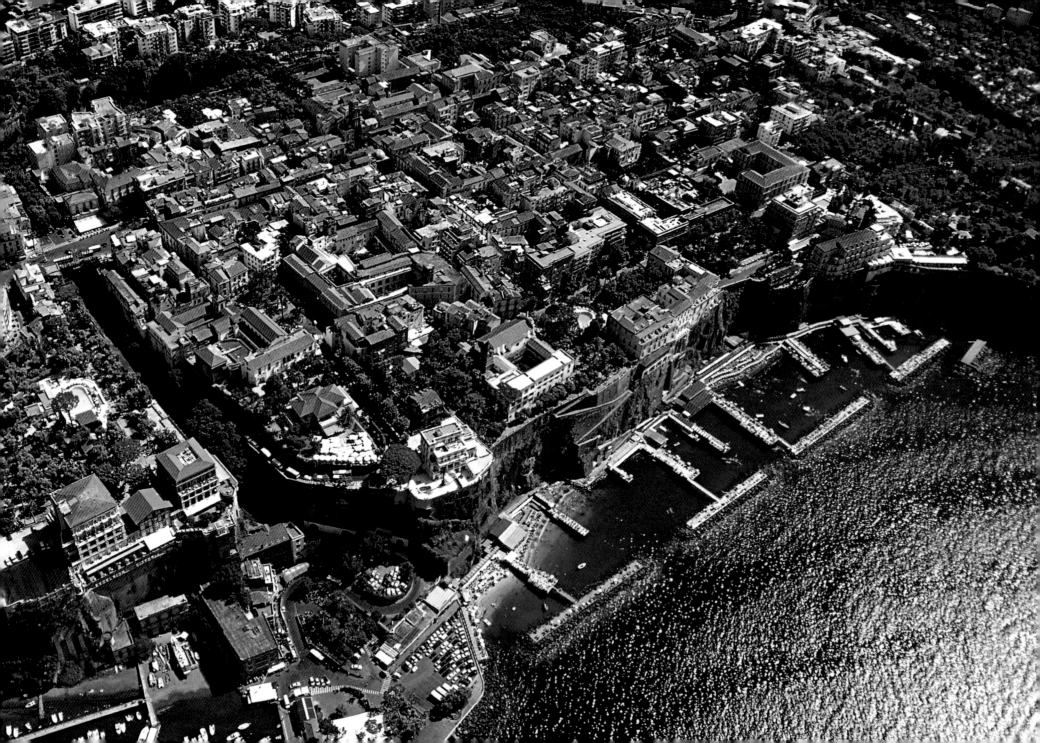

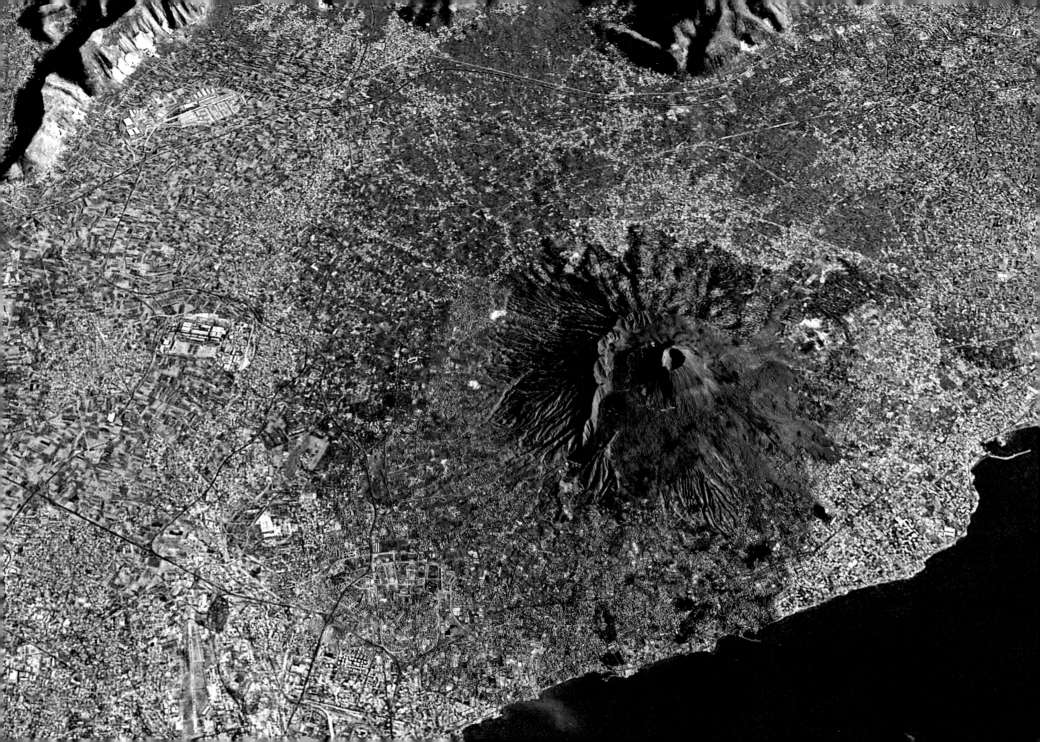

Basic information about Naples and Campania region

- Surface: 5250 square miles (13,595 square kilometers)
- Population: 5,725,098 (last census)
- Region's capital: Naples (1,008,419 citizens)
- Province's major cities: Avellino (54,277 citizens), Benevento (61,496), Caserta (74,837), Salerno (137,728)
- Total no. of communes: 551
- The landscape is predominantly hilly (50.8%), 34.6% of it is mountainous and 14.7% plains.
- Principal rivers: Volturno (109 miles/175 km), Tanagro (58 miles/92 km)
- Principal lakes: Matese Lake (2 sq. miles/5 sq. km), Patria Lake (0.8 sq. miles/1.9 sq. km), Fusaro Lake (0.4 sq. miles/1 sq. km), Averno Lake (0.22 sq. miles/0.55 sq. km)
- Principal islands: Ischia (18 sq. miles/46 sq. km, 58,000 citizens) Procida (1.6 sq. miles/4.1 sq. km, 10,694 citizens), Capri (1.6 sq. miles/3 sq. km, 7,278 citizens)
- Highest peak: Mount Miletto (6724 ft/2050 m)

- Volcanic areas: Vesuvius, Roccamonfina, Flegrean Fields, Mount Epomeo
- Population density: 419.4 per square kilometer
- Nature parks within Campania: Picentini Mountains Park, Partenio Park, Foce del Sele and Tanagro Nature Reserve, Matese Park, Taburno-Camposauro Park, Roccamonfina-Foce Garigliano Park, Castelvolturno Nature Reserve, Foce del Volturno and Costa di Licola Nature Reserve, Falciano Lake Nature Reserve, Bosco di San Silvestro Oasis, Vesuvius National Park, River Sarno Park, Flegrean Fields Park, Lattari Mountains Park, Astroni Crater Nature Park, Tirone Alto Vesuvio Nature Reserve, Marina Punta Campanella Nature Park, Submarine Park of Baia, Submarine Park of Gaiola, Baia di Leranto Nature Area, Cilento and Vallo di Diano National Park, Ferriere Valley Nature Reserve, Eremita-Marzano Mountains Nature Reserve, Mount Polveracchio Oasis, Diecimare Park, Alento River Site

The satellite photograph, computer enhanced to highlight the territory's characteristics, is centered on Vesuvius, one of Europe's most important active volcanoes, today in a dormant state. One can see the huge crater of Mount Somma around the principal cone, the ancient volcanic building exposed during the eruption of the 24 August AD 79. At the bottom one can recognize part of the Gulf of Naples and, on the coast, Torre del Greco; to the right Torre Annunziata (on the coast) and Bosco Tre Case (inland); to the left the outskirts of Naples, with Barra, San Giorgio a Cremano, Portici, Herculaneum and Resina. One can note the slopes of the Campanian Apennines and of the Irpini Mountains above.

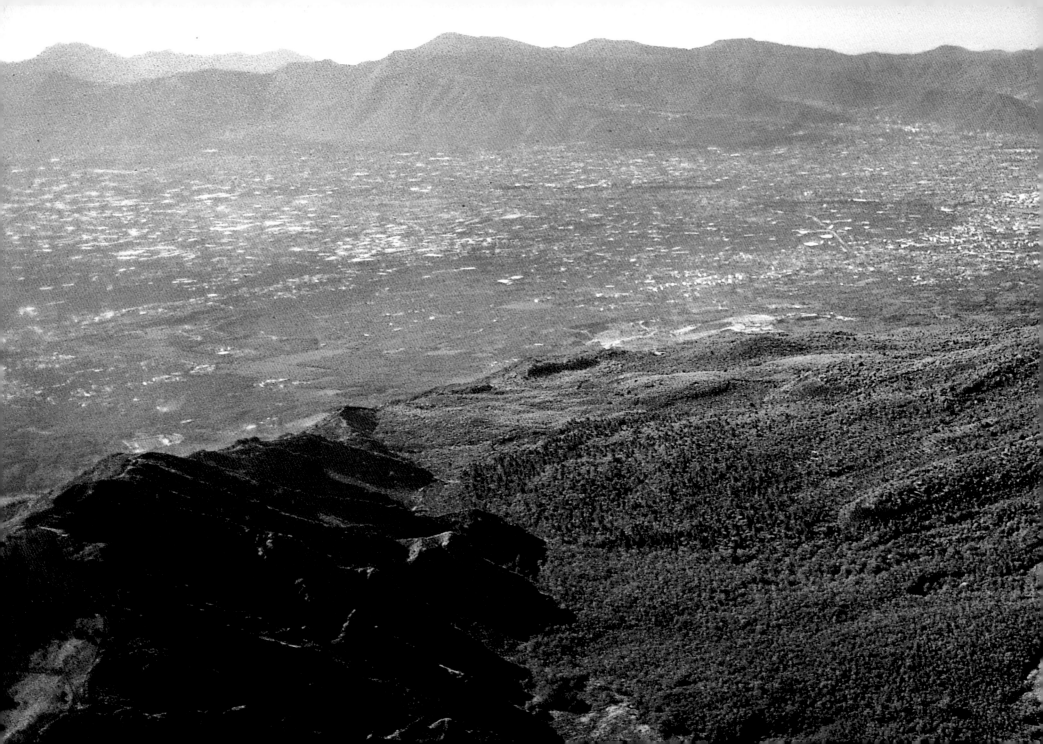

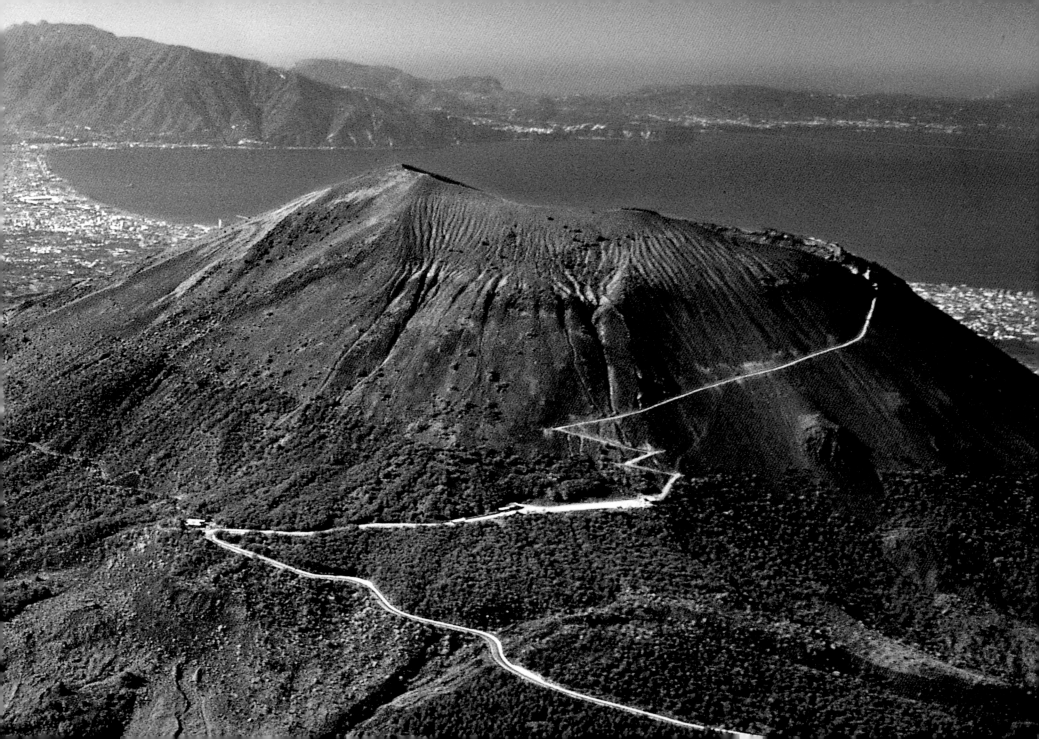

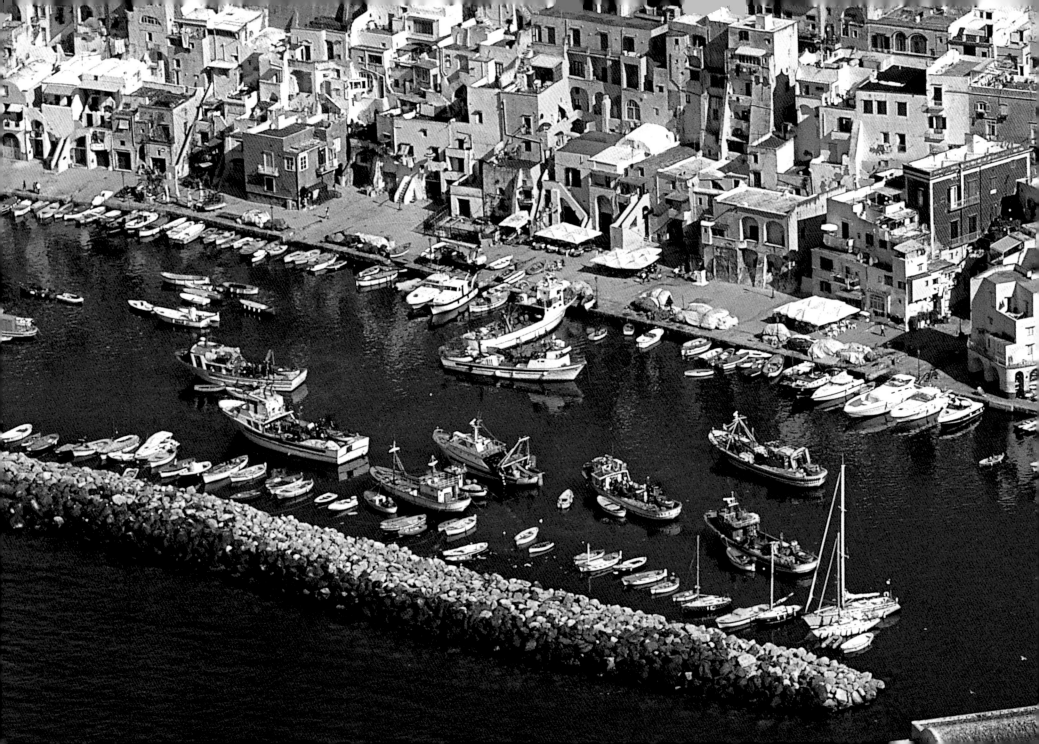

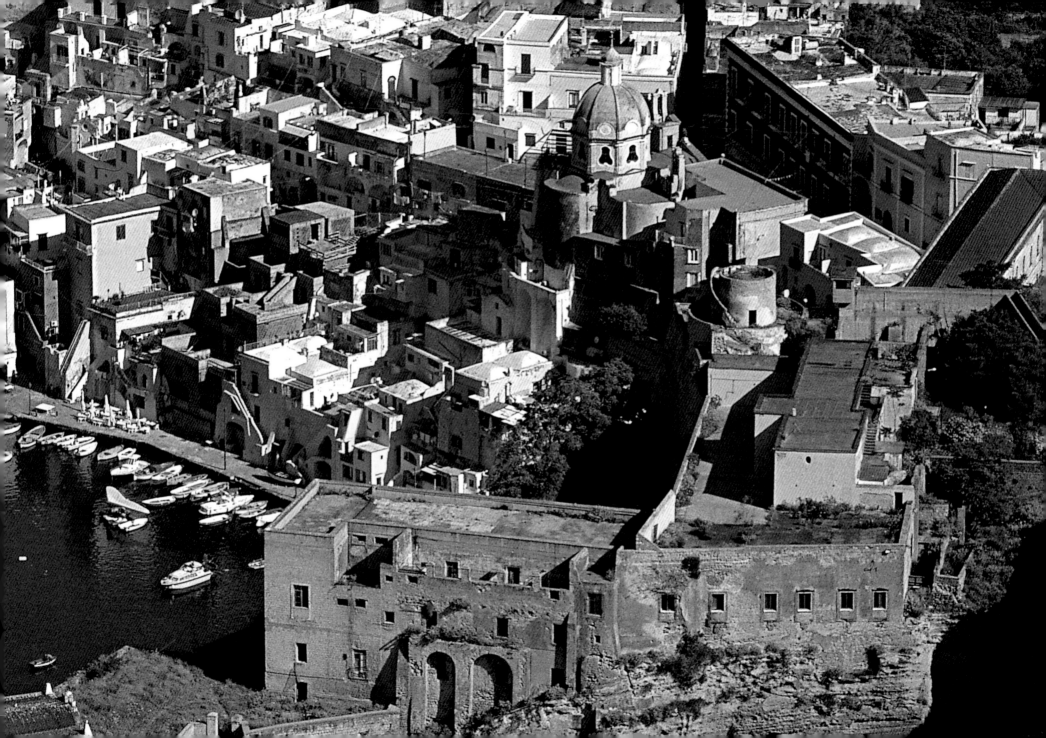

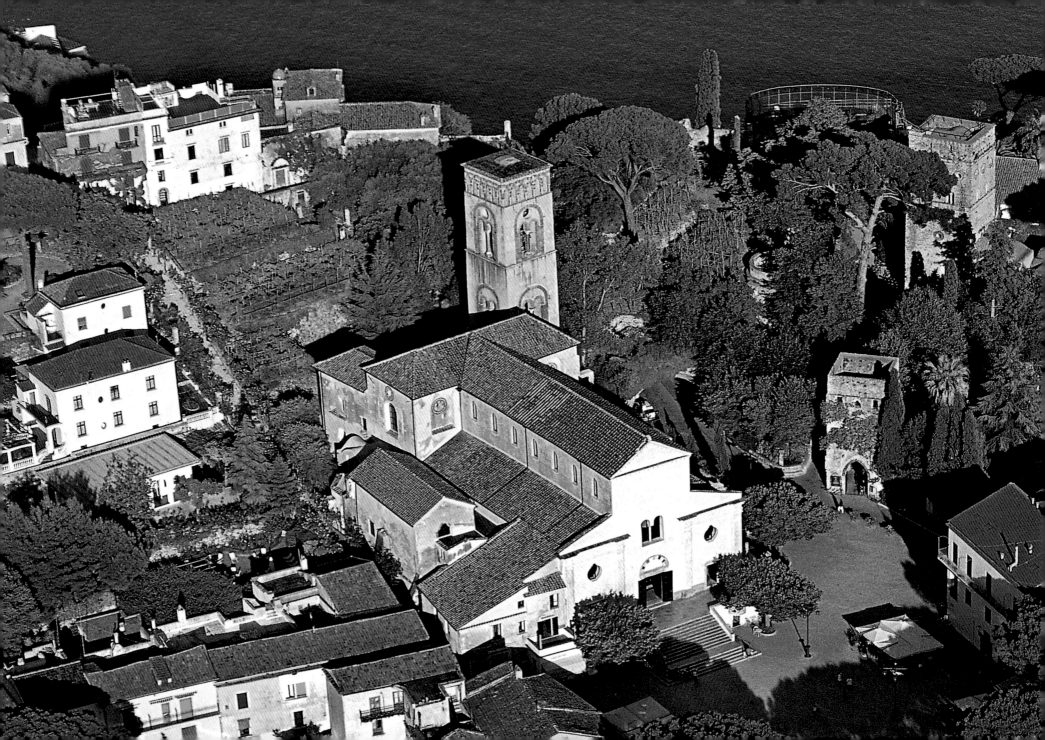

NAPLES

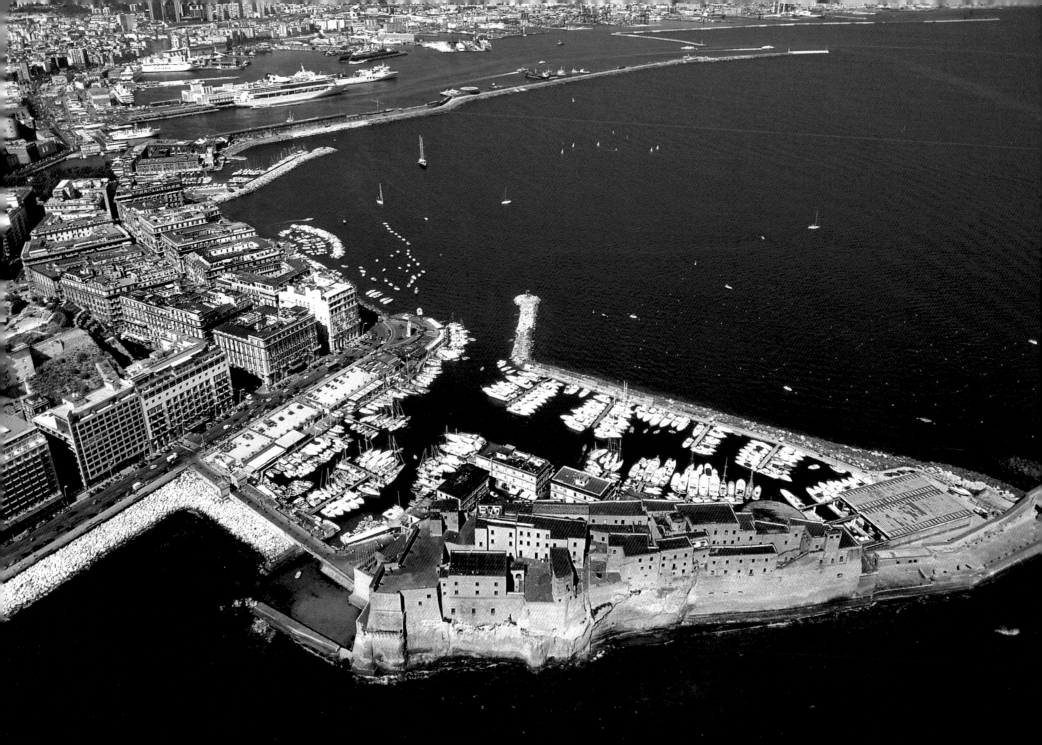

"Today I gave myself to pleasurable joy, dedicated all my time to these incomparable beauties. There is much to say, recount, paint; but they are above any type of description. The beach, the gulf, the sea creeks, Vesuvius, the cities, castles, suburbs, the villas! This evening we also went to the cave of Posillipo, in the moment when the setting sun passes with its rays up to the opposite part...I remembered with tenderness my father, who had preserved an indelible impression of these objects which I have seen today for the first time." It was 27 February 1787, and the hand which wrote this was Goethe's. This was the capital in the full Bourbon era. Dazzling, so much as to make famous even beyond its borders the saying "See Naples and then die." The passage from one dynasty to another was neither fast nor bloodless, but in 1734 Charles III of Bourbon rose to the throne and gave start to an era. The historian Angelantonio Spagnoletti writes thus: "When in 1734 don Charles of Bourbon, son of Philip V king of Spain and of Elisabetta Farnese, managed to install himself in Naples expelling the Austrians who had governed it since 1707, it was immediately clear to everyone that the conquest did not foreshadow at all a recovery of the Spanish dominion upon southern Italy.

In fact, even if it had maintained, especially in the first years, strong bonds with the court of Madrid, it was an independent political entity that affirmed itself at the time and, as such, was acknowledged by the peace treaty of Vienna in 1738 (...). After more than two centuries of subjection under foreign powers (first Spain and then, for almost 27 years, Austria), a new independent State appeared on the Italian politic horizon." For a quarter of a century, the duration of his reign, the sovereign limited the power to the clergy, tried to abolish the feudal system, brought remarkable improvements to the city and its economy, and turned it into one of Europe's most important cultural centers with a population second only to that of Paris.

The achievements, not just architectural, were impressive: the

24 left Located in a beautiful park, the Royal Palace of Capodimonte (Naples) was built under the orders of Charles III of Bourbon and which, besides a manufacture of porcelain, was intended as a place for preserving the collections left to him by his mother, Elisabetta Farnese.

24 right The church of San Gesù Nuovo was designed by Fr. Giuseppe Valeriani for the Jesuits from 1584–1601; of the original building only the ashlar facade of Novello di San Lucano has been preserved (1470). The interior is in the shape of a Greek cross.

25 The imposing Castel dell'Ovo, the oldest castle of the capital, was erected on the ancient Megaris, a rocky islet now connected to the mainland.

27 Castel Sant'Elmo is a strong star-shaped structure which dominates on the hill once called Paturesuyn. From its walls one can enjoy an incomparable panorama of Naples and its gulf. In the close up one can note the Carthusian Monastery of San Martino, AD 1300, most certainly altered subsequently, which guards the Treasure of Saint Januarius.

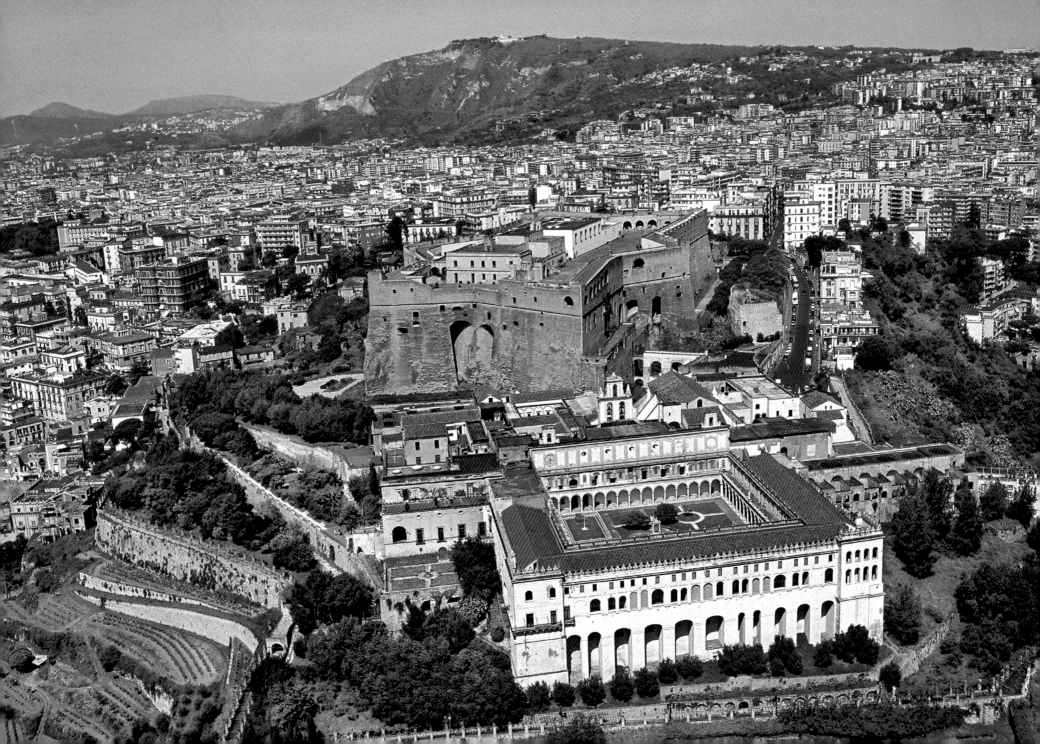

first, in 1734, was the Real Bosco, the green lung of Naples which embraces the Royal Palace of Capodimonte across 307 acres (124 hectares), thus becoming Charles III's hunting reserve. In 1738 the architect Ferdinand Sanfelice organized its architectural plan, with a Baroque scenographic structure. In 1737 the Saint Charles Theater was built: designed by Giovanni Antonio Medrano, it is Europe's oldest active theater and was an enormous attraction for Neapolitans and foreigners thanks to its splendid architecture, gold and silver decorations, the blue interior of the stages, as well as to its music and its performances. It was to be destroyed on the night of 12 February 1816, but Ferdinand I of Bourbon, six days after the fire, ordered its re-

building, entrusting it to Antonio Niccoli. The acoustics were improved, nowadays they are still considered perfect, and the stage-set enlarged; but, beyond a few other retouches, it appears today almost the same as it was.

Charles III, during the same period, decided to embellish the reserve, erecting a royal palace, always on Capodimonte hill, to use it as residence and as museum for the priceless art and antique collections inherited from his mother. Today it is rich with important and very precious collections, set up with effective solutions which, like the particular illumination of the rooms on the second floor, valorize the splendor of the priceless works which are housed there. In 1743, work started on the Royal Porcelain

28 left The city, seen from above in all its magnificence, had its apex between the 17th and the 19th century. The churches stand out prominently in the grid-like urban environment, such as San Francesco di Paola.

Factory, now known as Capodimonte, in the wooded area adjacent to the royal palace and was designed by the Neapolitan architect Ferdinand Sanfelice. Sanfelice was also appointed to the modernization and restoration of the Royal Palace which was in a state of abandonment when Charles III arrived.

Meanwhile, in 1783, the building of the Royal Palace of Portici also started, at the slopes of Vesuvius – a proximity which did not worry the king, who sustained that "God, the Virgin Mary and Saint Januarius would take care of me." And it is here that the first core collection from the Herculaneum excavations was created, as desired by the enlightened sovereign. He, very much loved, seemed tireless: in 1747–50 he ordered the building of the Steeple of the Immaculate; in 1751 the Hostel for the poor, for the "needy of the entire kingdom" and in 1752 Luigi Vanvitelli started the Royal Palace of Caserta. Its splendor can be appreciated from above where it is possible to observe the arrangement of the statues and fountains. It is one of Italy's most beautiful complexes.

The projects demanded by Charles III were completed in 1759 with the foundation of the Academy of Fine Arts. His father died and he had to take his throne in Spain. Charles III therefore left Naples to his son Ferdinand IV, only eight years old, who a very good regent, Tanucci, who continued the economic and cultural development up to the prince's coming of age. This period was interrupted in 1768 when the regent was discharged by Maria Carolina of Habsburg, the new queen.

Meanwhile in 1765, the city was divided into 12 quarters and the first urban police force was born; in 1777 Ferdinand IV, heir to the greatest Italian art collection, the Farnese, decided to set up in the 16th century Palazzo degli Studi, the National Archeological Museum. In 1860 the museum became state owned and in the meantime the king's fabulous wealth was enriched with one of the greatest archeological collections of the time: the precious findings of the sites buried by Vesuvius during the AD 79 eruption, to which were added the Etruscan and Roman findings from Capua, Nola, Pozzuoli, Baia, Miseno, Capri and several other cities.

Walking along the seafront of Via Caracciolo one can admire the Villa Comunale, built between 1778 and 1780.

Over half a mile (1 km) long and rich with thousands-year old trees like palm trees, pines, holms, araucarias and eucalyptus, and also fountains, statues and busts. Inside one finds the An-

28 center At the end of the 20th century there was a great push in Naples for novelty and bold architecture. Behind the railway station of Garibaldi Square, in Poggioreale, there is the Centro Direzionale, designed by the Japanese architect Kenzo Tange in 1982.

28 right The island of Nisida is connected to the mainland by a dam-bridge which crosses around 984 ft (300 m) of sea. It has an almost round shape, with a perimeter of just under one and a quarter miles (2 km) and rises opposite Coroglio.

ton Dohrn Zoological Station, the oldest in the world and sole testimony to a 19th century aquarium.

In 1799 the Bourbons were expelled by the French troops, sought refuge in Sicily, returned to Naples (taking the opportunity in 1804 to open the Library of Charles III to the public), and then they were deposed by Napoleon. Then followed the so-called "French decade" (1806–15) but, after the Congress of Vienna in 1815, Ferdinand regained power in Naples. One of his first interventions was in 1817 when he acquired a beautiful estate on Vomero to act as summer residence for the Duchess Floridia Lucia Migliaccio, his second morganatic wife. Thus rose the Floridiana, elegant neo-classical villa designed by the Tuscan architect Antonio Piccolini.

Another valuable architectural masterpiece is the church of San Franceso di Paola, in Plebiscito Square, once venue of official ceremonies and military parades and today symbol of the city's rebirth. Ferdinand I asked Antonio Canova to court in order to commission a statue of Charles III and, in 1819 one of the king himself, but by now the artist was old and sick and could only model the horse, and entrusted the completion of the statue to Antonio Cali. The two monuments were then positioned in the piazza in 1829.

In 1820 an extraordinary turn occurred, following insurgent movements, with the royal family conceding to the new Constitution which was revoked the following year. Francis I reigned from 1825 to 1830 and after his death his son Ferdinand II took the throne and governed initially with moderation and wisdom. Under his reign there were amnesties and reforms; Donizetti's "Lucia of Lammermoor" was performed with enormous success in 1835, in 1839 the first Italian railway from Naples to Portici was inaugurated and in the same year the tomb of Giacomo Leopardi, who died in Naples in 1837, was erected in the Virgilian Park. Marine trade increased (the first Italian steam powered vessel under regular line service was launched), the military trade was reformed and Naples was connected to Sicily with a pioneering telegraphic network.

In 1840 the road from Vietri to Positano was opened; today it has the name of Statale 163 Amalfitana, and five years later the 7th Scientific Congress took place in the capital. But, after a promising start the sovereign also had to confront the riotous: in 1848 he conceded a new Constitution which was also revoked the following year. In 1857 the attempt for rebellion fronted by Carlo Pisacane ended in bloodshed. The only positive was Cumae's first systematic excavations between 1852 and 1857. The last king of the Two Sicilies, Francis II, took the crown in 1859, but his rule was broken by Garibaldi in 1860.

31 Ordered by Charles I and started in 1279, Castel Nuovo (known as Maschio Angioino) rises on the southern part of Municipio Square (Town Hall Square). It is characterized by five cylindrical towers decorated with crenellations, with the Triumphal Arch of Alphonse of Aragon, squeezed between two of them.

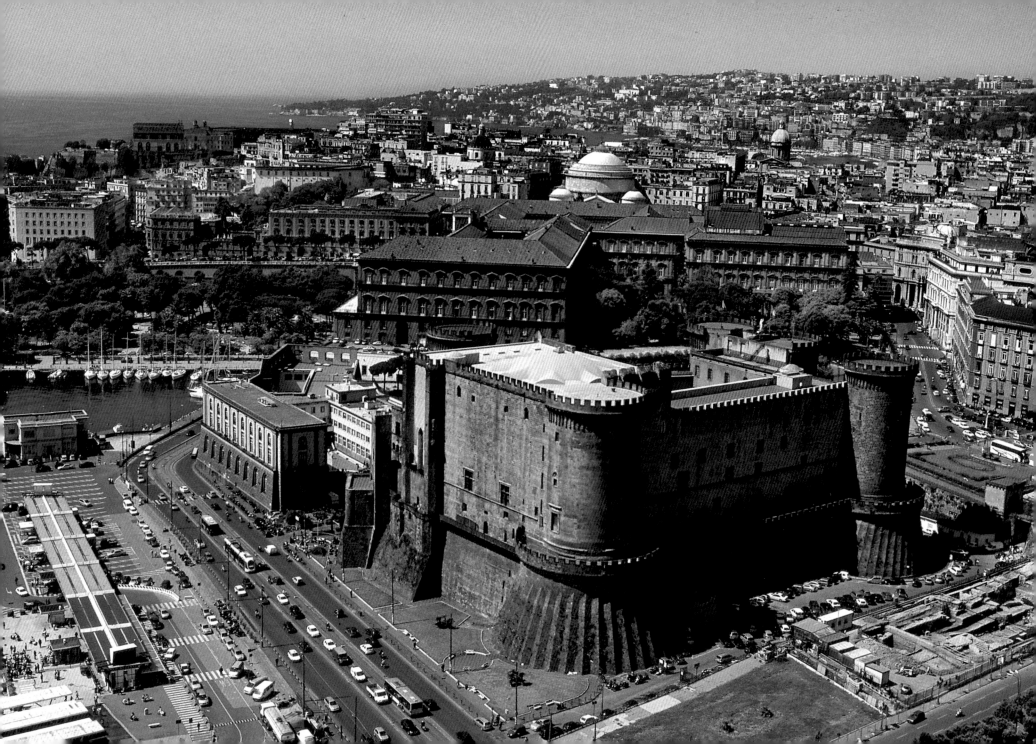

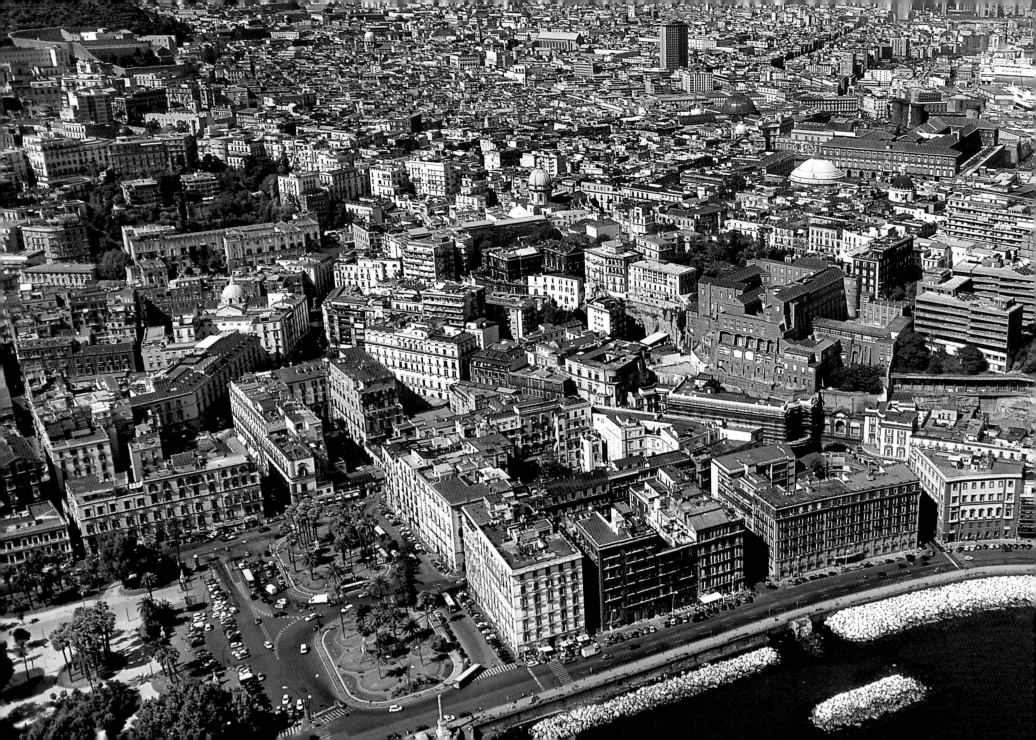

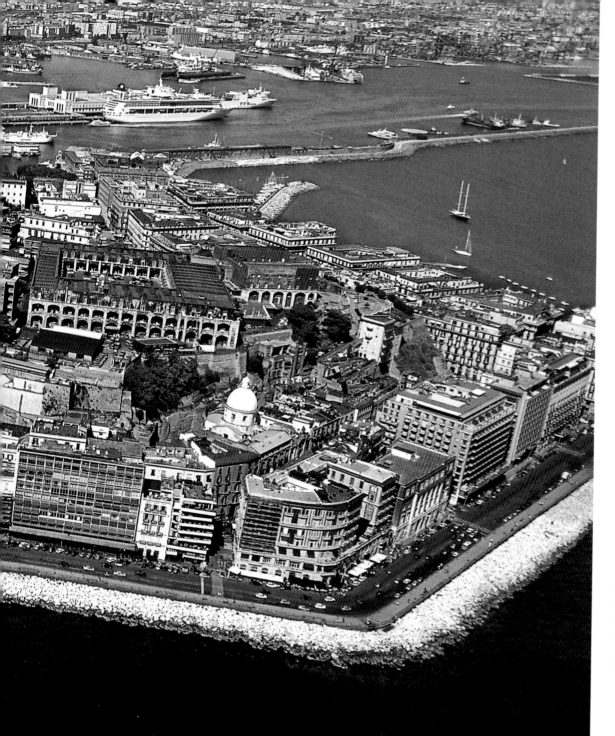

32-33 This part of Naples seafront sees, in the bottom left, the last part of Via Caracciolo which comes to Victory Square. The commemorated battle is that of Lepanto in 1571 in which numerous Neapolitan crews and vessels took part.

35 Castel dell'Ovo is located on a famous islet where, it is said, lies the body of the siren Partenope. What is more likely is that the Cumaen disembarked here in the 6th century BC to establish the beginnings of the future city. During the centuries the place had various fortunes, up until Robert of Anjou erected a proper castle with strong square towers which still inspire reverence today. It was restored over the years and the last major restoration was carried out by the Bourbons, which gave it most of the features seen today.

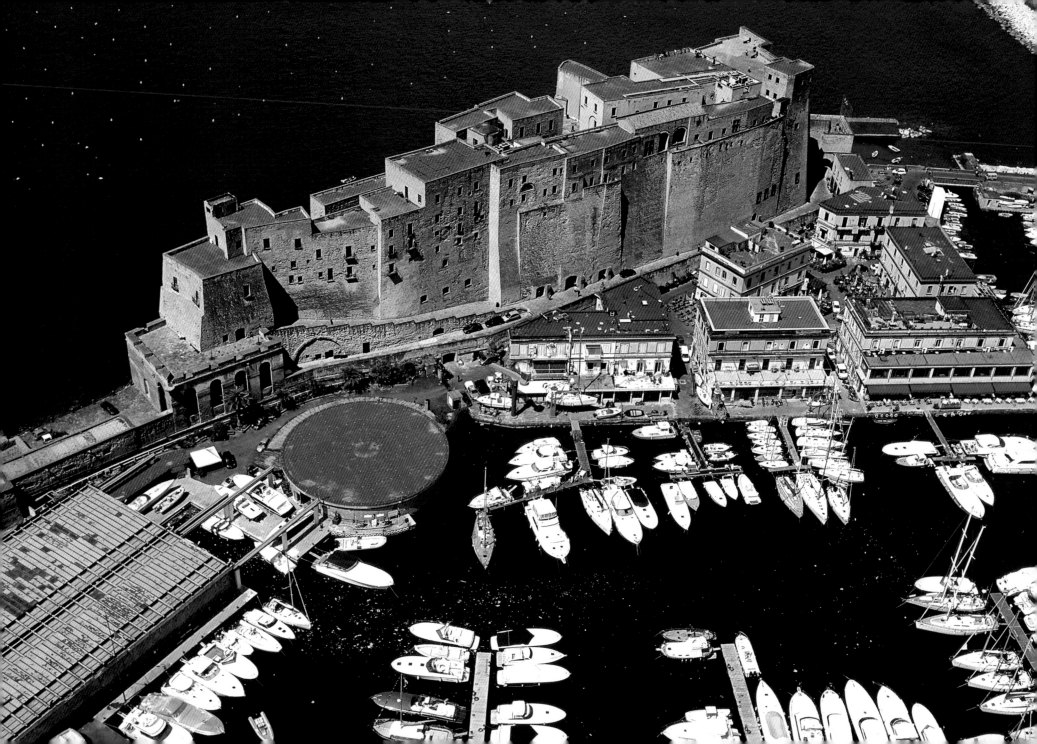

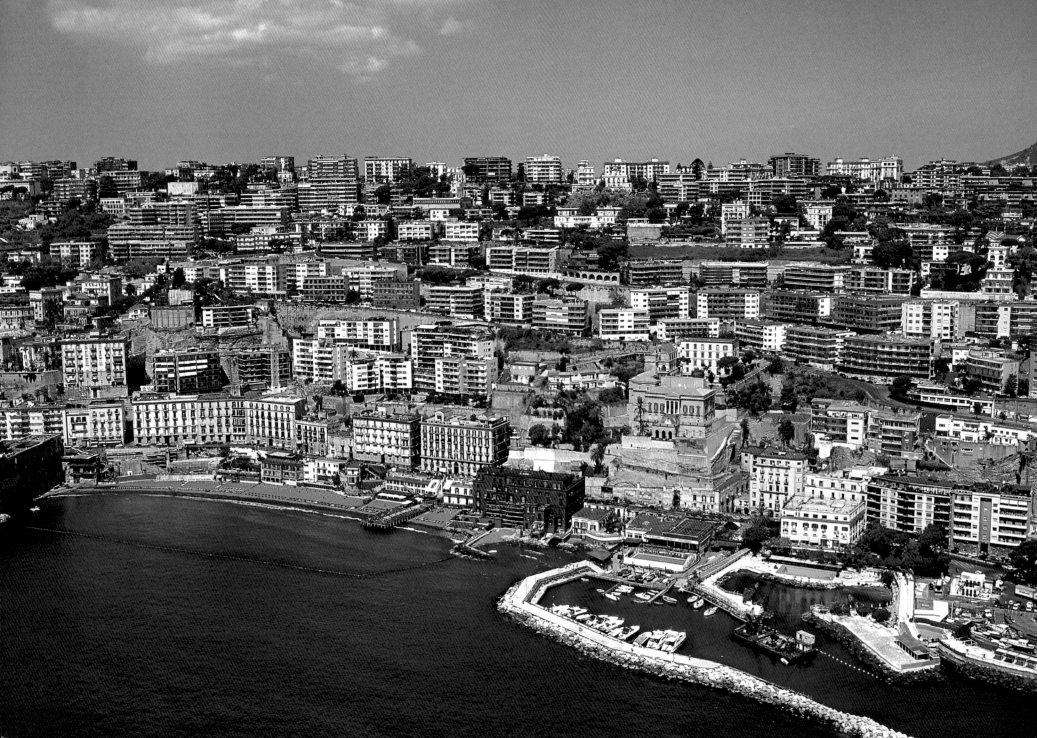

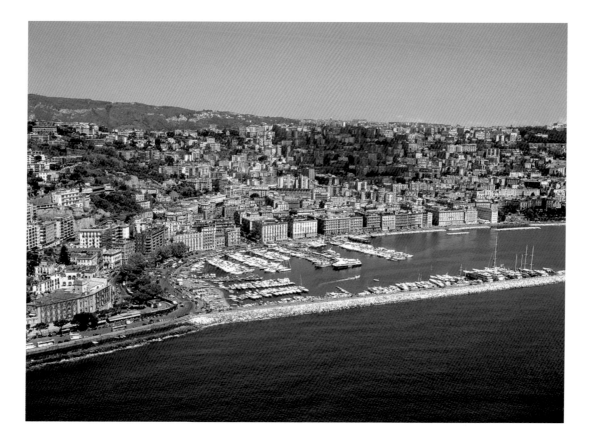

36 and 37 Started by Charles II with the Molo Angioino (Angevin Wharf), the port underwent various transformations; Charles of Bourbon ordered the erection on the east the Wharf of the Immacolatella, creating a characteristic rectangular shape, enclosed on three sides and in part on the fourth. In 1924 the major work started which increased Naples' commercial role and which gave the port its current size and shape.

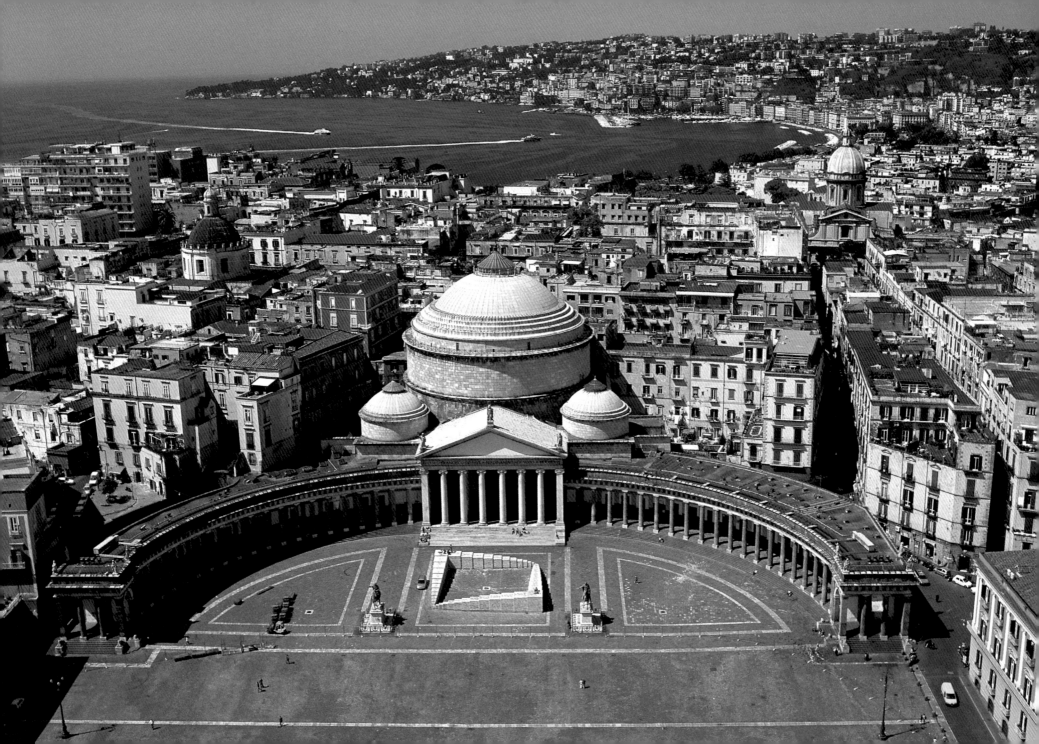

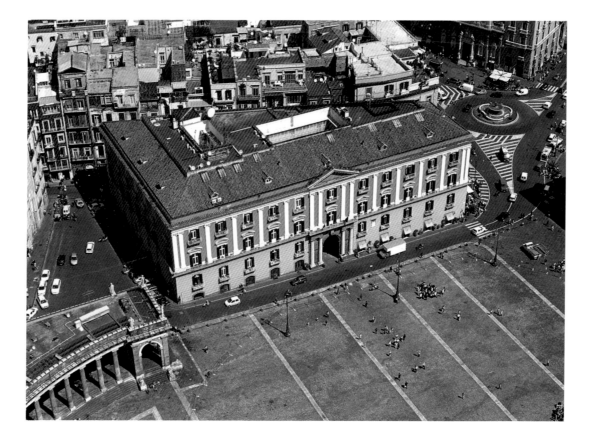

38 The church of San Francesco di Paola was built in the area of the 19th century Largo di Palazzo, today's Plebiscito Square. The square was ordered by Joachim Murat in 1809 and designed by the architect Leopoldo Laperuta and included a semi-circular colonnade, called Foro Murat.

39 The history of the Prefecture's main office (once the Foresteria di Palazzo or Palace Guest Quarters) is tightly intertwined with the layout of the Piazza del Palazzo Reale (Royal Palace Square). In 1812, Joachim Murat called for a competition for the redesign of the space in front. In the original plan, in place of the church, Murat had thought of an immense circular hall for the civic reunions and, in the lateral chambers, a National Museum of Science, Technology and Work.

40 The Market and Pendino districts have their roots in the beginnings of the city of Naples, given their vicinity to the harbor. Market Square and the Carmine Square in front have witnessed much of the city's history, from the revolt of Masaniello to the beheading of Conradin of Swabia on 29 October 1268..

41 On the other side of Via Mezzocannone, in front of the monastery complex of San Marcellino, rises the church of Gesù Vecchio (Old Jesus). It rose as the first church of the order of Jesuits in Naples. The church underwent deep transformation when the Jesuits where expelled from the Kingdom of Naples in 1767: the convent and the beautiful annexed cloister became the head office of the Università degli Studi.

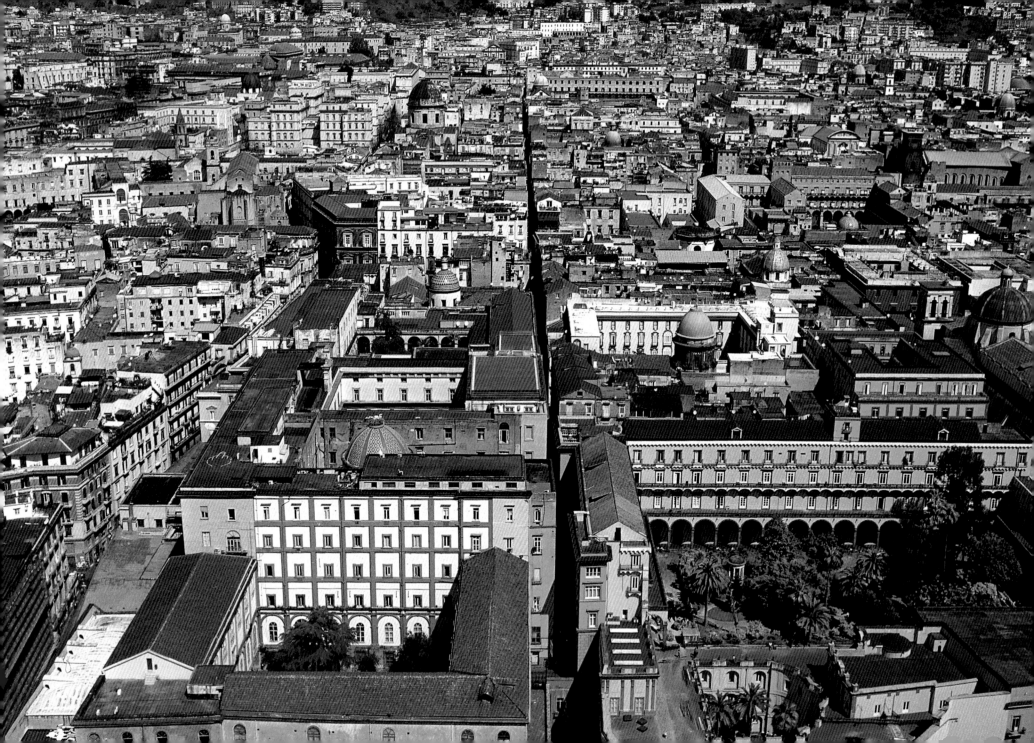

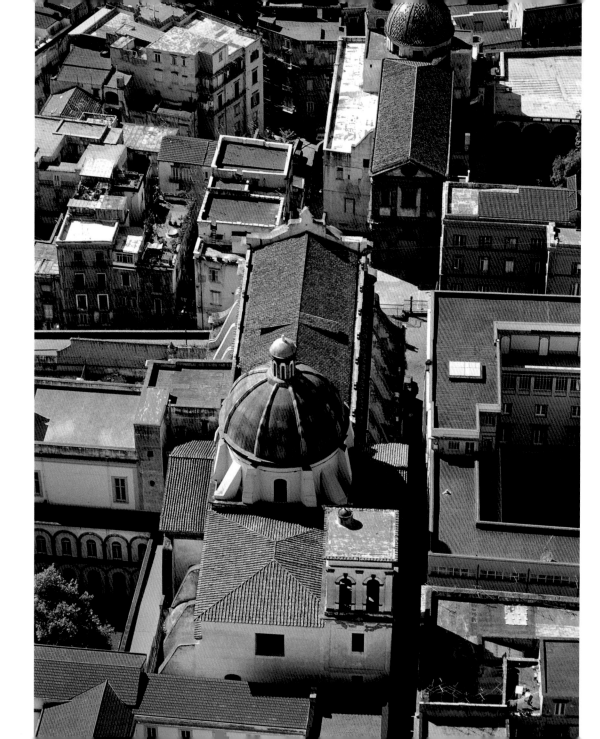

42 The church of San Severino e Sossio (seen from behind) is built opposite the seventeenth century church of Saints Marcellino and Festo.

43 Grand expression of the Neapolitan Baroque, the church of Gesù Nuovo (New Jesus) was dedicated, on the wishes of the viceroy, to the Immaculate Conception. When, in 1767, the Jesuit order was banished from the kingdom, the church passed to the reformed Franciscans who dedicated it to the Trinita Maggiore (Great Trinity).

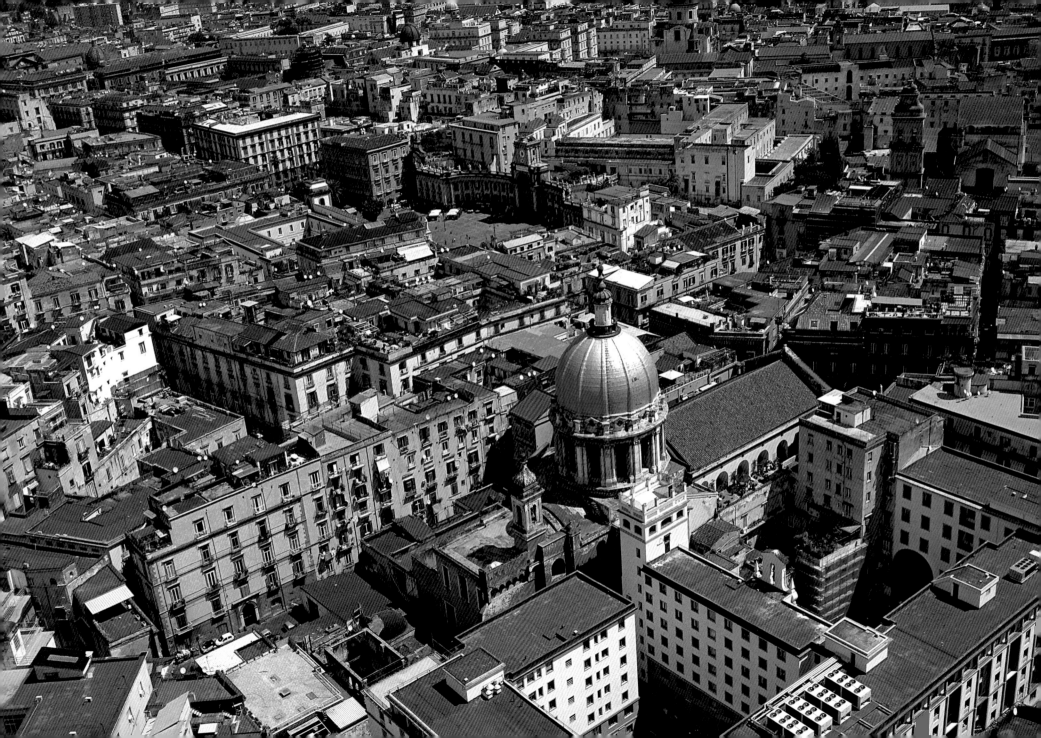

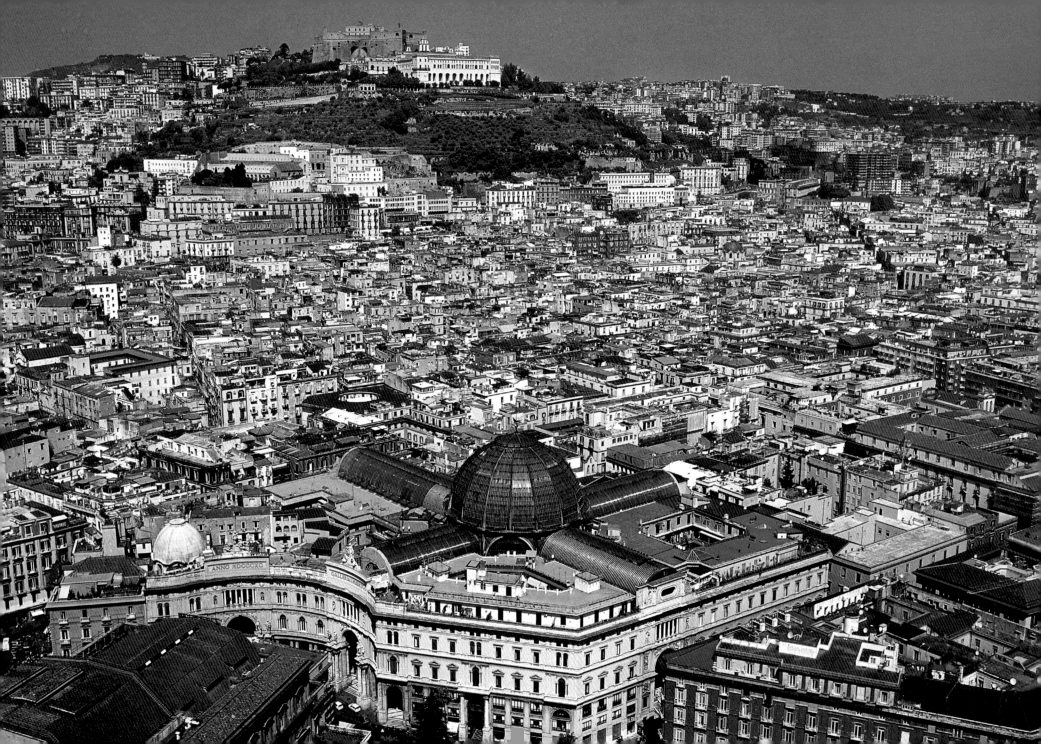

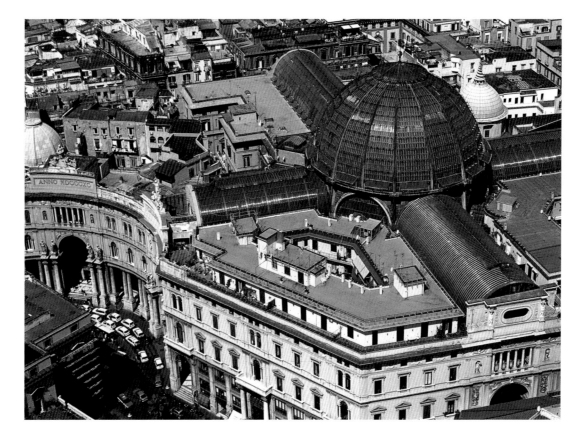

44 and 45 A panorama and a detailed view of the Umberto I Gallery. Typical example of Umbertine architecture – reminiscent of Vittorio Emanuele's Gallery in Milan – the Neapolitan Gallery is one of the peninsula's most majestic buildings of this kind, for the imposing nature of its iron and glass architecture and for its grand proportions.

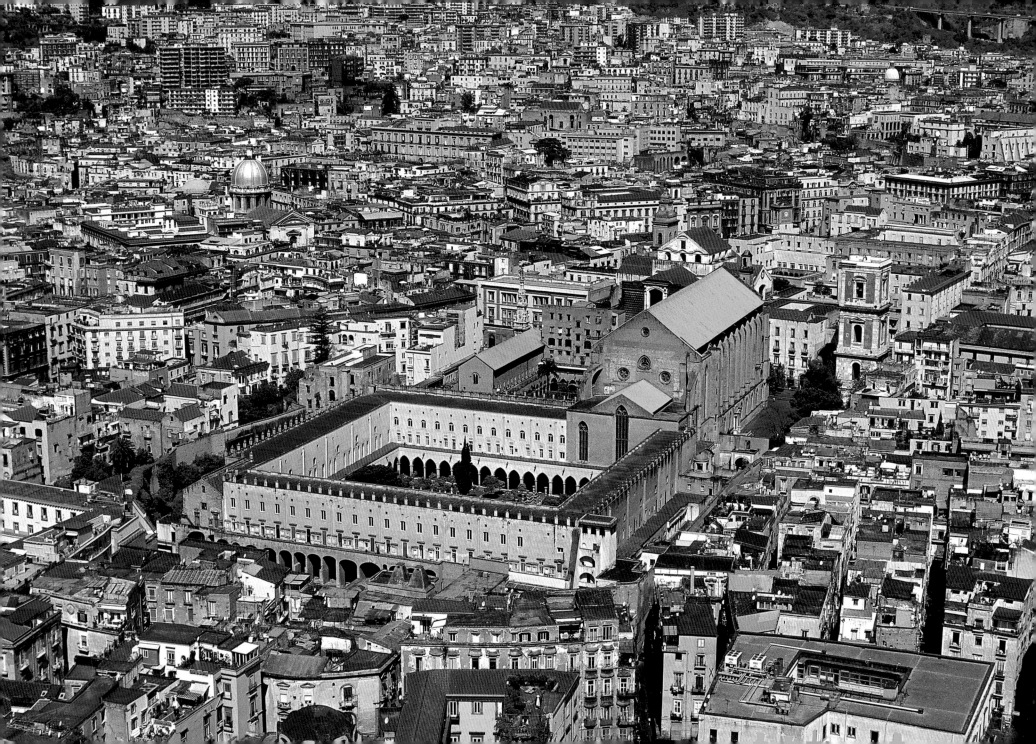

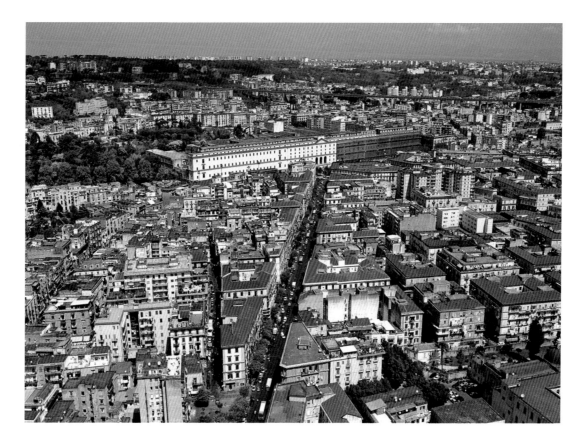

46 The fourteenth century monumental complex of Saint Clare is one of the most valuable buildings ordered by the Angevins who were particularly devoted to the Franciscan order.

47 Spaccanapoli (divider of Naples) is the popular name for the street which splits a large part of the city in two. It is actually called San Biagio dei Librai for part of its stretch and starts from the Pignasecca district, crossing the whole of the historical center and arriving at the back of Castel Capuano, close to the Central Station.

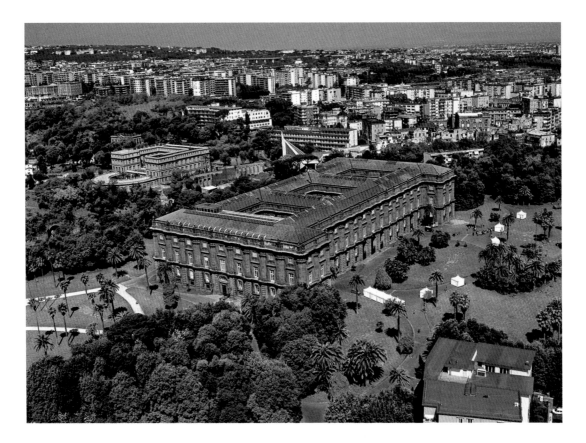

48 In 1738, under the orders of Charles of Bourbon, work started on the Royal Palace of Capodimonte in the city's hilly northern area. It was to become the sovereign's place for hunting and recreation. Today it hosts the National Museum with an immense collection of paintings, artifacts and archeological findings.

49 From 1600 to 1946 the Royal Palace had always been the monarchic power's head office in Naples and Southern Italy: it was first inhabited by the Spanish and Austrian viceroys, then by the Bourbons and finally by the Savoia. The three-tier facade is the one which most complies with Fontana's original project. Vanvitelli had to intervene in 1753 making some modifications for structural reasons.

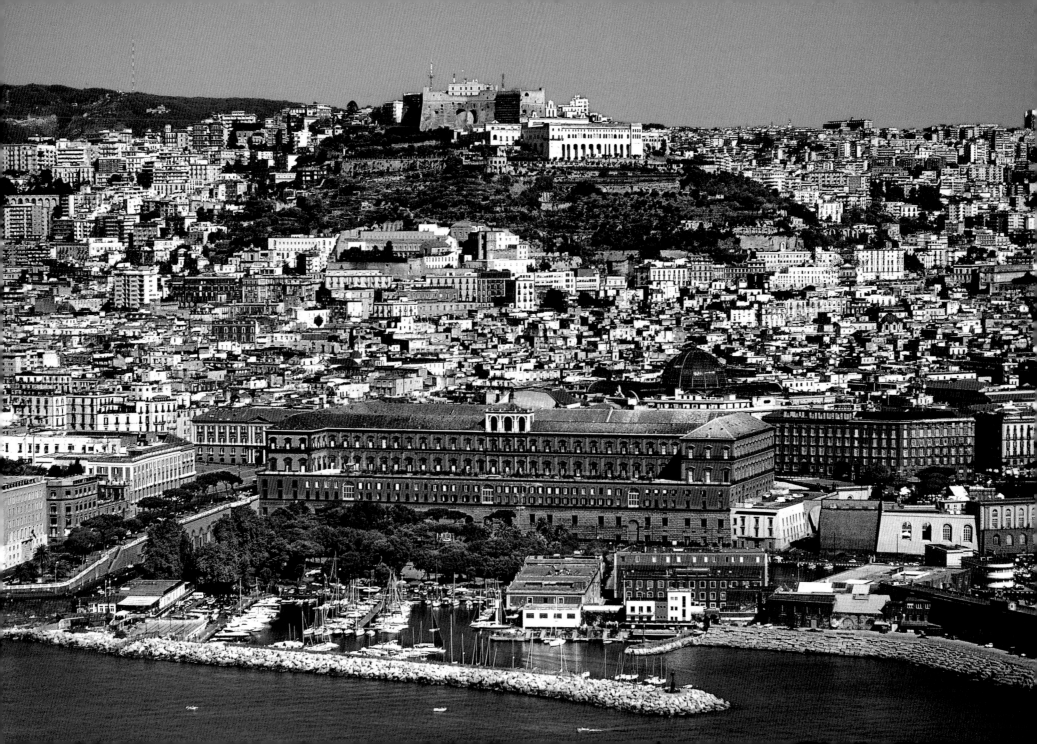

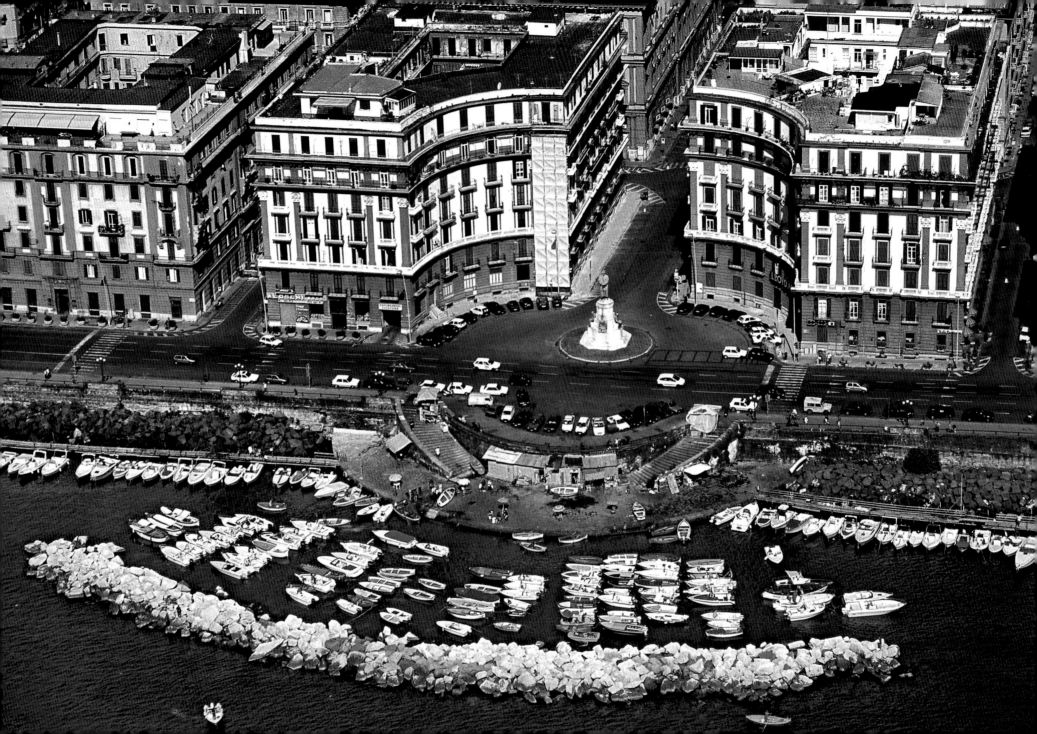

50 Santa Lucia is the seafront area in front of Castel dell'Ovo. Up until the 16th century it had only been a fishing village but in 1599 the Spanish viceroy decided to transform it into a prestigious area.

51 A panoramic view which ranges over Castel Sant'Elmo in Santa Lucia. The castle's original structure has never been altered. Witness to the last moments in the life of the 1799 Neapolitan Republic, it was state military property up to 1976.

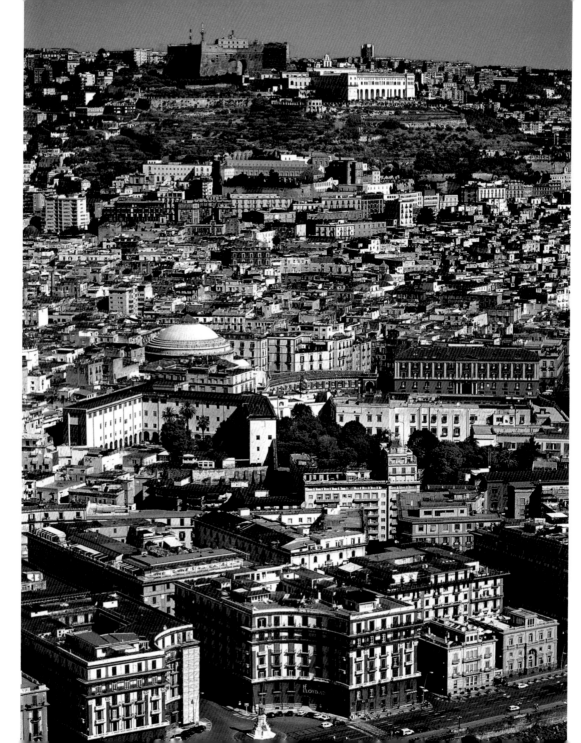

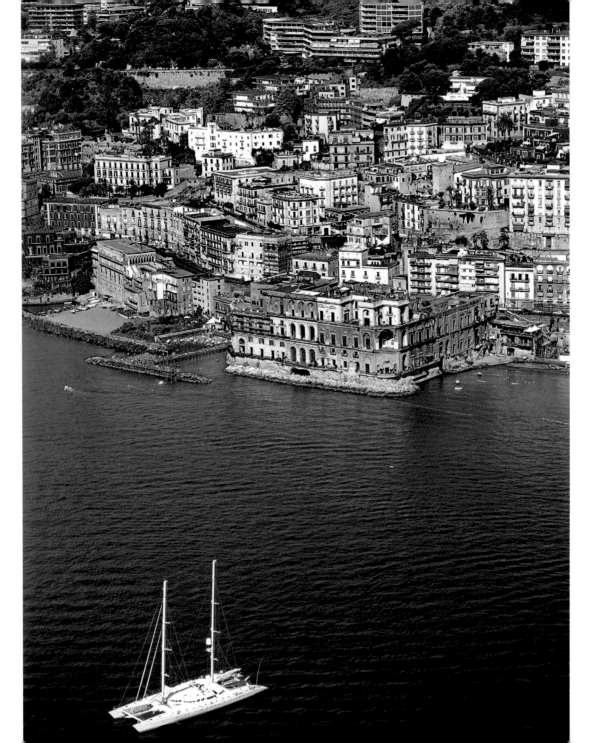

52 and 53 Posillipo is the beautiful promontory which closes the territory of Campania's capital to the west and stretches towards the sea dividing Naples Bay from that of Pozzuoli. In the right of the photograph one can see Palazzo Donn'Anna, a majestic tuff building built in 1637 by the Spanish viceroy Ramiro Guzman for his marriage to the Neapolitan princess Anna Carafa.

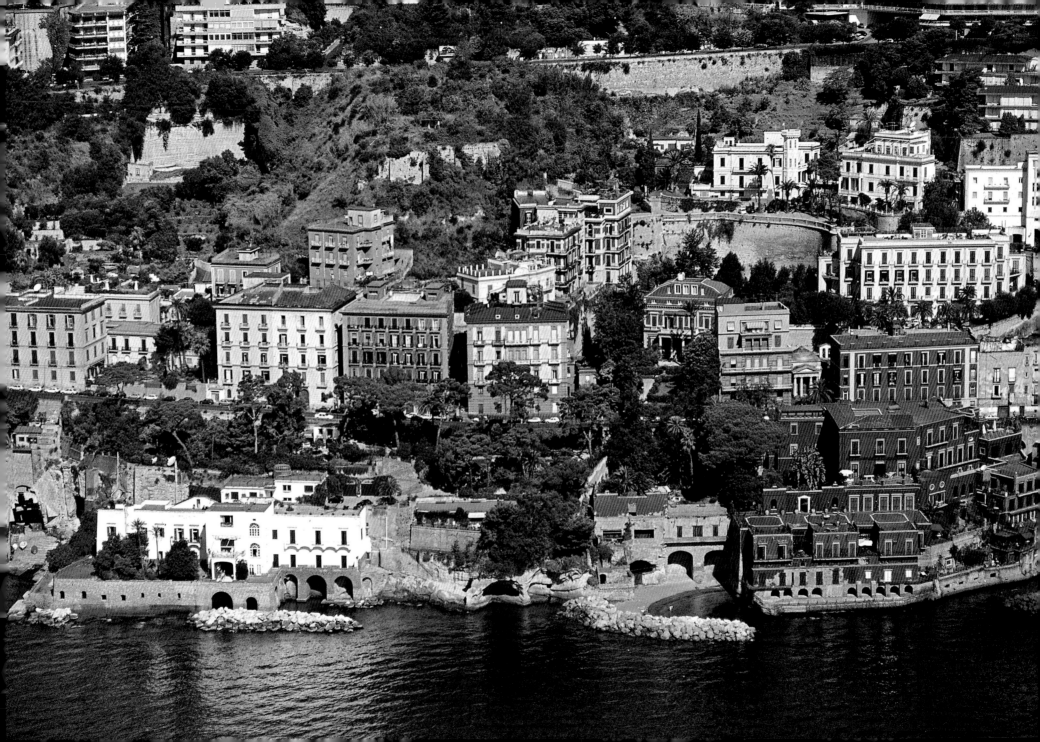

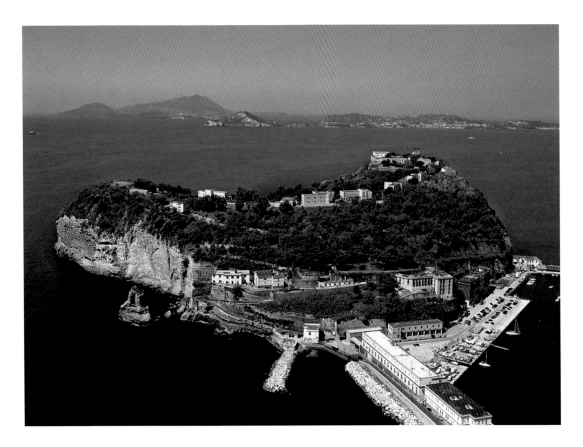

54 The west coast yellow tuff walls, in front of the Nisida islet, steeply rise from the sea but slope gently inland, offering a fascinating and varied combination of panoramic views.

55 Nisida was a privileged place during the Roman era: one of its luxurious villas formed the headquarters of Brutus and Cassius during their conspiracy against Caesar and the battles which followed.

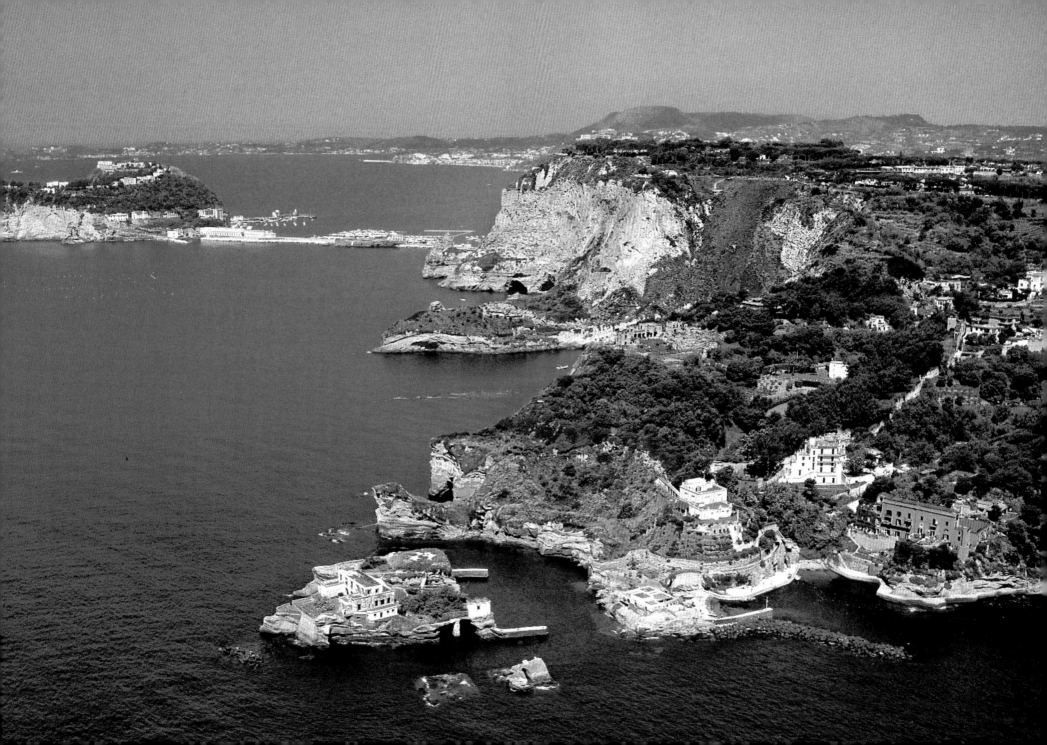

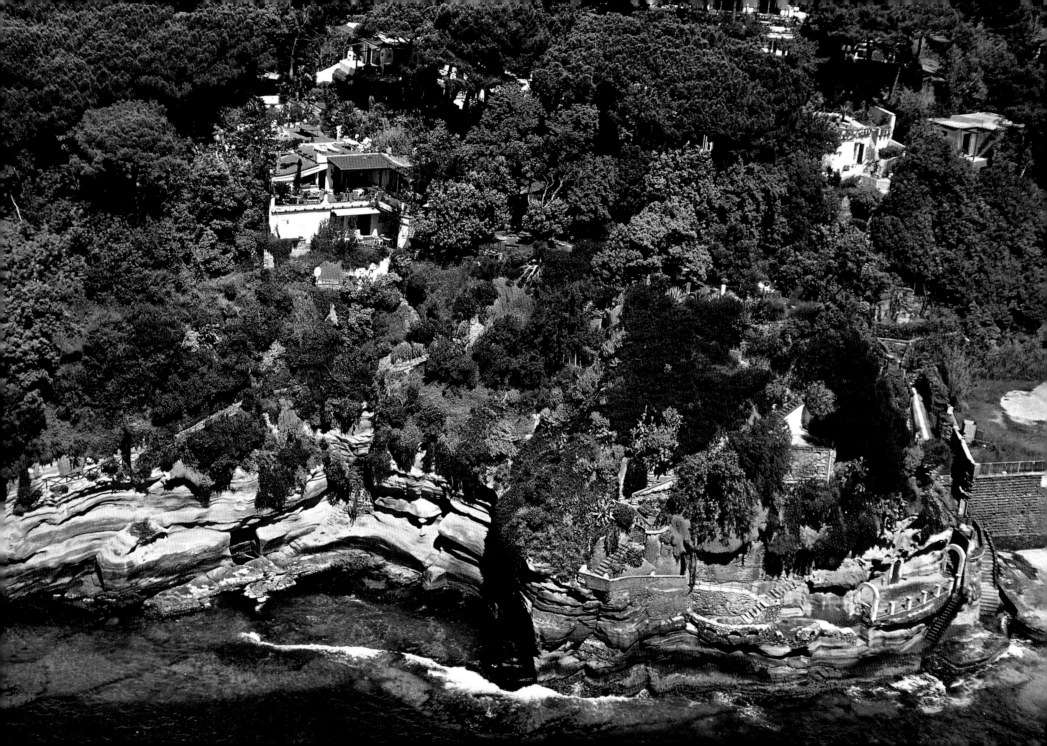

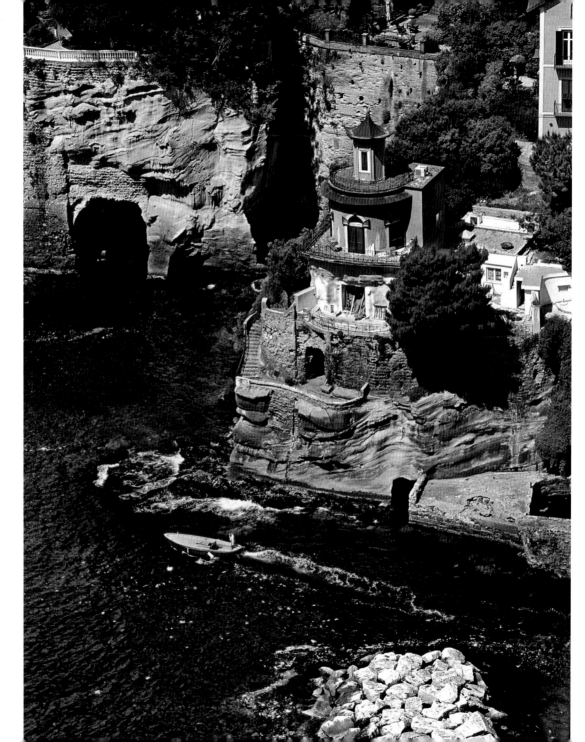

56 and 57 The western littoral of the Gulf of Naples has always been described, in Neapolitan song, as a perfect place, garden of delights. Villas and parks still recount its great beauty.

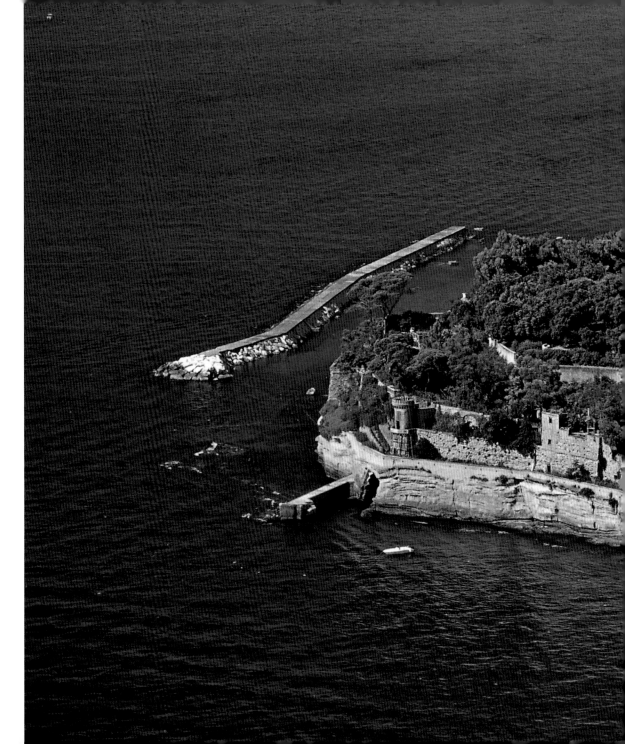

58-59 On the Posillipo promontory, sloping gently towards the sea, is located a creek protected by a small wharf named Riva Fiorita (Flowery shore). The towers are from Villa Volpicelli built in the 19th century in a 16th century style.

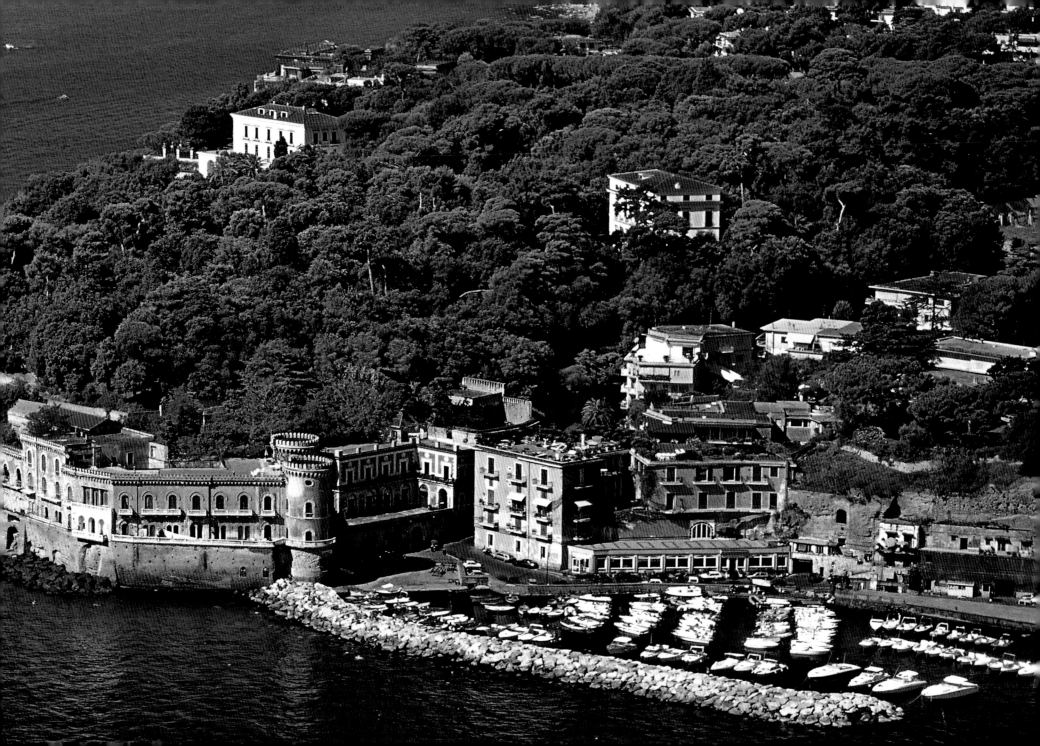

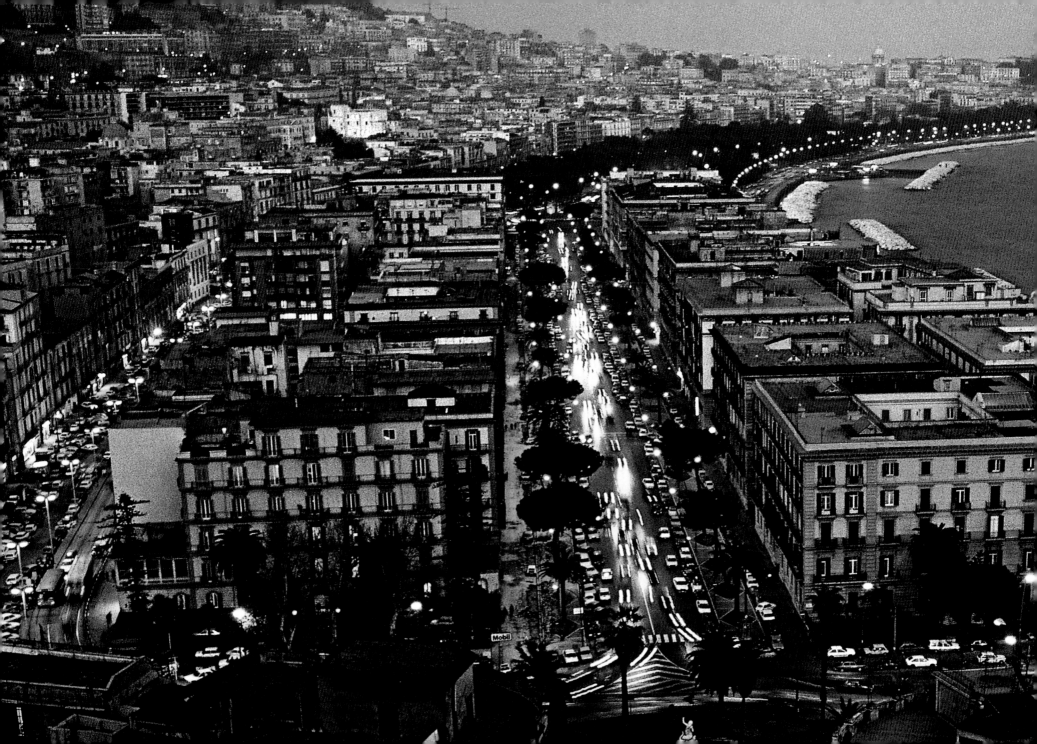

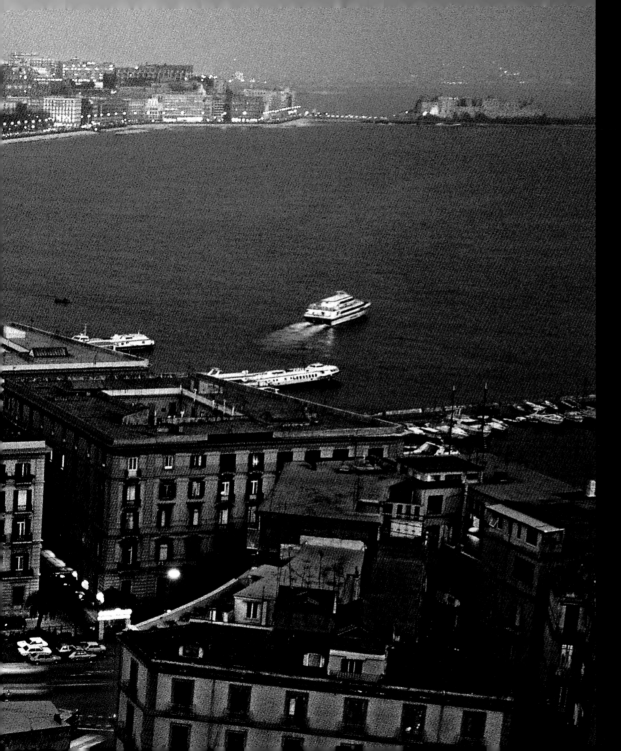

60-61 Mergellina (here a view of Via Antonio Gramsci at sunset) has been mentioned for centuries by poets, painters and musicians as one of the most suggestive places in Naples; here, the humanist Jacopo Sannazaro (1458-1530) lived and composed the "Arcadia" his most important poem. Today the pace is very different, having been absorbed into the city and there is a marina and the hydrofoil terminal which join the islands of the gulf.

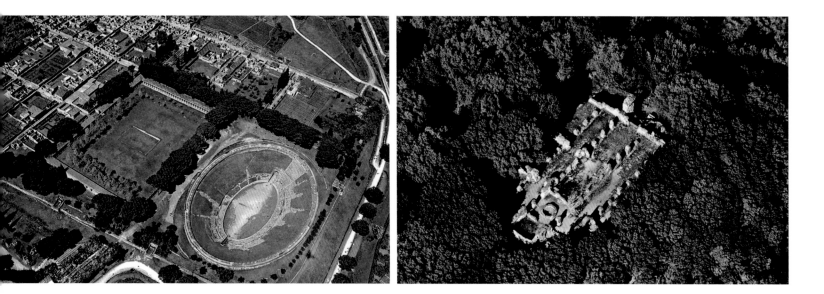

ARCHEOLOGICAL SITES

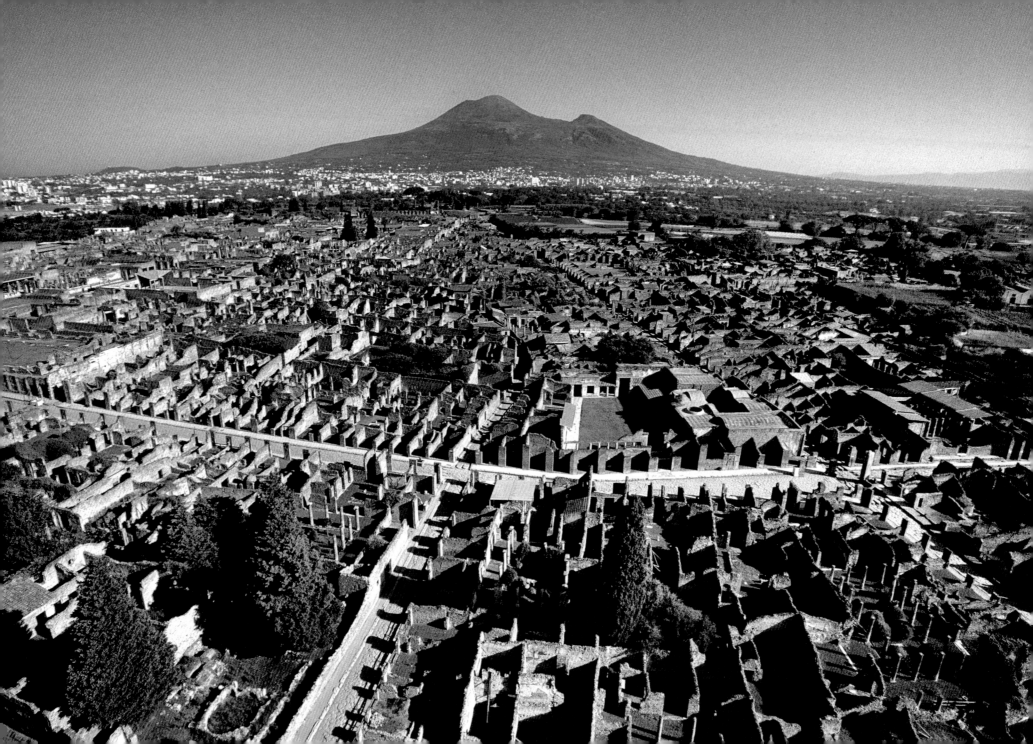

"On 24 August, around one o'clock in the afternoon, when my mother informed him that an extraordinary cloud, both for its largeness and appearance, appeared...Requesting his sandals he climbed on a hill upon which he could better observe the phenomenon (...). The cloud was growing bigger, now white, now dirty and spotted according to the quantity of ash and earth which had been raised..." With these words Pliny the Younger described, in a letter addressed to Tacito, the beginning of the eruption of the AD 79 during which his uncle, the famous naturalist Pliny the Elder, captain of the fleet stationed in Miseno, lost his life. And the course of history changed. Devoted to commerce and the pleasures of life, densely populated and pious, Pompeii was a lovely place where altars smoked with offerings and the scents wafted up to the gods. Luxury was diffuse, its gardens and thermal baths were magnificent, affording a place where one could both converse and exercise. Pompeii was proud of its large Palestra (gymnasium) and its crowded theaters, where, in the evening, the sounds of music and poetry encroached gently on silent Campania. Its story starts around the 7th century BC on the shores of the Sarno River which gave Pompeii access to the sea, in a fertile land which made it instantly rich. The nearby Greek and Etruscan populations had a big impact on cultural and urban development but it was the Samnites, in the 5th century BC, who dominated it up until the Roman era. In the 1st century BC the inhabitants of Pompeii wanted to become citizens of the empire and in order to obtain this privilege, decided to enter into war. Thus they found themselves taking part in the battles between Rome and the allies. With the arrival of the veterans, the city became Roman in every respect, taking on the appearance of a proper imperial center which continued to base its economy upon trade. Then, in AD 62, an earthquake damaged it in quite a serious way, so much so that when it was buried by the lapillus it was still undergoing construction and growing and was a home to 20–30,000 inhabitants. The first archeological digs were done in 1592, on Sarno, but they were not considered important until findings were discovered in Herculaneum. In 1748, investigations began which, however, only had the intention of surfacing interesting or

62 left The Large Theater in Pompeii (Naples) was built in the 2nd century BC. It could hold 5000 spectators and enjoyed a magnificent position with mountains that acted as a natural background.

62 right Cumae (Naples), Kyme in Greek, despite having been inhabited since the Iron Age, was colonized by the Chalcis of Eubea in the 8th century BC. It reached its greatest splendor between the 7th and the 6th century BC.

63 Pompeii (Naples) is the most extraordinary example of a Roman city in the world. Immense and opulent, saved from various earthquakes it was finally buried by the Vesuvius eruption of AD 79.

65 Paestum (Salerno): a view of two magnificent temples. In close up the Heraion, the urban sanctuary of Hera, commonly called Basilica. In the background the so-called Temple of Neptune.

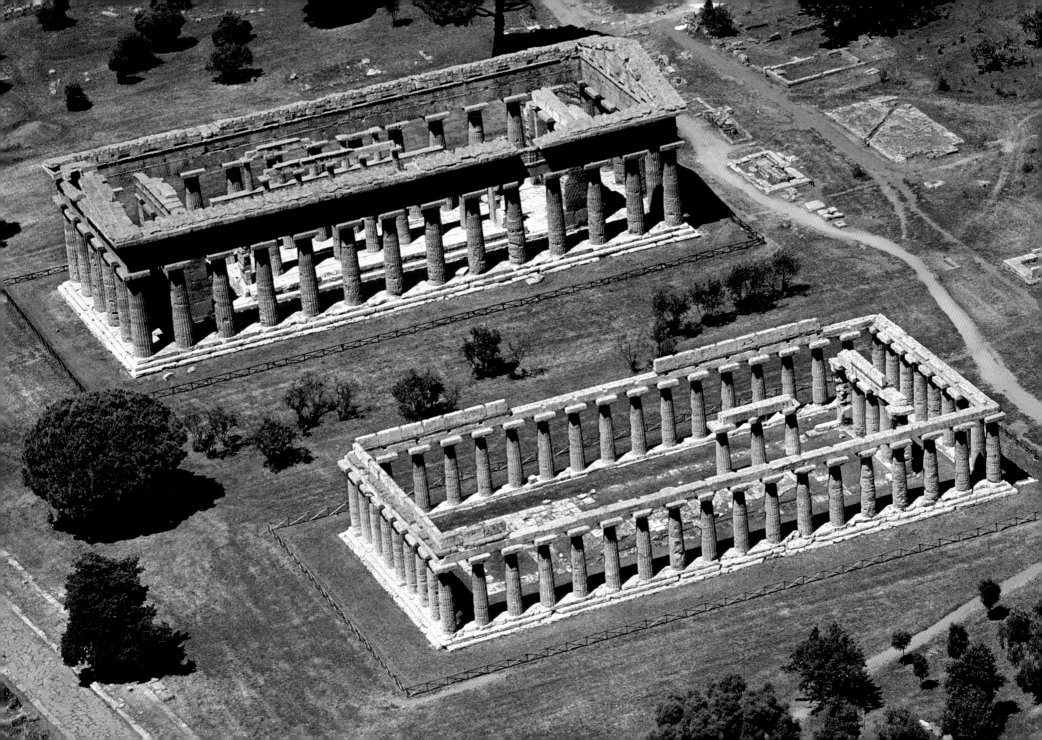

precious materials which would be transferred to the Royal Villa of Portici and then taken to the Archeological Museum of Naples. The ancient city returned to the light and to her former splendor, becoming one of the most visited places of the 19th century and Alexandre Dumas Senior managed its work. Today it is one of the most well known archeological sites in the world, also thanks to Giuseppe Fiorelli, the 19th century archeologist who restarted the excavations on a scientific basis and had the brilliant idea of "freezing" in plaster molds the final living moments of its citizens. Pompeii was hard-working and lively, until its gods decided otherwise. Illuminated by the sun's setting rays, and the Vesuvius, right there, high on the right, Herculaneum is the archetype of a postcard. Beautiful and almost intact. Gathered as it is under the volcano's slopes, dotted by palm trees and umbrella pines, it offers a beautiful sight. The view captures a real slice of a city, from the gymnasium to the thermal baths. The houses stand out under the Campania sky, high with surprisingly little damage from the eruption. The city was inhabited by the Osci, Etruscans, Samnites and, lastly, by the Romans, though maintained for a long time the Oscan language and culture. Set between the refinement of the Greek Naples and the commerce of Pozzuoli, at the beginning of the 1st century BC, Herculaneum was populated with magnificent villas of Roman patricians, who were attracted by the mild climate and the cultivation of the fertile earth, popular for its figs. In the Augustan era there was

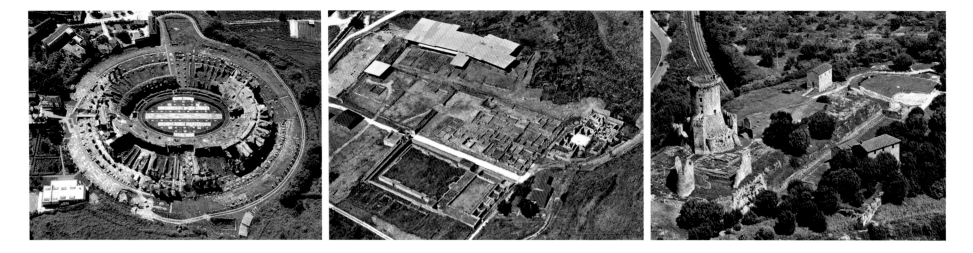

66 left Santa Maria Capua Vetere (Caserta) used to be known solely as Capua in the 4th century BC when it was the largest city of the peninsula, rich with splendid monuments like the Amphitheater.

the first, great building drive and the center was enriched with a theater and a basilica, public fountains and the imposing Palestra (gymnasium), besides two thermal complexes and the walls. The site was discovered in 1709, by accident, by a farmer who was digging a well and from that moment excavations took place with alternating luck, until 1927, when the famous archeologist Amedeo Maiuri brought to light almost the entire part which is visible now, extracting highly valuable items today found in the Museum of Naples. The uncovered surface is just a small part of the city, which housed around 5000 inhabitants. It was organized in streets which were parallel to the coast and which intersected at right angles, with blocks called insulae, divided into several apartments and on various levels, built with a central courtyard and a hall instead of a peristyle and an atrium. Boscoreale is located north of Pompeii, still beneath the slopes of the volcano, and it has been inhabited since the most ancient of times and reoccupied in the 3rd century AD, after the eruption. At the end of the 19th century, when the first excavations started, around thirty rustic villas were discovered, luxurious houses or agricultural settlements tied to the cultivation of olive trees, grain and grapevines. Unfortunately the findings are now, for the most part, in foreign museums, and the villas have been stripped over the course of the years. Villa della Pisanella was one victim: excavated at the end of the 19th century, the treasure found is now divided between the Louvre and the Rothschild Collection. 1037 gold coins were found (equal to 102,800 Roman coins) and a silver set composed of 108 Augustan era pieces as well as several jewels. Another beautiful villa was that of Publius Fannius Synistor, excavated in 1900 in Fondo Vona. It was decorated with beautiful paintings in the 2nd Pompeian style, similar to those of the Villa dei Misteri of Pompeii and dating around 40–30 BC. The most spectacular walls were shared between the Museums of Naples, New York, Brussels, Paris, Mariemont and Amsterdam. The name Oplontis, in the center of Torre Annunziata, is uniquely found in the Tabula Peutingeriana, a medieval copy of an ancient map concerning the existing roads in Italy during the Roman Empire, and indicates some villas amongst Pompeii and Herculaneum. There was probably a scattering of villas and coastal settlements since the Greek geographer Strabo wrote in the Augustan era: "The coast from Miseno to Sorrento has the appearance of a unique city." It is in the 18th century that the first official study starts, in Mascatelle, when a gallery which started with an excavation of Sarno's Canal Conte, still visible on the southern part of the archeological area. The excavations were closed, resumed and then abandoned again, in the first half of the 19th century, until the area was bought by the state. Organized investigation started in 1964 and important findings are still being uncovered.

66 center and right Velia (Salerno): on the southern coast of Cilento, not far from the town of Ascea Marina, extends the promontory which in ancient times hosted Velia, once called Elea, renowned particularly for the famous philosophy school of Parmenides and Zeno. In the center photograph we can admire the excavations and the Hellenistic thermal baths (on the right, 3rd century BC); in the photograph on the right the remains of the Acropolis.

Stabiae was the ancient name of the current city of Castellammare di Stabia, coming from Naples it was the Sorrentine Peninsula's first center. Inhabited since the 7th century BC, in 1957 a necropolis with over 300 burials was unearthed. The extreme significance of the findings and the presence of funerary offerings of Corinthian, Ethruscan, Chalcis and Athenian pottery, reveal the important commercial role of this city. Stabiae was an oppidum (town), a fortified place, as can be deduced by the fact that Silla did not just want to occupy it but destroy it (in the 1st century BC). But Stabiae did not cease to exist. In the hinterland, leisure and rustic villas were built and were ornamented with thermal baths, arcades, paintings and mosaics. The real excavations started in 1749 under the orders of King Charles III. But Campania's archeology is not just composed of Vesuvian sites: in the Piana del Sele rises Paestum, the pink city, which myth states was founded by the Argonauts after the stealing of the Golden Fleece. In reality the area had always been inhabited, but from the 7th-6th century BC was taken by the Sybarites who gave the city the name of Poseidonia and immediately started to trade with nearby populations. Thus it became one of the most flourishing cities of the Mediterranean and became even more so, welcoming the refugees from Sybaris destroyed by Croton in 510 BC, who brought all their wealth with them. Monuments and sacred buildings were built, a large urban sanctuary at the center of the inhabited area and a mysterious sacellum, west of the agora (marketplace), containing an iron bed and various furnishings, without names to identify to whom it was dedicated. In 273 BC the city took its current name, since it was a nominated Roman colony. Then oblivion and malaria arrived. Under Charles III it was "rediscovered," and the site today consists of a pentagonal enclosure with city walls and four doors. On the inside are three fantastic Doric temples. Heraion I, called the Basilica, is, dating from the 6th century BC, the oldest and is dedicated to Hera. On the right there is Heraion II or Poseidonion, Temple of Poseidon (450 BC), the most intact and spectacular temple of its style in Magna Grecia. To the north lies Athenaion, from the end of the 6th century BC: together, they give life to a complex where the beauty of the monuments fuses with that of the location, surrounded by the Biferi Rosaria Paesti, the rose trees celebrated by Virgil which bloom twice a year. Last but not least, Velia, the Phocean colony which gave philosophy a vital push with its Eleatic school, founded by Xenophanes and continued by Parmenides (who proclaimed the earth's roundness in the 5th century BC) and Zeno. They, together, laid the foundations of modernity.

69 Herculaneum (Naples), according to the historian Dionysius of Halicarnassus, was founded by the demi-god Hercules whilst he was returning from his tenth labor, the capture of the cattle of Geryon. Thus the name was Herákleion in Greek and Herculaneum in Latin.

70-71 The city of Pompeii is said to derive its name from the term pompe, which in the Oscan language means five. There were many agricultural centers which unified in 7th BC to give life to the unlucky center.

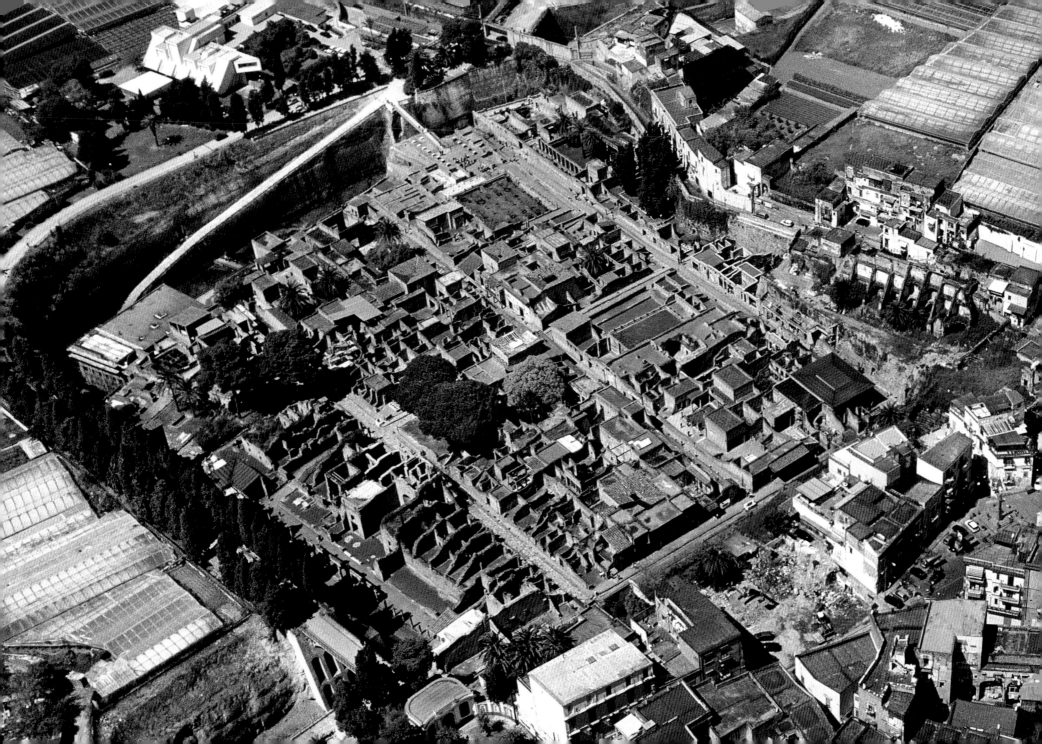

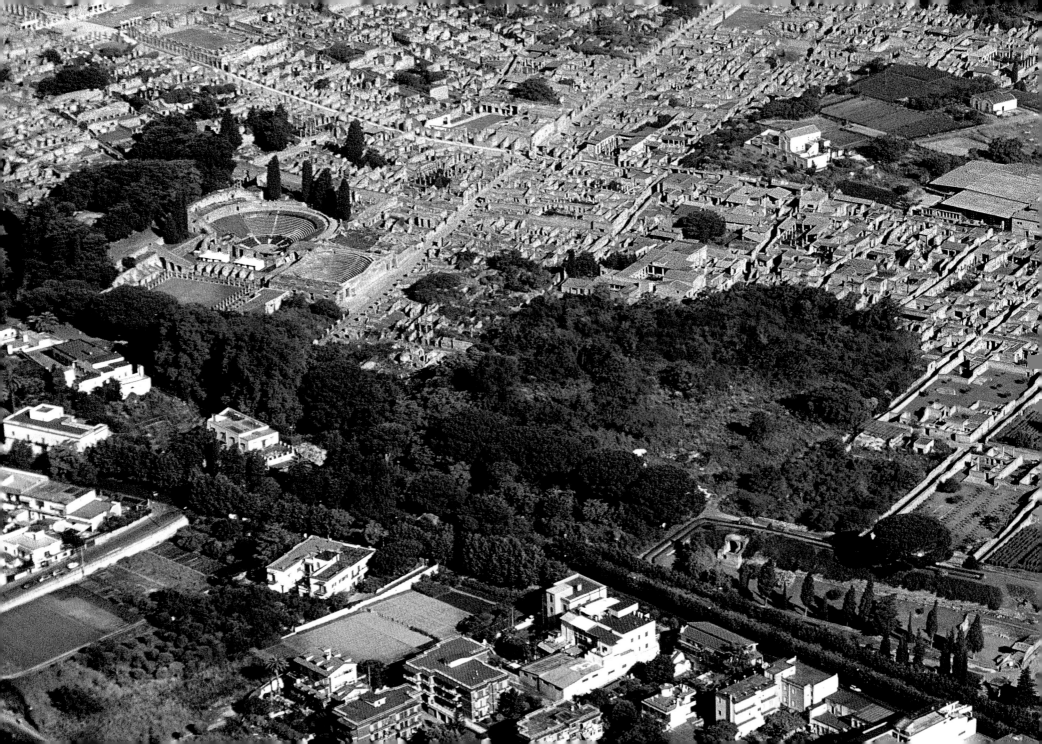

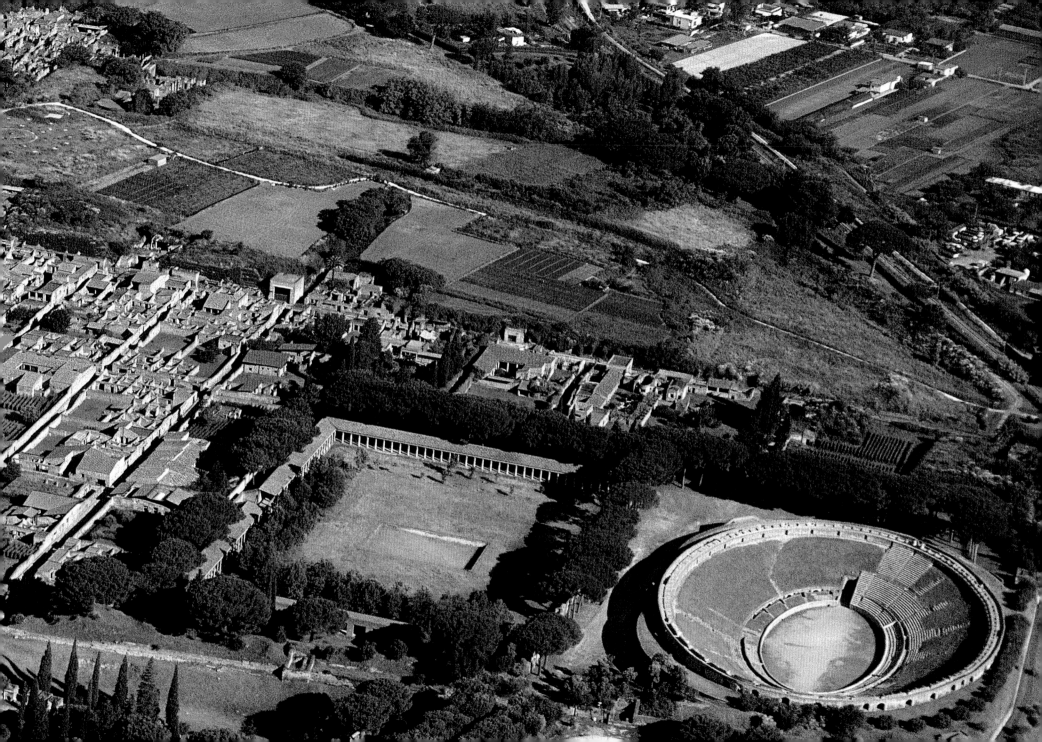

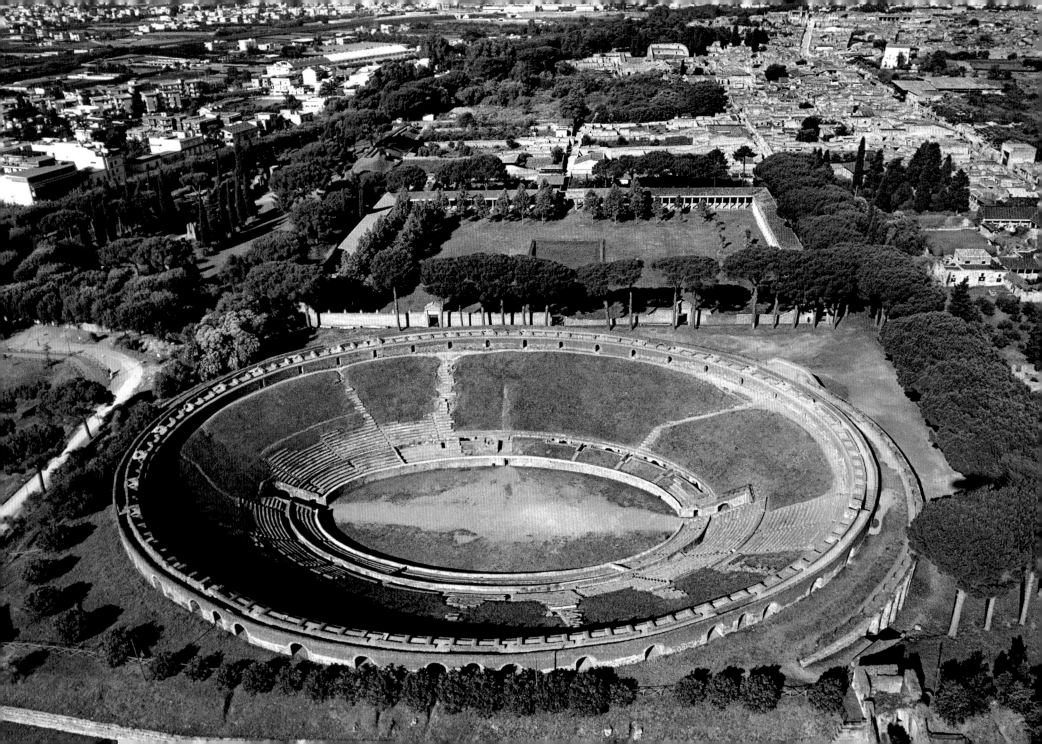

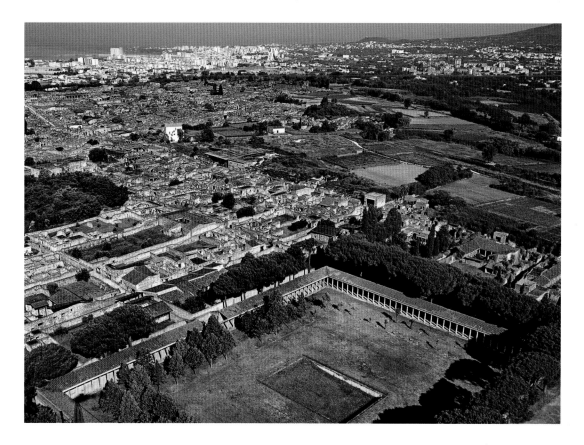

72 Pompeii (Naples): the Amphitheater is grandiose, with an estimated capacity of 12,000 to 20,000 spectators. This was the venue for all the gladiator games and circus performances which always had an enormous influence on the public.

73 The Palestra Grande (Great Gymnasium), of the 1st century AD has an enormous quadrangular shaped arcade which includes a large space for physical exercise. It also contained a swimming pool.

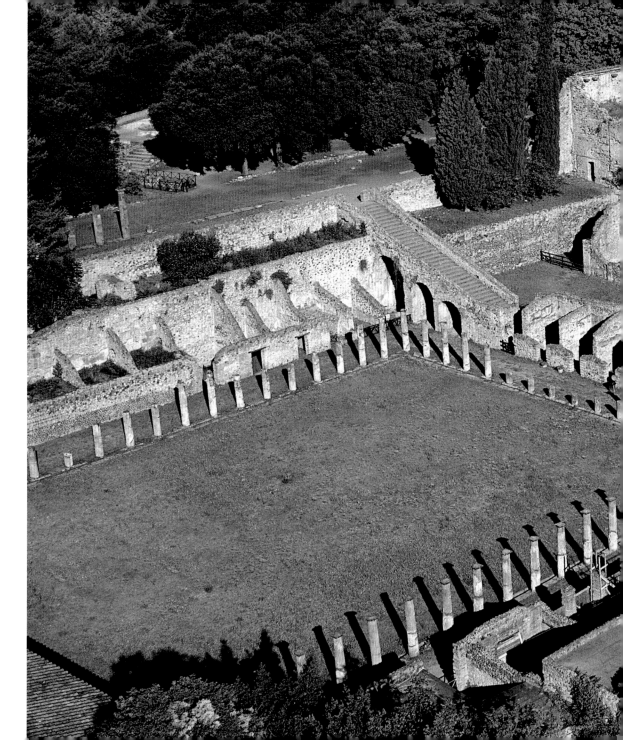

74

74-75 Pompeii (Naples): the gladiators' barracks (in the photograph on the left) is very ancient, and is usually used as foyer for the theater (center). Under Nero it became the barracks where the performing fighters lodged. On the right, one notes the well-proportioned Teatro Piccolo (Small Theater), also called the Odeon, balanced in his forms which could contain as many as a thousand spectators inside.

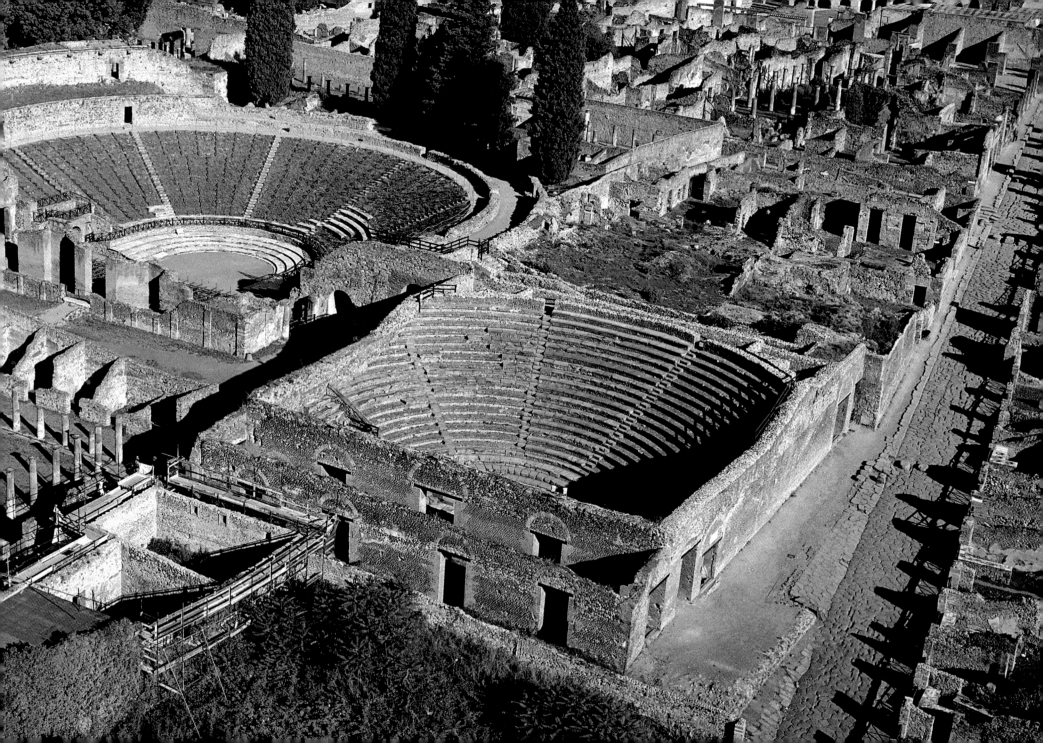

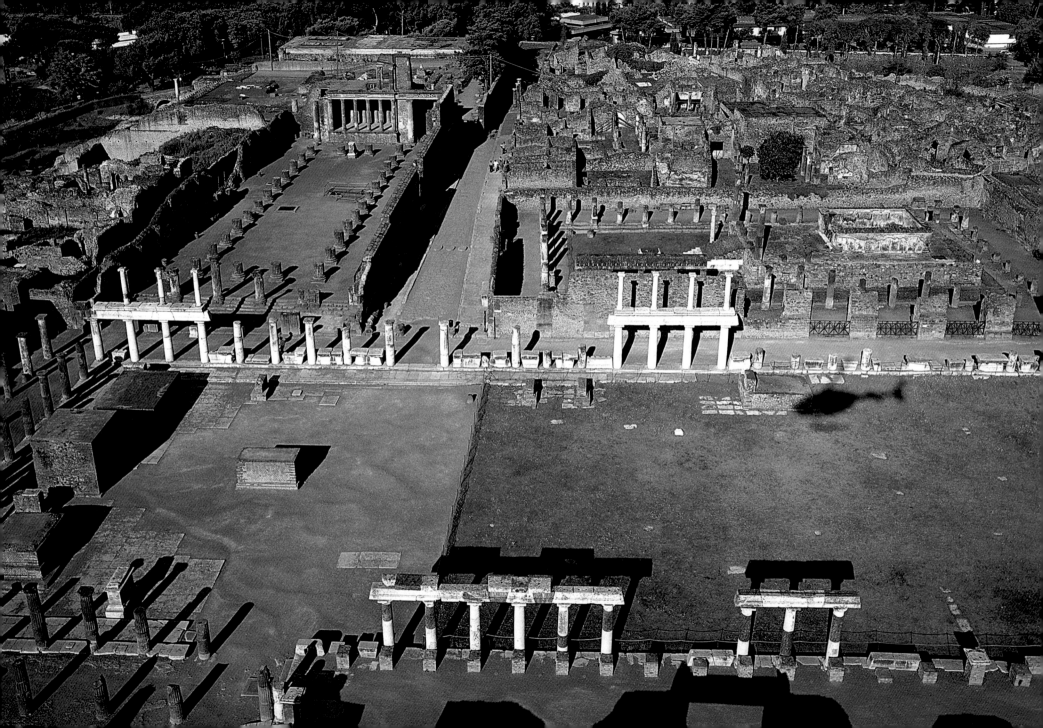

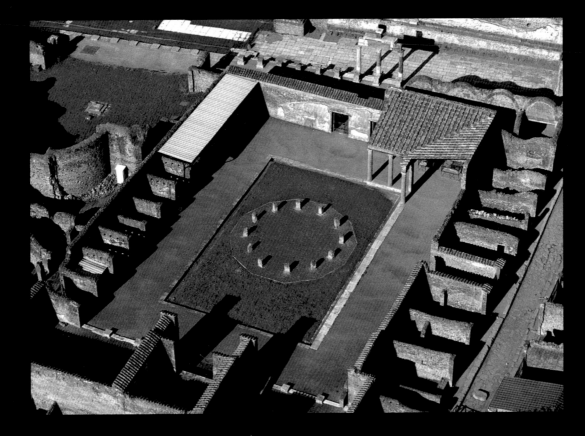

76 The Forum was the public center, especially from a religious, economic and political point of view, as justice was also administered here; this was overseen by the Basilica.

77 The Macellum, from the 1st century AD, was the public market. Preceded by a square planned portico where traders settled themselves, and at the center of which was located a pool filled with water (and perhaps with fish to be sold), surmounted by a dome standing upon 12 columns.

78-79 The villa of Giulia Felice includes an actual villa, a group of shops and even a thermal spa for public use. The garden is beautiful, with columns, fountains and bridges. Behind the building there is a large area for fruit and vegetable gardens.

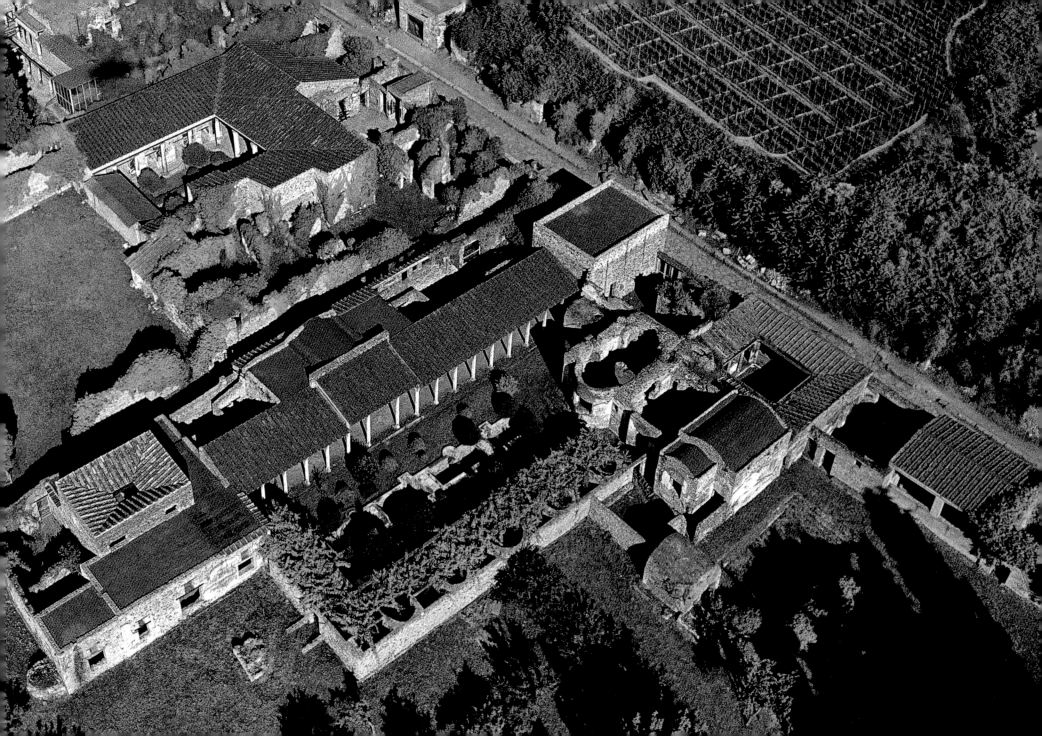

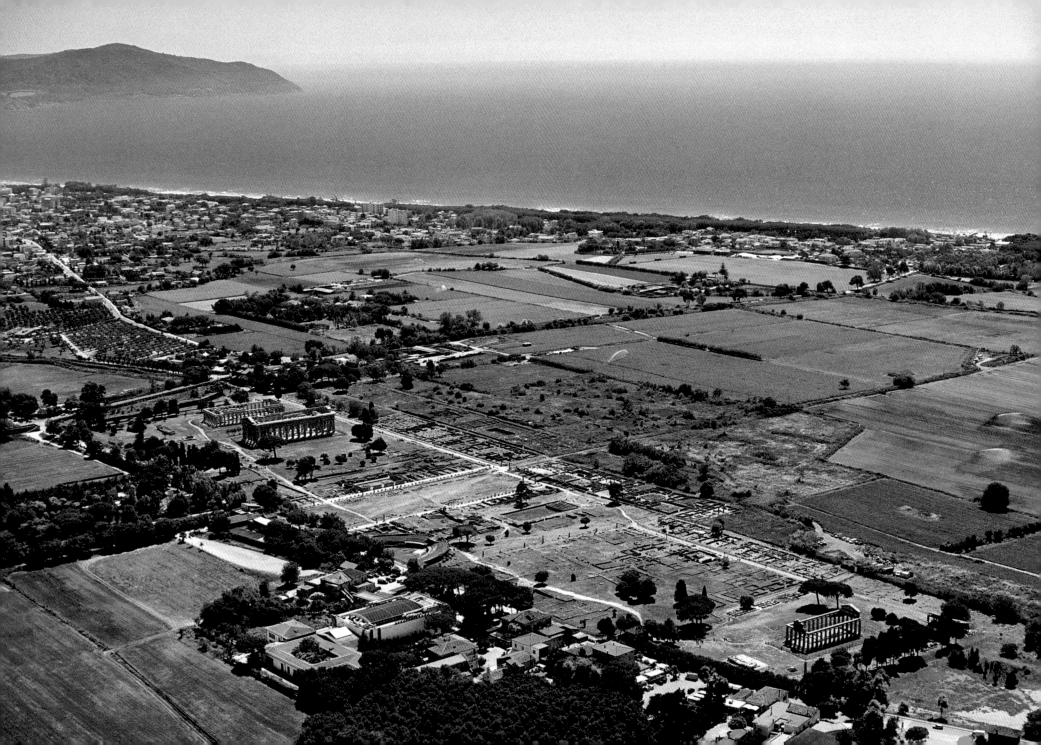

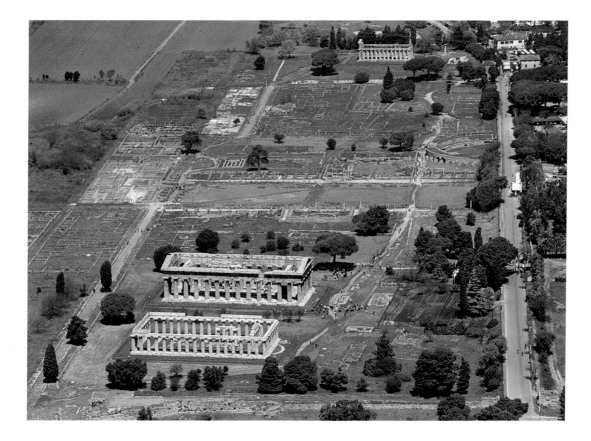

80-81 The plain of Paestum (Salerno) since the city's foundation (6th century BC) was an important commercial and cultural bartering center, also thanks to its strategic position, near the outlet of the Sele River. Here rise the three best preserved Doric temples in the world.

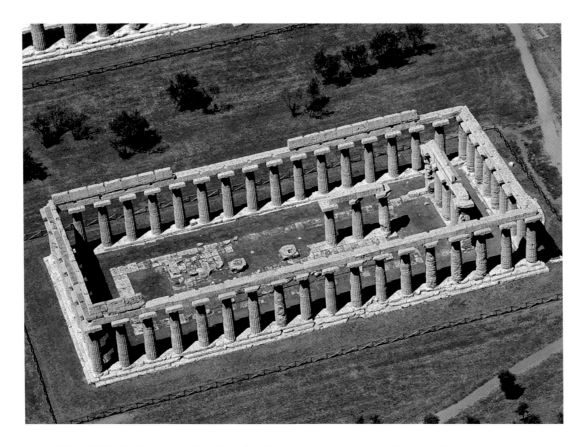

82 and 83 The Basilica and the Temple of Neptune (photograph on the right). The latter was in fact dedicated to Hera or to Zeus and dates back to circa 460 BC. The Basilica (photograph on above) is the southernmost and the most ancient of the temples, as it was built in the middle of the 6th century BC. It possesses nine columns on its short sides and 18 on its long sides. It too was dedicated to Hera, the divinity of the Achean.

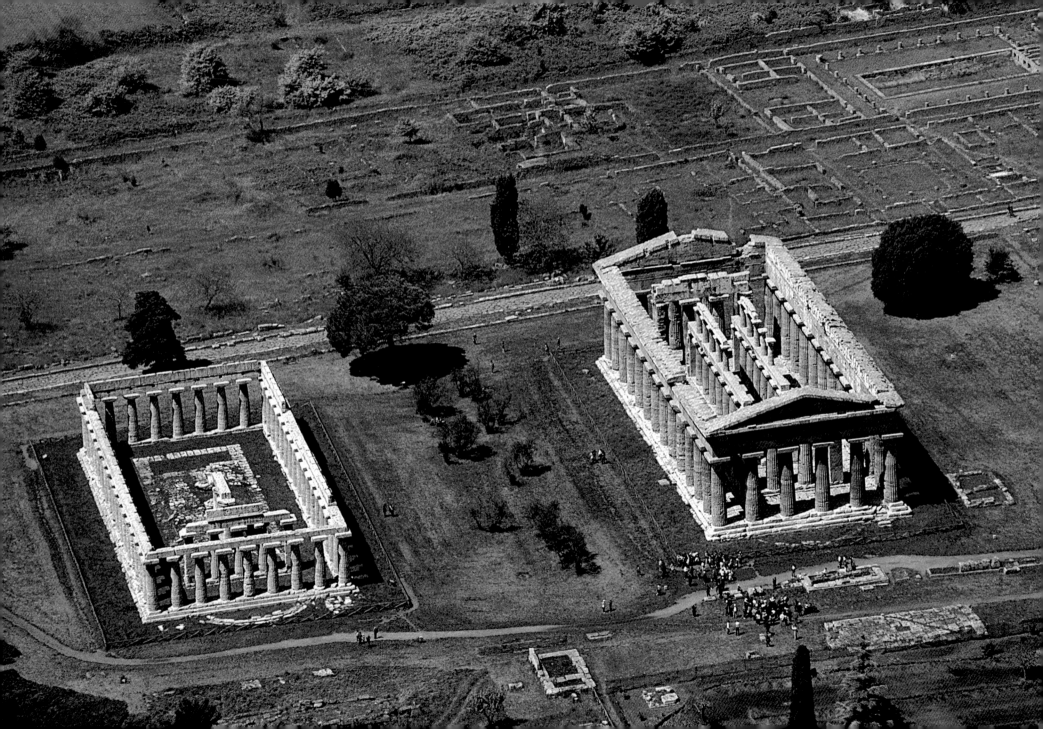

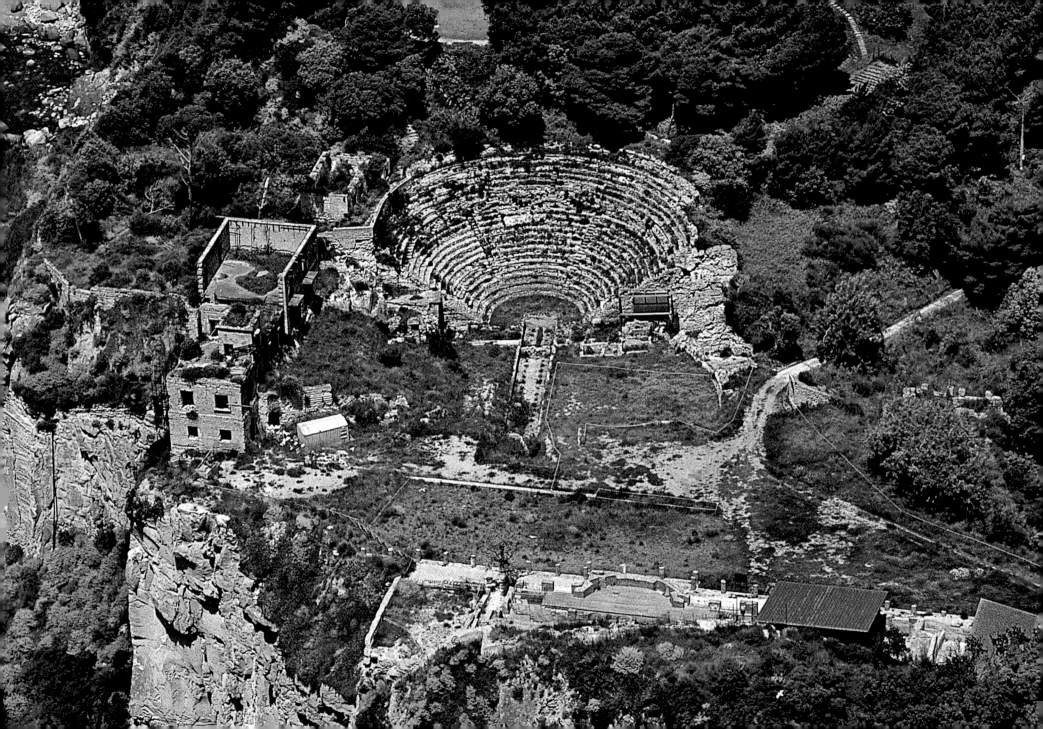

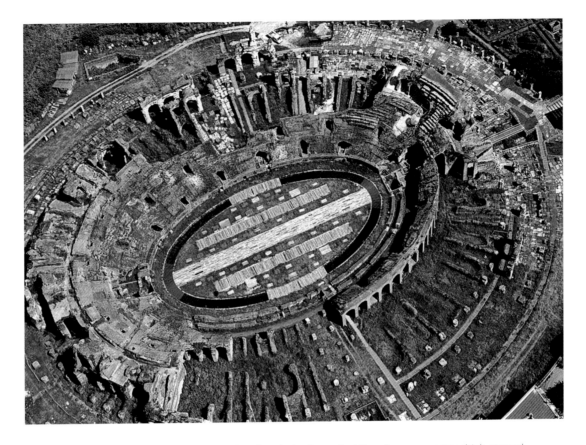

84 The villa of Vedio Pollione in Posillipo (Naples) – first called Pausilypon, a name which spread throughout the surrounding territory – rises upon a promontory located between the two islets of Gaiola, and was built in the 1st century BC.

85 The Amphitheater of Santa Maria Capua Vetere (Caserta), the old Capua, was built between the 1st and the 2nd century AD on the ruins of an earlier amphitheater and is thought to be just a few years after the Colosseum of Rome. In AD 119 it was then decorated by Hadrian with statues and columns which, during the Lombard era, ended up being used in the construction of the village. Some statues now adorn the Town Hall's facade.

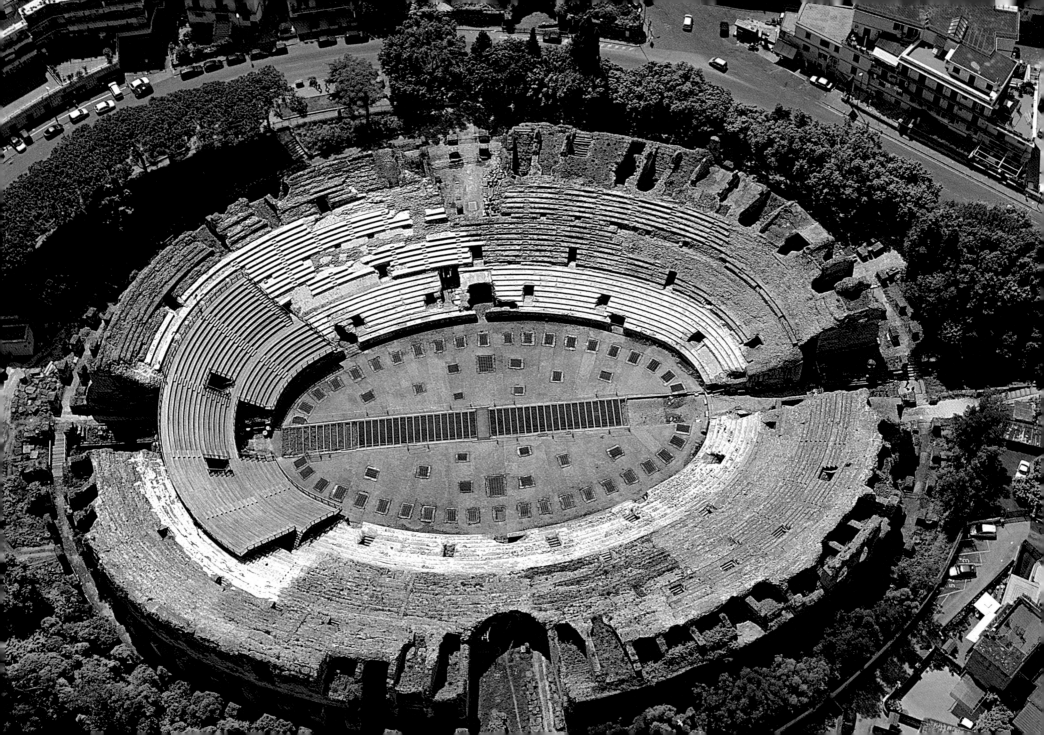

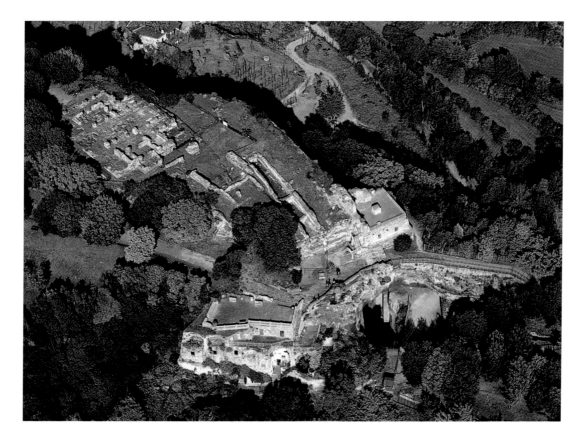

86 The Flavian Amphitheater in Pozzuoli (Naples) was designed by the same architects who built the Colosseum of Rome for Vespasiano and, when it was inaugurated by Titus (1st century AD) it was certainly the third in Italy after Rome and Capua both in terms of beauty and size (483 x 385.20 ft/147 x 117.44 m).

87 Cumae (Naples) is known mostly for the famous Antro della Sibilla (Cave of the Sibyl), a cave at the end of a trapezoidal gallery where the prophetess, intoxicated by the fumes of a special plant, responded to the questions posed to her.

LANDSCAPES AND VILLAGES

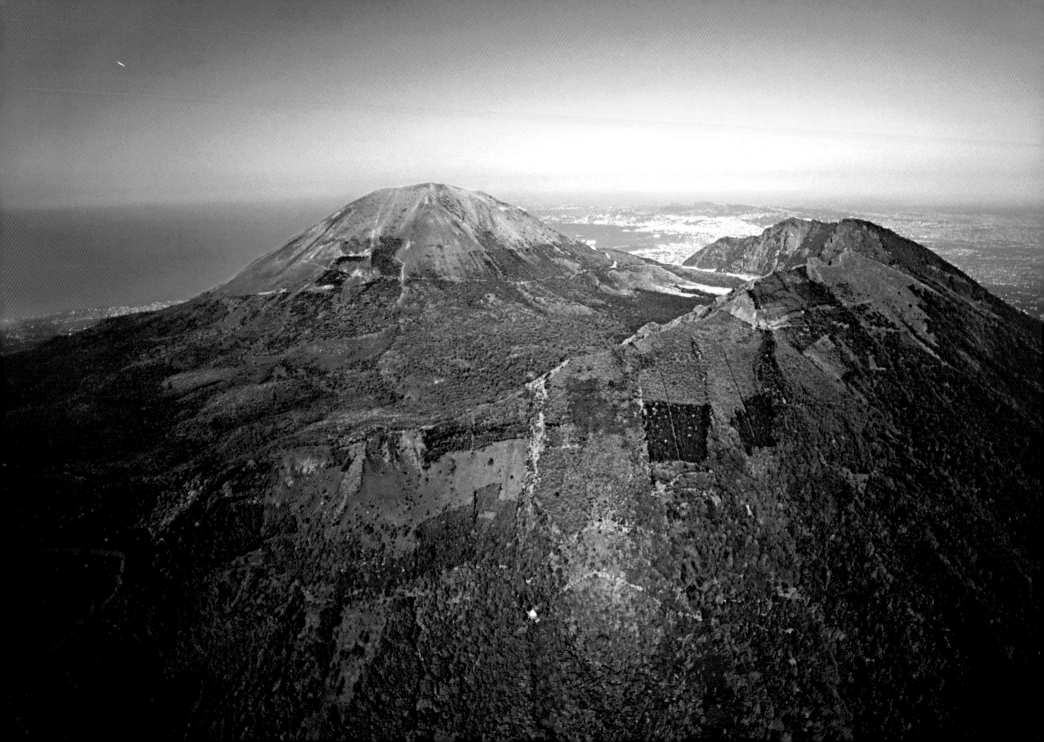

Campania's heartland is magnificent, though in a totally different manner from the coast: between nature parks and abbeys, fortified cities and villages, one breathes a solid and unchanged atmosphere, like the statues of Venus and Mater Matuta which look more like the strong women of the place than the ethereal Aphrodite. It is impossible to draw up a list of all the places to see: it is enough to know that, from above, some are easily recognizable, others are secret areas to be explored with patience and plenty of walking, in the footsteps of Giustino Fortunato, the bizarrely named politician with a great passion for the mountain, the proponent of local hiking. The old Capua has become Santa Maria Capua Vetere, to the north of Naples, and of the city which once decided the faiths of the south remains the splendid Amphitheater, second only to the Colosseum, the Duomo, the Mitreo and the Arch of Hadrian.

A few miles away, without a doubt a must is the cycle of frescoes at the Benedictine basilica of Sant'Angelo in Formis. Further to the north one finds the first park, the regional park of Matese, one of the major calcareous massifs of peninsular Italy, which divides the Volturno and Calore valleys from Molisano. Plush beech woods are crossed by streets which rise from San Gregorio Matese towards the Bocca della Selva and Selva del Perrone passes: 200 square miles (50,000 hectares) of protected surface stretch out in hills and mountains which can reach up to 6724 ft (2050 m), the height of Mount Miletto (the highest in Campania). Lakes are thousands of feet high, like the Matese which, ever since ancient times, has been composed of a series of morasses, created due to karstic phenomena. Nowadays it is possible to navigate on the lake by boat to observe the many bird species, possible because of a system of

88 left The Arch of Hadrian, also called Arch of Capua, perfectly delimits the old city, now Santa Maria Capua Vetere as opposed to today's Capua. It seems that Hadrian loved to rest here before returning to Rome.

88 right Cilento (Salerno) and its Nature Park (which are two distinct entities), feature mostly hills and mountains, but also contain small coastal plains and the Vallo di Diano, a great internal plain, once occupied by a lake which no longer exists. The Alento River, around nineteen miles (thirty kilometers) long, flows into the Tyrrhenian Sea which has contributed to the fertility of its territory. The name Cilento derives in fact from Cis Alentum (From here to Alento).

89 Vesuvius is the only active volcano in continental Europe: despite being one of the smallest it is certainly the best known both for its history and for its ease of access.

91 The Royal Palace of Caserta is a must to learn about 18th century Neapolitan culture: it is one of Italy's most magnificent noble buildings, surrounded by a picturesque park.

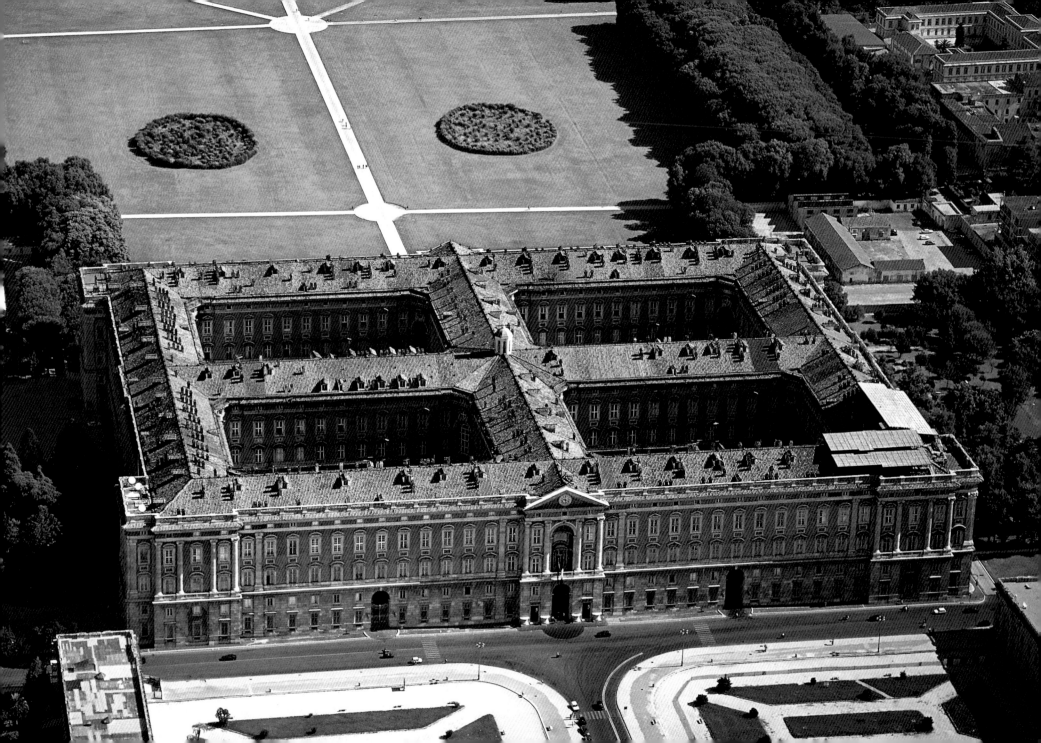

dams making the depth approx. sixteen feet (five meters),. Then there are the forests, the caves, the canyon: the Vallone dell' Inferno (Hell's Valley) is one of the park's most spectacular places, whilst Hannibal's Bridge is one of the most romantic and the Mount Mutria one of the most exciting, since it is easy to spot the Golden Eagle here. The deer, the wolf, the badger, the wild cat, the weasel, the squirrel and the hare instead can be seen almost everywhere with due patience. Lastly, the settlements: from the majestic medieval castle of Gioia Sannitica to the Samnite settlement of Piedimonte Matese, center of the protected area, a gathering of walls and houses perched on the rock, alleys and small piazzas, in the shadow of the mountains and along the valleys.

Moving east, one passes the province of Benevento and Sannio. The capital, the Roman Maleventum, lies in a dip at the meeting point of the rivers Calore and Sabato and, therefore, had remarkable strategic importance along the old Appian Way. As proof of this one can easily see the Roman Theater of the 2nd century AD, which is still used today for spectacles during the summer season, with 25 arches and a capacity of 20,000 seats, as well as the Arch of Trajan, the superb commemorative monument built for route of the same name, which in the first twenty years of the 2nd century AD joined the city to the port of Brindisi with a consequent flow of trade. Slightly more to the south, on the other hand, is Sant'Agata de'

92 left The Abbey of San Guglielmo al Goleto (Avellino) was founded by the Vercellese saint who learnt about Irpinia during his pilgrimage to the Holy Land and, after having lived in the cavity of a tree, founded the first female order in Goleto in 1133.

Goti, a very high row of houses situated on a cliff over the river, which encloses the medieval center like city walls. The village is small but boasts ten churches, whose steeples and domes shine under the radiant sun and the beautiful thatched roofed buildings. The surrounding landscape is remarkable, with its roots in Samnite history which has so much pervaded the region. A very variegated territory formed by plains, Apennine ridges and plateaus which have never made the life of ancient traders easy whilst they acted as perfect defense against the invaders.

Today those lands which saw the clashing of Greeks, Etruscans, Samnites and Romans, are in peace, some of them protected like the WWF oasis of the Campolattaro Lake. It is an artificial basin formed by the weir on the Tammaro River, at a height of almost 1312 ft (400 m), which has given life to a forest of poplars, willows, alders, and beautiful meadows were orchids flower spontaneously, to be precise Ophrys apifera, Ophrys fuciflora and Serapias vomeracea. It is a great habitat for birds and among those seen are herons, cormorants, marsh harriers, swans and nocturnal birds of prey, just to cite a few.

Progressing in a clockwise direction one arrives at Irpinia. Not far from Benevento rises the abbey of Goleto, ordered like Montevergine by Saint Guglielmo, close to Sant'Angelo of the Lombards, a commune much damaged by the 1980 earthquake but with the cathedral and the Lombard castle intact. It is formed by two churches superimposed on each other, erected half a century apart between 1142 and 1200, and represents one of the most striking monumental complexes of southern Italy. The restored Alta Valle dell'Ofanto dominates with its imposing circular walls, and it is a fantastic sight. The surrounding inland areas are very green and mountainous but poor, while the coastal stretch is richer.

This difference has meant that the villages on the hills have remained almost like "Christmas cribs," like Andretta, Aquilonia, Lioni and Sant'Angelo. Here the panoramas are harsh, without limits, rugged, but unforgettable for this very reason. The Picentini Mountains then, situated right at the border which divides the province of Avellino from that of Salerno, are wild and unspoilt, with forests of beech and the regional park's chestnuts, flown over by the eagles which nest on the rocky peaks of Accellica and Terminio, and frequented by wolves. For hikers, the

92 center The Alburni Mountains, part of the Campanian Apennines, are a karstic conformation, with sinkholes, grottos and cavities. In ancient times it was believed that the Titans had taken refuge inside them after having escaped from Neptune's rage in the Tyrrhenian Sea.

92 right Cilento (below the Alento River) is a prevalently hilly and mountainous area except for the Vallo di Diano, a long fertile plain, which used to be occupied by a lake which no longer exists.

best routes start from Bagnoli Irpino and Montella, whilst those who want to ski can climb up to the highest peak, the Cervialto (5934 ft/1809 m) which overlooks the wintry Piano Laceno (Laceno Plain). Avellino, then, is the result of all the earthquakes endured but should not to be avoided for this reason.

Just over a mile (two kilometers) away there are the Foro Romano (Roman Forum) and the Amphitheater, which are proof of the empire which had globalized the pre-existent inhabitants of Irpinia. But subsequently Abellinum was totally rebuilt by the Lombards whose vestiges can still be seen in the historical center, between the castle and Amendola Square. The sanctuary of Montevergine is visible from the capital, amidst trees and rocks. Here the so-called Mamma Schiavona (Slave Mother) is venerated, a black Virgin which now reigns undisputed over the place already sacred to the goddesses Cibeles and Diana. Guglielmo da Vercelli founded the settlement in 1119, rendering it a very popular pilgrimage destination, still evidenced by the large quantity of ex voto left by the believers for the graces received.

The route inland concludes with the Cilento and its national park, over 699 sq. miles (181,000 hectares) of Tyrrhenian coast up to the foot of the Campano-Lucanian Apennines. The territory is made up largely of hills and mountains, besides small coastal plains and the Vallo di Diano, a large internal plain once occupied by a lake which no longer exists but which should be seen even if only for Teggiano, a fortified village remaining intact. The park, the second largest in the country in terms of surface area, was classified by UNESCO as a World Heritage site in 1998 and is of the realm of wolves, roe, golden eagles and otters, which live in the Sele. Its boundaries to the south are marked by beautiful scenes, such as the stretch of Ascea Marina in Policastro, Cilento's best coastal and beach area. It entwines bays, beaches, old fishing villages and the elegant mundaneness life of Palinuro with its caves which rival those of Capri for the effects of light and crystalline water.

One finds, along the coast, the famous Marina di Camerota, the Infreschi Harbor and the coastal village of Scario, which marks the entry to the Gulf of Policastro, very popular in the Greek era for its convenient inlet where one could arrive at shore. To the north, instead, one goes from the Castle of Reggiano to the Carthusian Monastery of Padula, an extraordinary example of 14th century architecture, to the natural beauties of the Angel's Caves (Grotte di Pertosa), already inhabited in the Neolithic era. One can easily reach the Alburni Mountains from here with their white, calcareous walls, up to the Postiglione and Eboli outposts, the country written about by Carlo Levi.

95 Salerno is a very active city from a commercial point of view (especially as regards to the fruit and vegetable market), with an industrious port and a tourist airport, and among other things is thanks to its fortuitous position, with the sea on one side and the hills on the other.

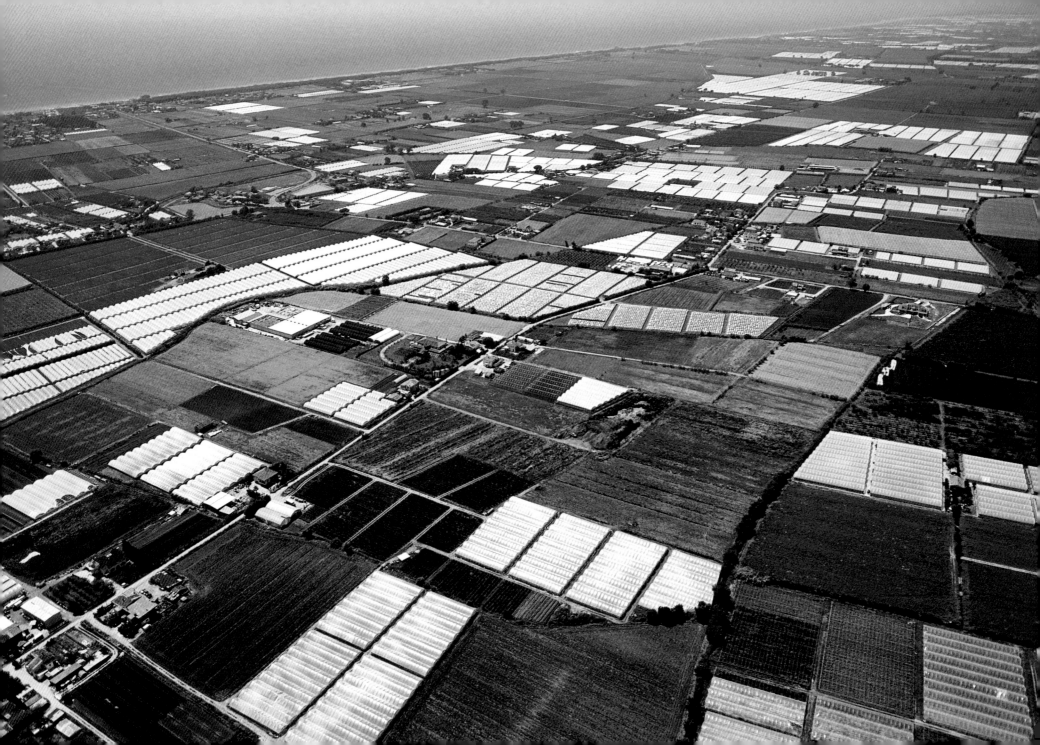

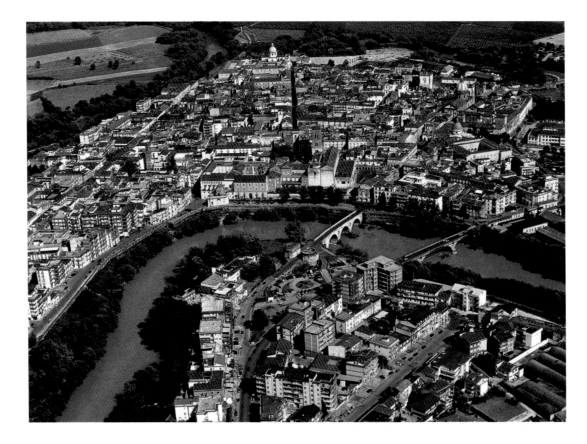

96 Modern Capua (Caserta) took shape on the sides of the Volturno River. At the center of the photograph one can note the Ponte Romano (Roman Bridge) to the left and the so-called Ponte Nuovo (New Bridge) on the right.

97 Sessa Aurunca (Caserta) is a flourishing city of ancient origins: at the center of the photograph one can note the 15th century church of Sant' Eustachio (or of the Assumption), with an imposing tri-portal facade and an ample dome covered by blue and gold majolica which date back to the 18th century. The structure has three naves.

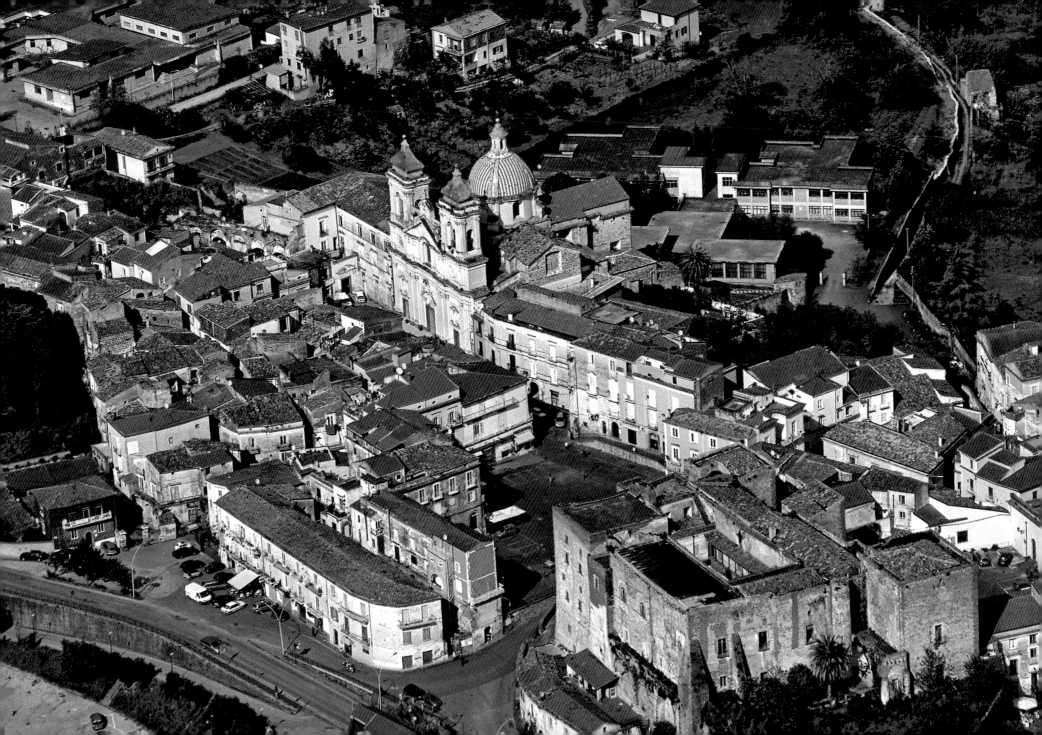

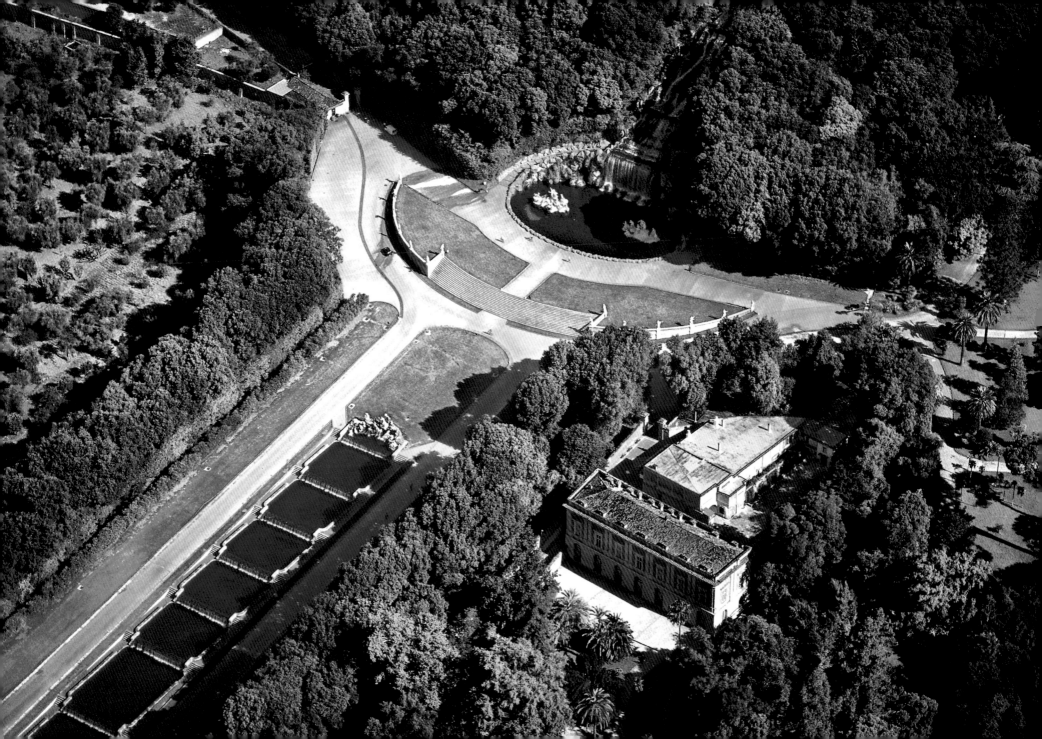

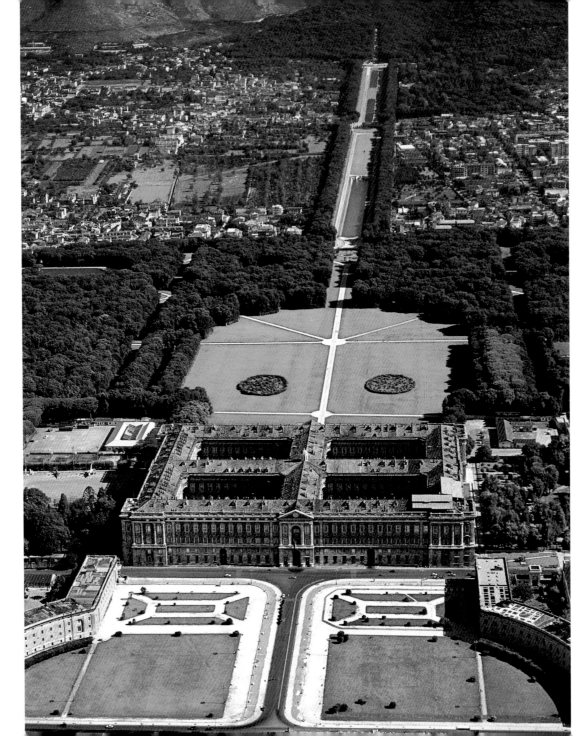

98 and 99 The Royal Palace of Caserta: the park extends for half a square mile (120 hectares) with roads stretching two miles (three kilometers), at the end of which is the splendid Pool of Acteon and Diana, fed by the great cascade inaugurated on 17 March 1762. The very realistic statues were sculpted by various artists: the two groups were shaped by Tommaso Solari, the wax sketches of the groups of Diana and Acteon were done by Paolo Persico, whilst Angelo Brunelli sculpted the nymphs, and Pietro Solari the hounds.

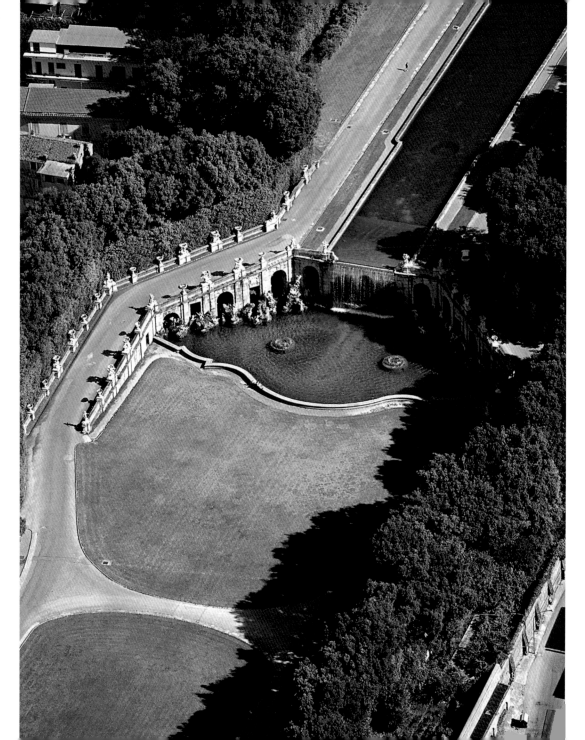

100 and 101 There are six fountains in the park of the Royal Palace of Caserta, which starts at the bottom of the gallery crossing the palace: one of the most beautiful (photograph on the left) is the one called Reggia di Eolo (Eolo's Palace), a work made with Carrara marble and travertine by the sculptors Brunelli, Persico, Salomone and Solari.

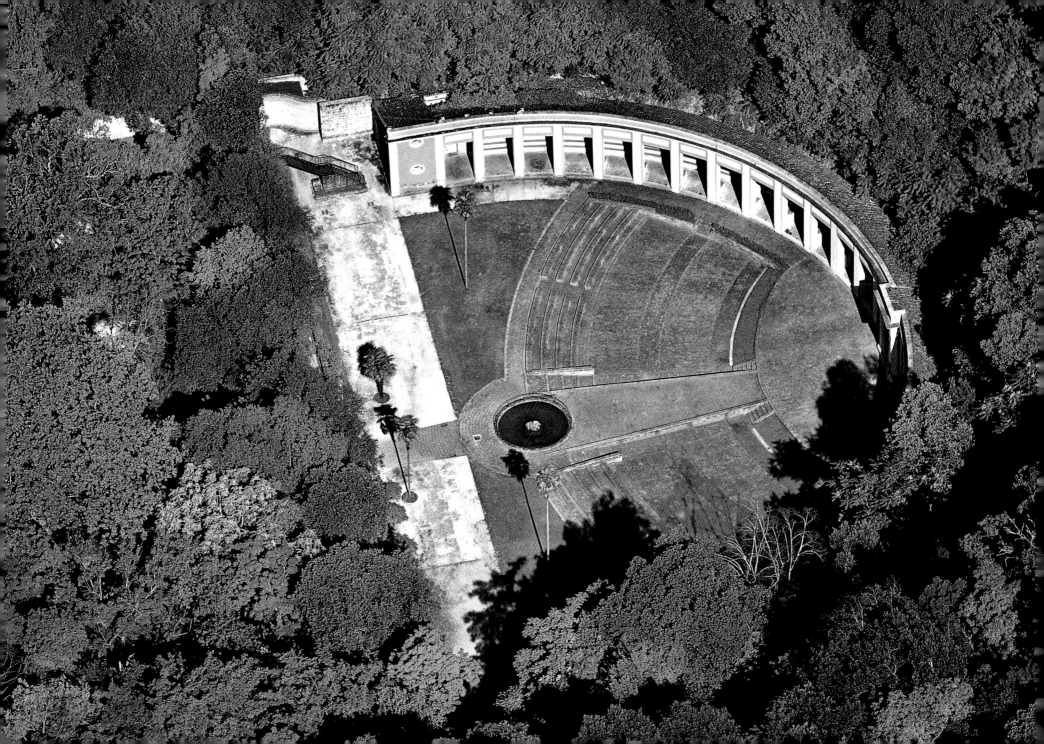

102 The new city of Caserta extends from around the Bourbon palace. It was founded by the transfer here of the inhabitants from the ancient Casa Hirta (Hirta House). The city's center of civic life can be seen in the photograph. On the left one can see the circular Dante Square, known until 1860 as Quattro Cantoni (Four Cantons), because, in effect, it is formed by four large and uniform structures, with open galleries which look onto the piazza.

103 The G. Amico Barracks are located right in the center of the city of Caserta and accommodates, amongst others, the Genio Guastatori and Genio Pontieri regiments.

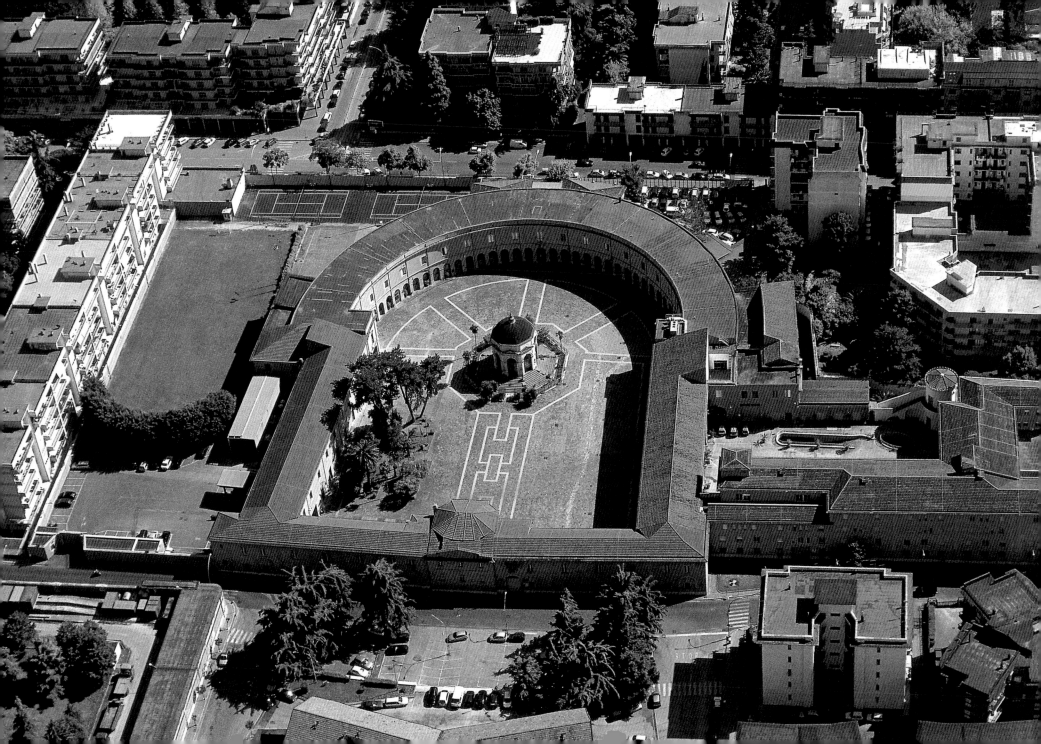

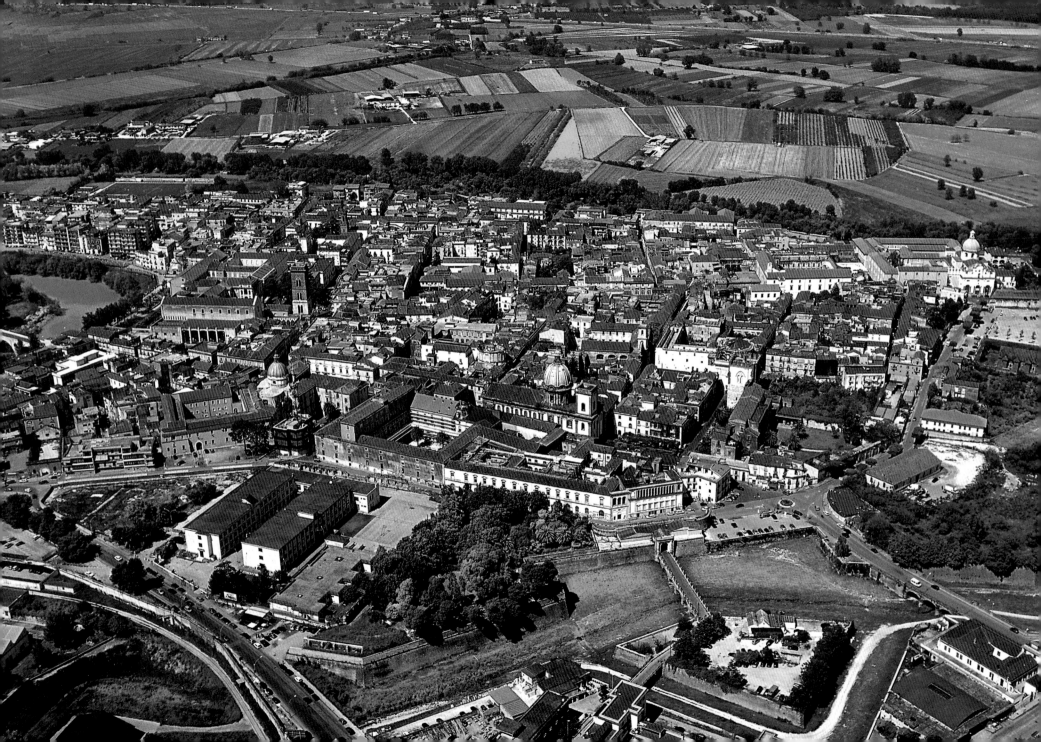

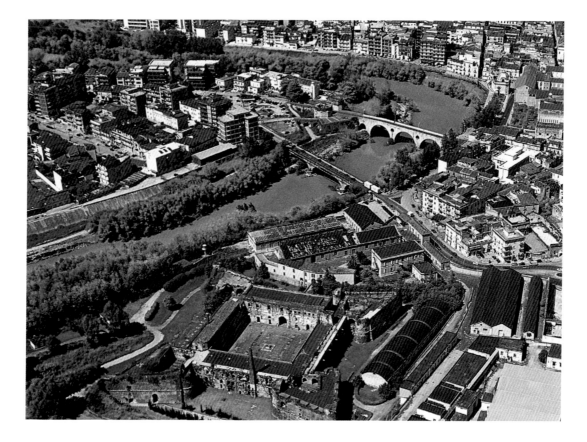

104 Capua (Caserta) rises up from a curve of the Volturno River and was founded in AD 856 by the Lombards on a pre-existent site. There are three important places of worship in the city. From the left, the dome (right on the river shore), the Church of the Assumption and to the far right the monastery of Santa Maria delle Dame Monache.

105 The Capua Dome, built by the Lombards, underwent various restorations, especially after the last war. The vestry is home to an inestimable treasure. The Ponte Romano (above) on the river has remained perfectly intact.

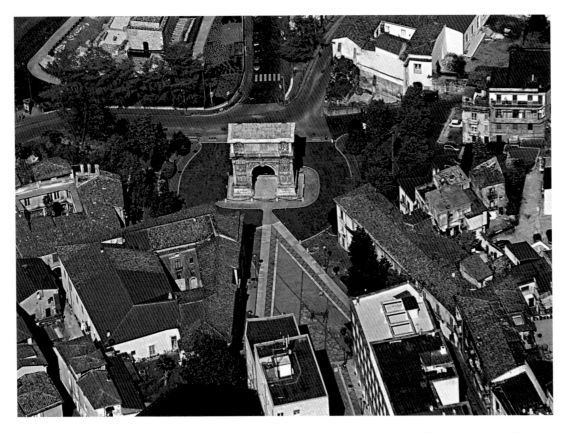

106 The Arch of Trajan has just one arch and was erected to commemorate the inauguration of the Via Appia Traiana (Trajan Appian Way), which reduced a good part of the route from Rome to Brindisi. It became a gateway to the walled city of Benevento.

107 The church of Santa Sofia in Benevento was begun by Duke Gisulf II and finished by Arechi II, son-in-law of King Desiderius, as soon as he became Duke of Benevento. It was completed in the year AD 762 and is considered one of the boldest and most imaginative of the High Middle Ages' constructions.

108-109 In the close up of the city of Benevento , the Roman Theater is clearly seen on the right. It was built during Hadrian's era and then expanded on a large scale by Caracalla between AD 200 and AD 210; it could host around 10,000 spectators.

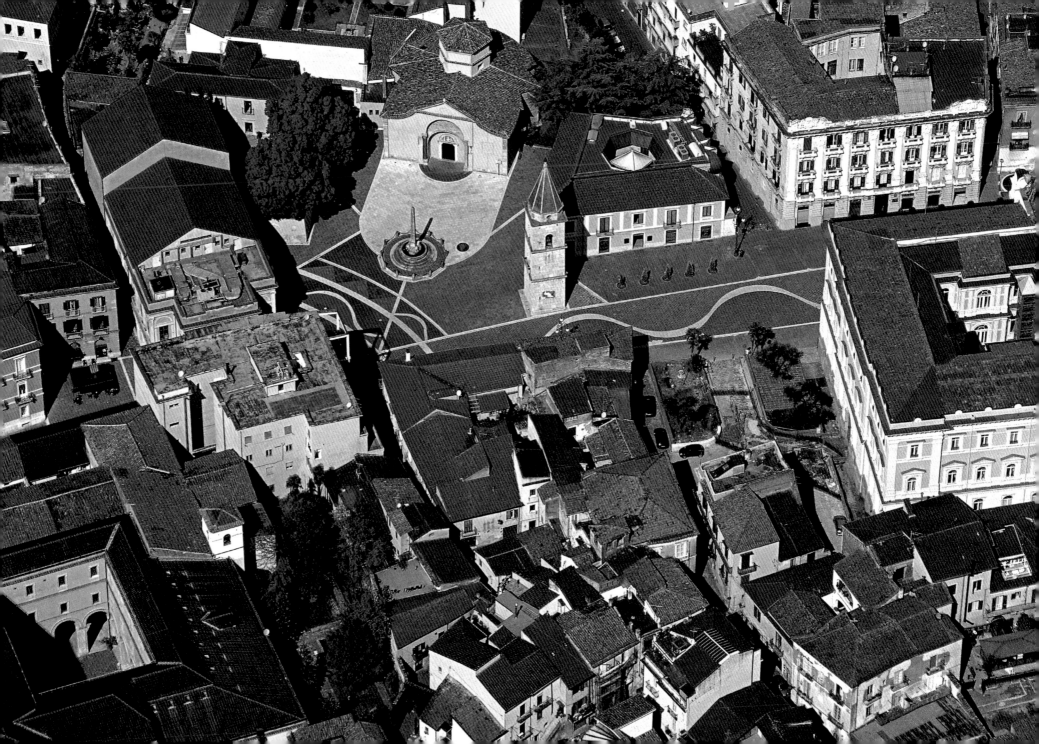

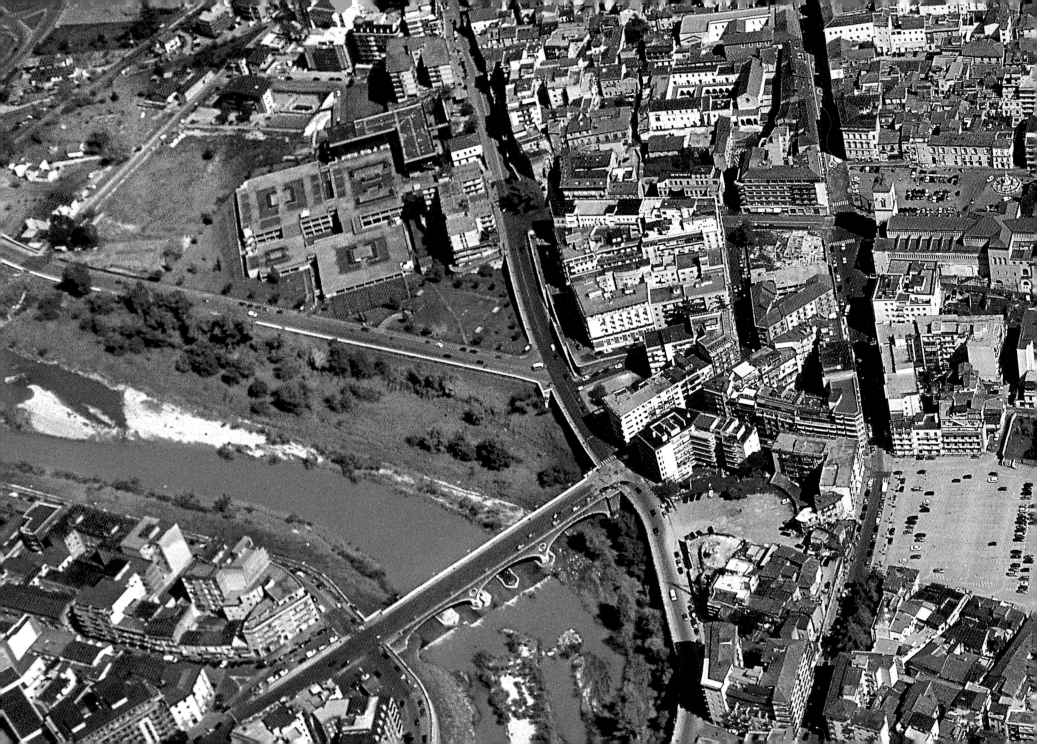

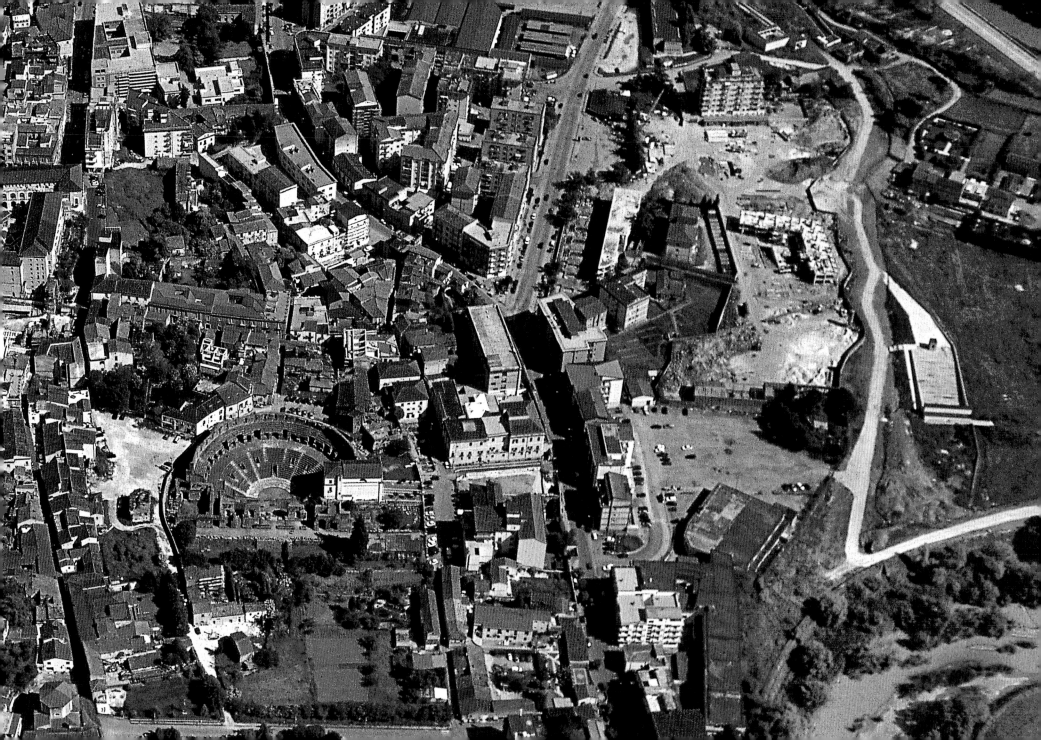

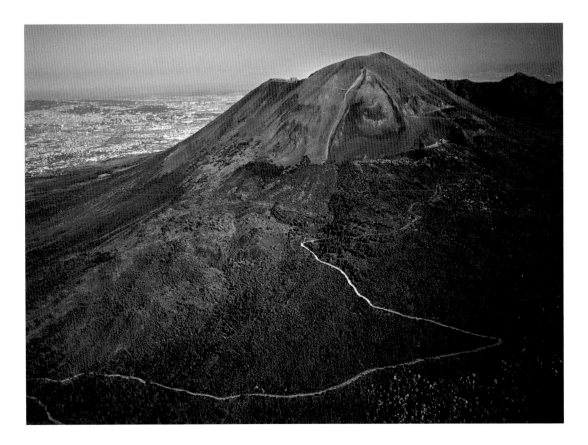

110 and 111 Vesuvius is a twin peak mountain, meaning, having two peaks: the Vesuvian Cone (4202 ft/1281 m) and Mount Somma (3712 ft/1132 m), joined by a valley at a height of around 2296 ft (700 m). Prior to the epochal eruption of AD 79 it was renowned for its wine, Lacryma Christi, which was produced upon its slopes. This volcano is considered young by geologists: in fact it is only 12,000 years old. It is possible for enthusiasts to ascend the volcano following a road from Herculaneum which climbs 8 miles (12 km).

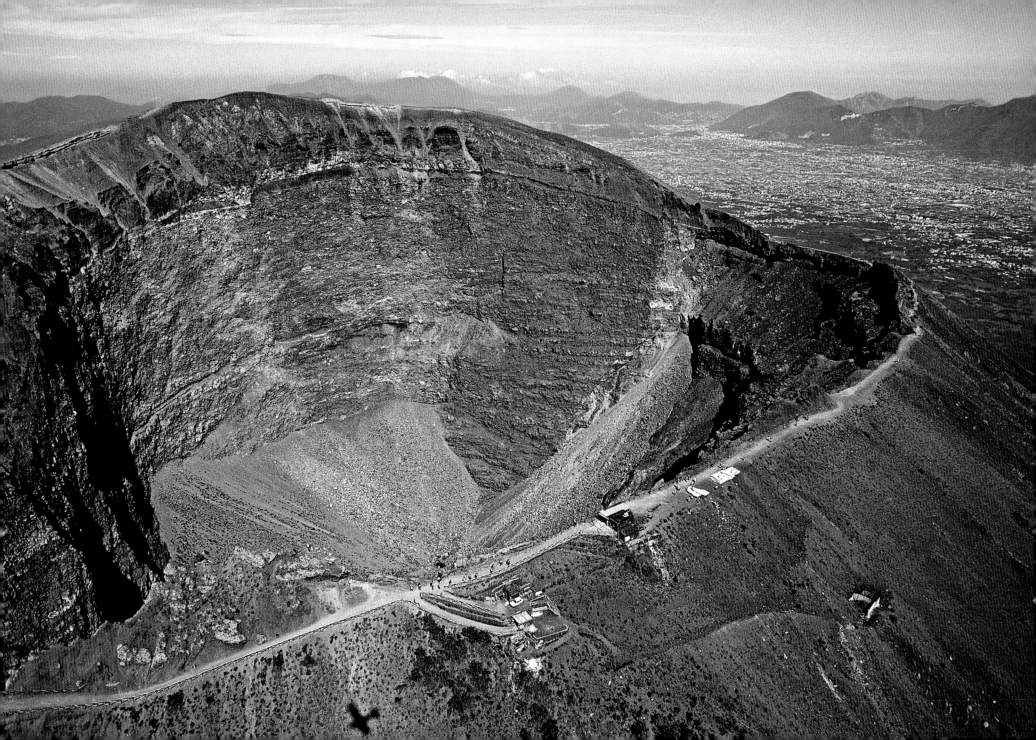

112 From Avellino, the capital of Irpinia, extends the Valle del Sabato. Standing out in the photograph on the left is the Duomo whose construction was started in 1132 by Bishop Roberto and was completed in 1167 by Bishop Guglielmo.

113 The city of Avellino is mostly modern except for the medieval fragment between the Duomo and the castle's remains. Caserma Berardi (Berardi Barracks) rises along the main street Italia, one of the city's main arteries.

114-115 The Mercogliano commune (Avellino) is located on the southern slopes of the Partenio Massif and possesses a territory which is amongst the most interesting of Southern Italy in terms of nature and landscape.

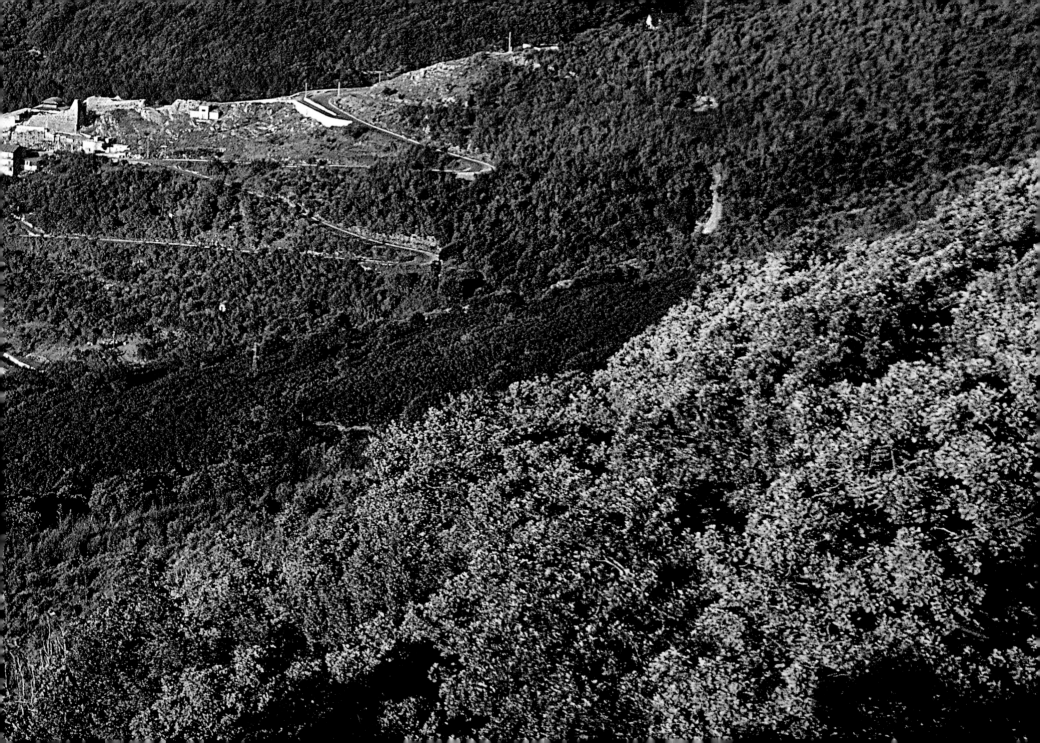

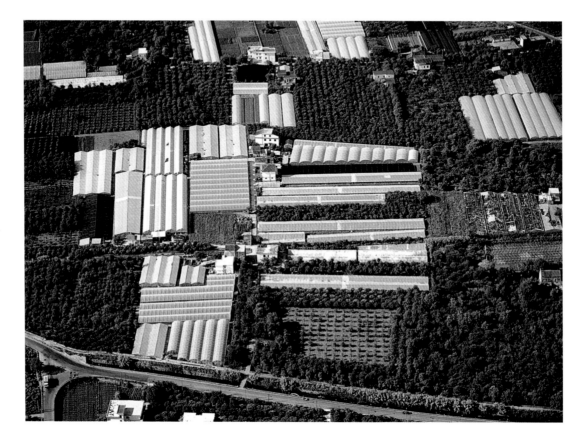

116 and 117 The Sarno Plain (Naples) is the area which derives its name from the river which crosses it and is situated at the foot of Pizzo d'Alvano's mountain range. Over the course of time it has become a renowned agricultural, industrial and commercial center, famous for its canvas manufacturing, the production of food preserves, textiles and shoes.

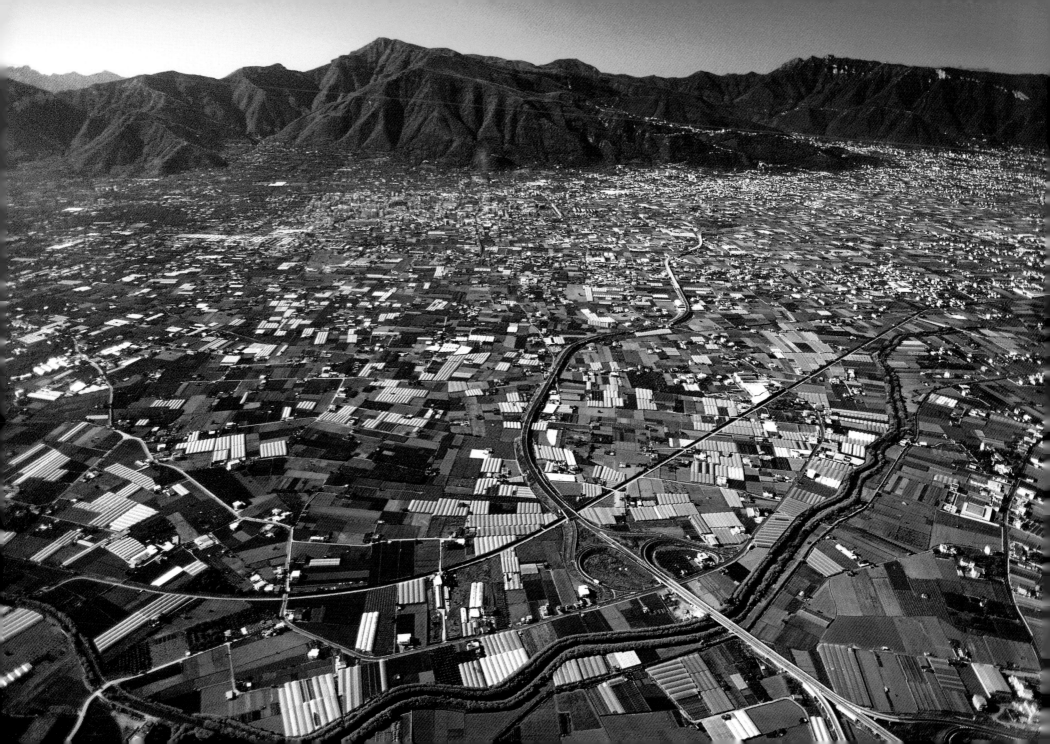

118-119 One part of Campania is historically called "land of the Leborini." This name does not refer to the intensely cultivated and fertile land, but to an ancient Leborini land and the Leborini population which used to inhabit it.

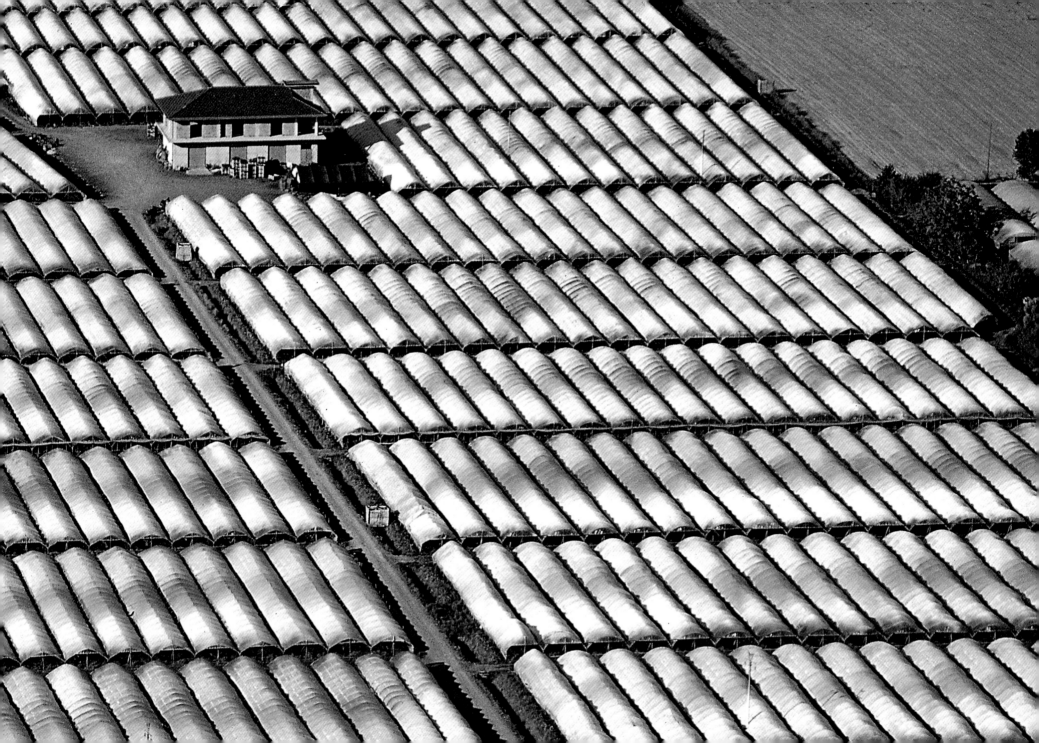

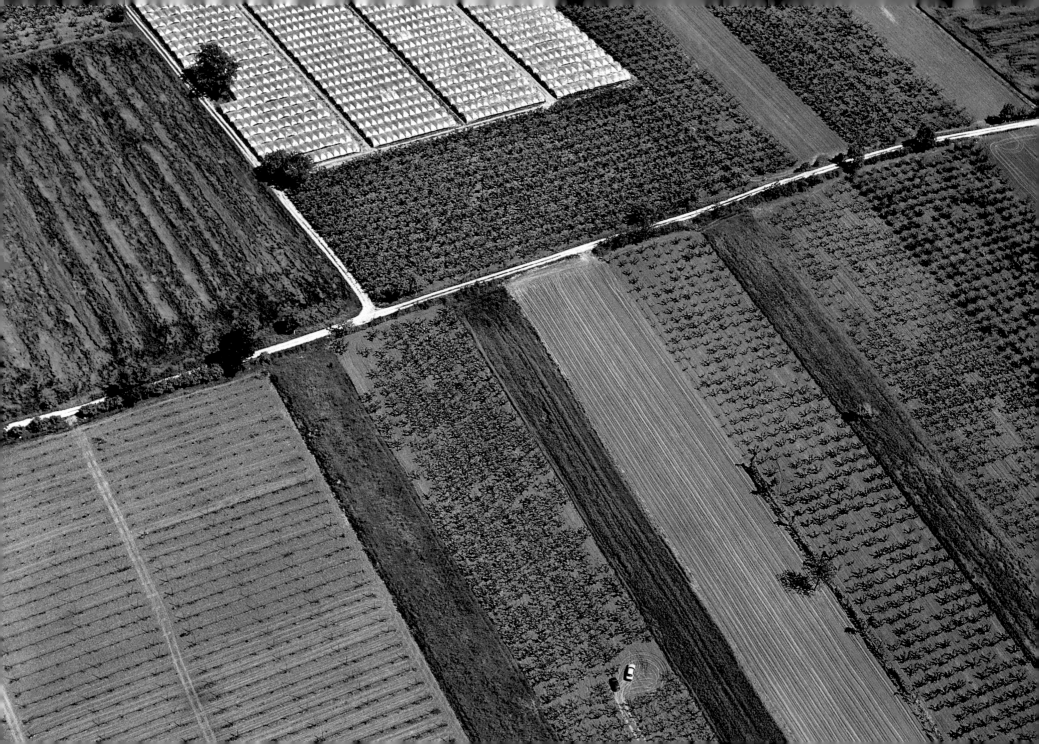

120-121 The agricultural productivity of the Campania plains is amongst the highest of the peninsula. One of the major difficulties in maintaining this level is irrigation which often still performed using naturally deep channels.

122-123 In the Sarno Plain (Naples) they specialize in intensive cultivation in order to obtain maximum profit from the specialized fruit and vegetable agro-ecosystems.

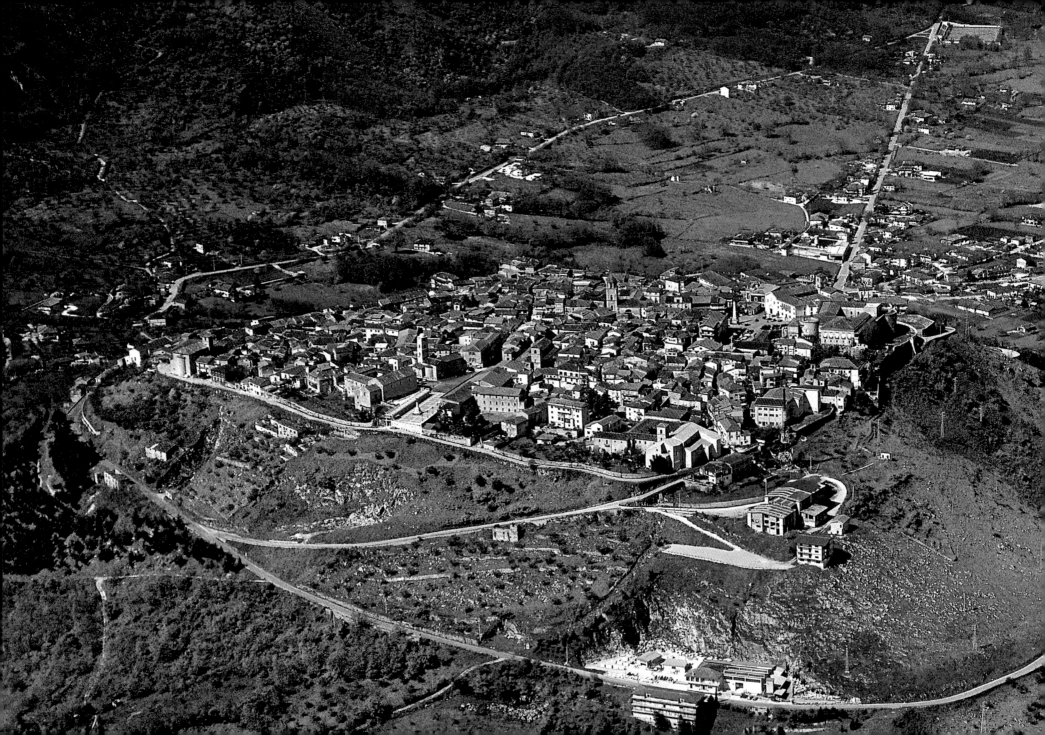

124-125 Teggiano (Salerno) is certainly one of the most historically important centers of the Salernitan province. Situated on the hill, set almost in the middle of the Vallo di Diano, it has preserved numerous traces of its past.

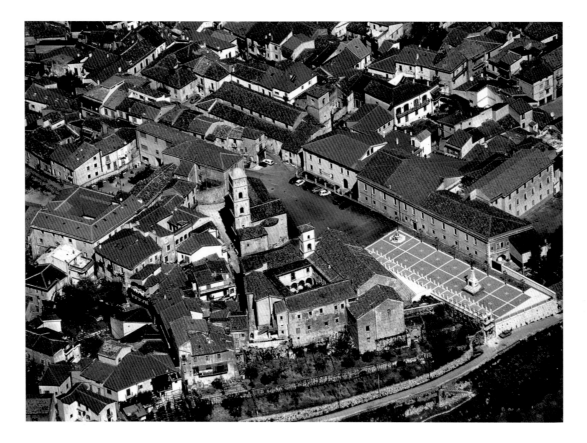

126 The Church of San Pietro a Teggiano (Teggiano) was deconsecrated in 1987 and became first the main office of the Civic Museum and then of the Diocesan Museum. The findings inside date from the Roman to the Renaissance era.

127 Teggiano (Salerno), which now forms part of Cilento Park and Vallo di Diano, has an urban conformation which is typically medieval, with the houses which enclose the imposing castle which belonged in the Middle Ages to the Sanseverino, princes of Salerno. It has been included by UNESCO as a World Heritage site.

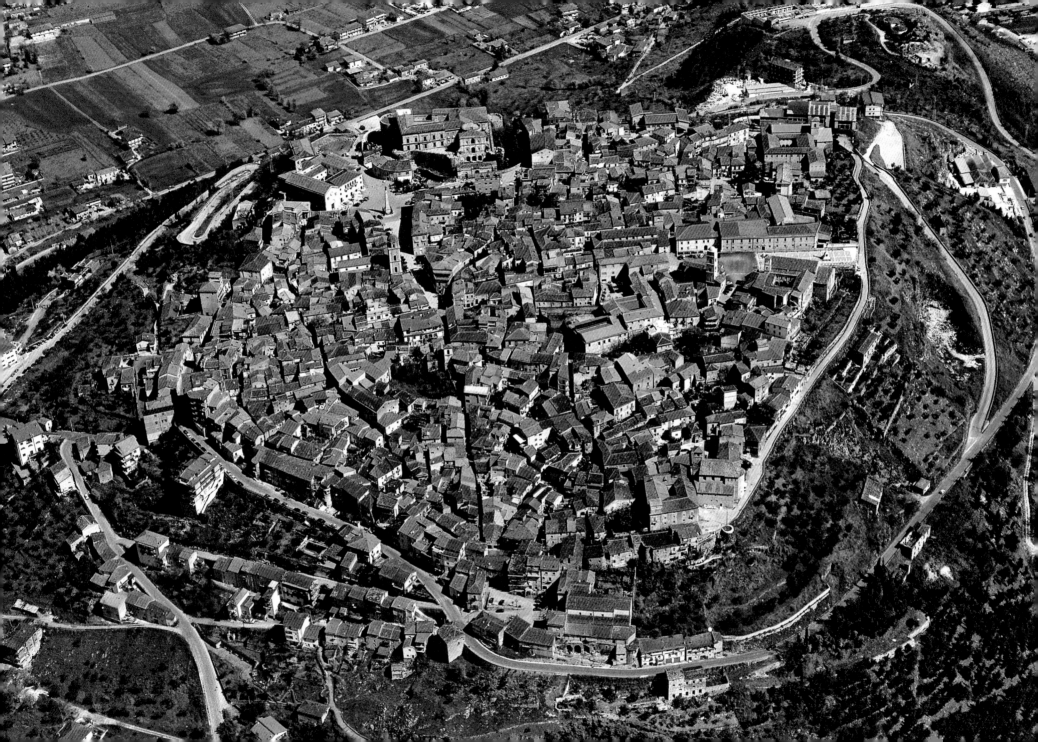

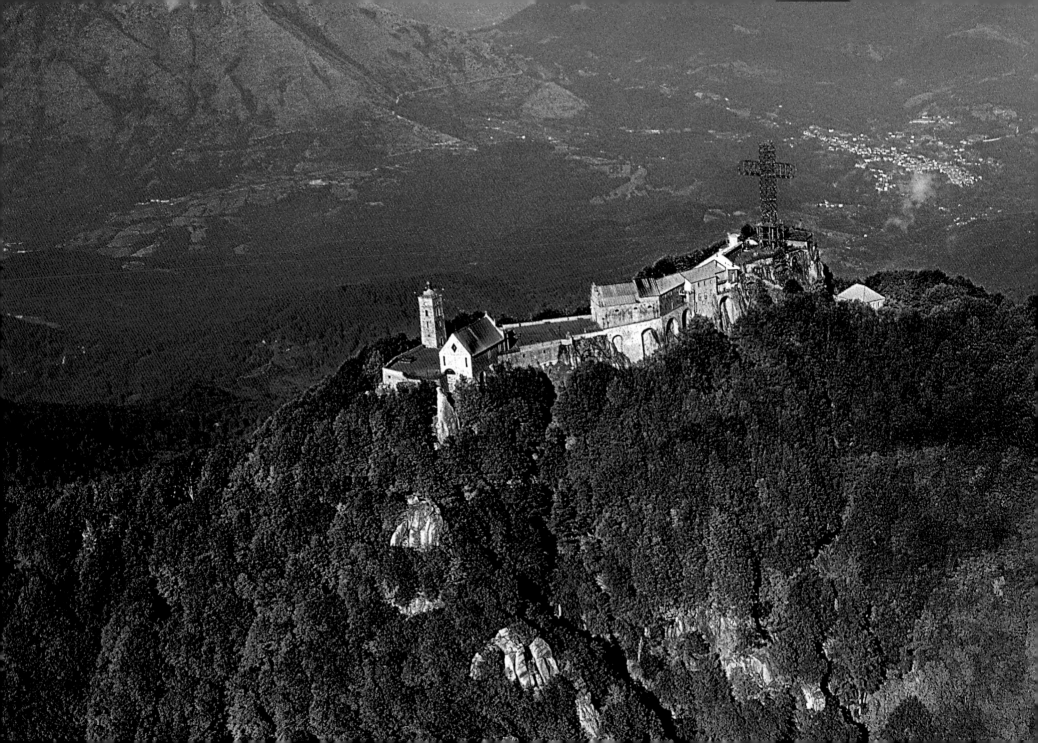

128-129 Gelbison Mount, also called Monte Sacro (Sacred Mount), at 5593 ft (1705 m), is Cilento's highest mount. The Sanctuary of Maria SS. del Sacro Monte rises on its peak. It is the destination of numerous pilgrims.

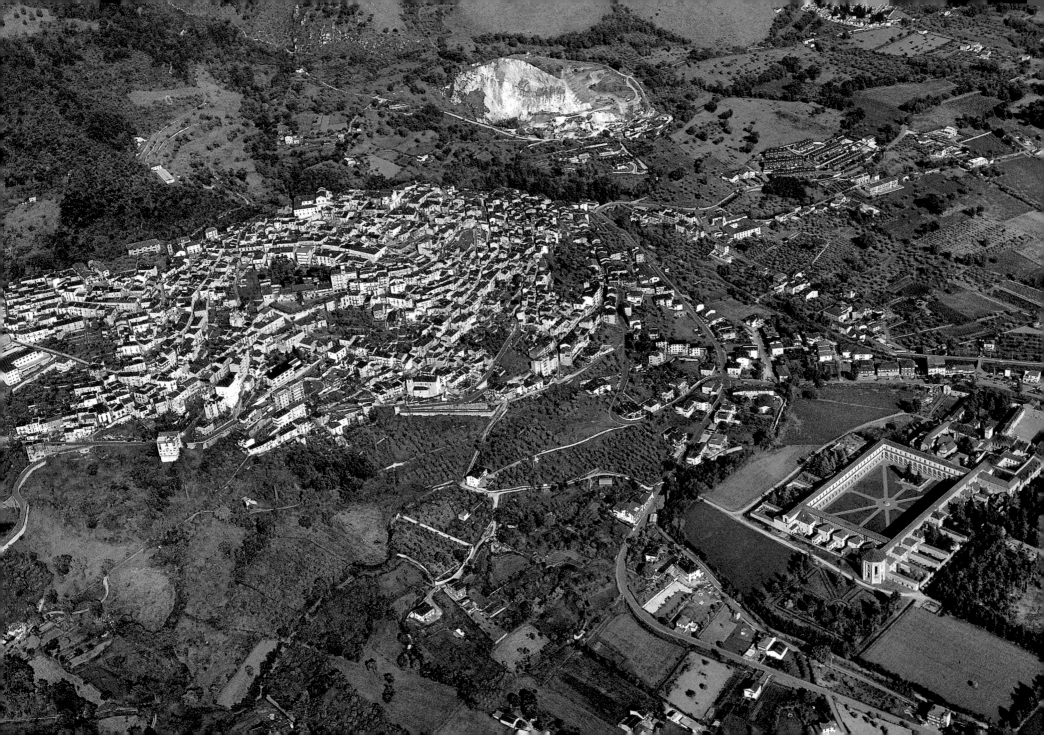

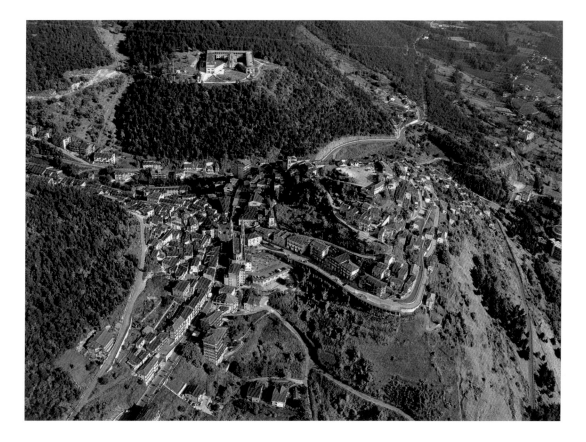

130 Padula, in the province of Salerno, rises on the slopes of the Magdalene Mountains and dominates Vallo di Diano. Its foundation dates back to the 9th–10th century, when its inhabitants moved away from the coasts which had been plundered by the Saracen.

131 Montesano della Marcellana (Salerno) rises in the southern part of Vallo di Diano and its origins date back to the year AD 1000 when the population of the Magna Grecia was looking for healthier places to live. The fertile area is rich in water and still today offers therapeutic waters.

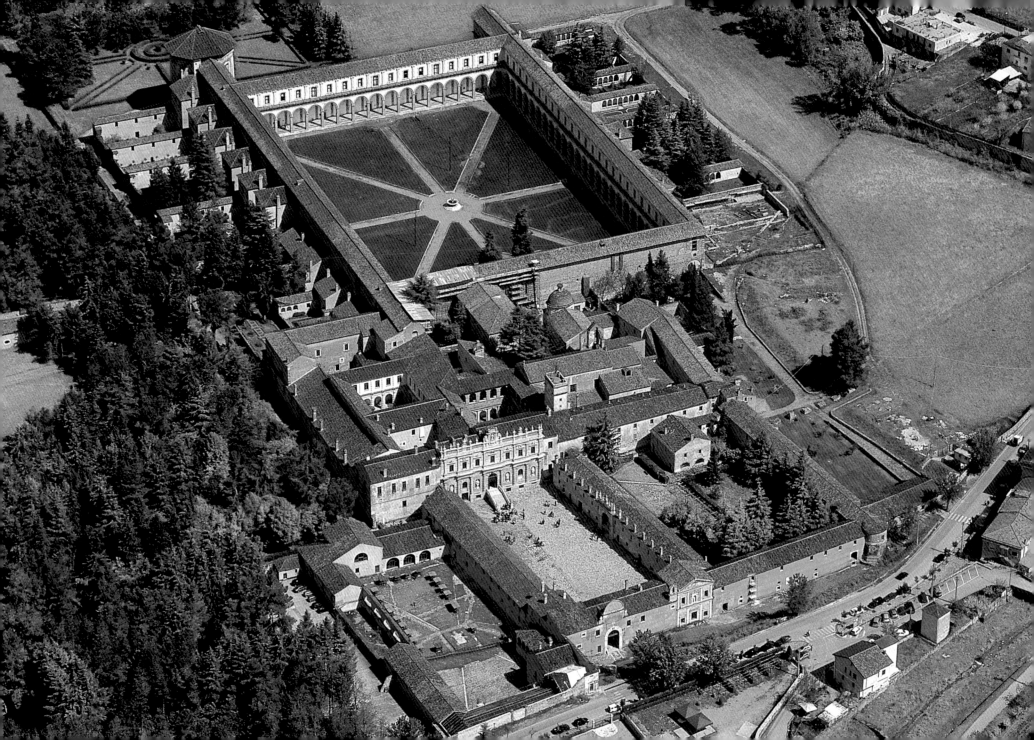

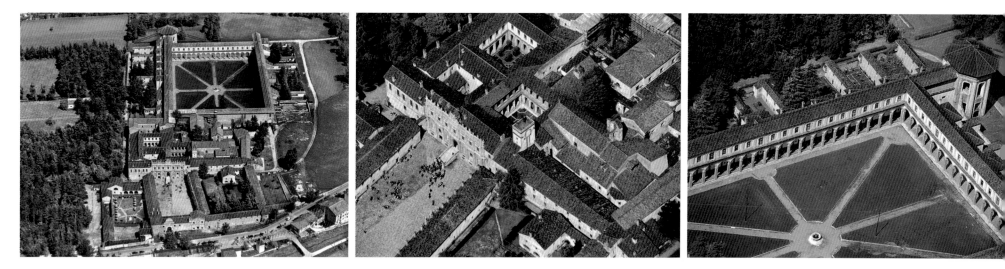

132 and 133 The Carthusian Monastery of Padula (Salerno) is divided into "casa bassa" (low house) and "casa alta" (high house): the former was a place of work, the latter was the area where the monks lived, the kingdom of the seclusion. At the end of the 18th century the golden age of this complex ends because, during the "French Period" (1807), the Carthusian Monastery was suppressed and the monks were forced to abandon it. All the art treasure was taken away, including the books from the rich library, and lost.

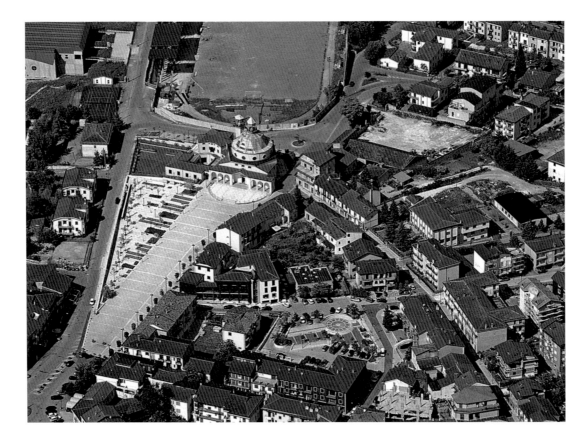

134 The history of Lioni (Avellino) has its origins in the Roman senate's decision to repopulate Irpinia thus forcefully transferring here the Apuan Ligurians, the rebel tribe subdued in AD 180 by the consuls Cornelius and Bebio. In the photograph a glimpse of the Sanctuary of San Rocco.

135 Capital of Irpinia, Avellino is a prevalently modern city. The hexagonal structure of the ex-Bourbon Prison (1827), is an example of the "Benthamian Prison" so called because of J. Bentham's theory that it was the most suitable structure in which to serve a prison sentence. Today it is the main office of the Archeological Superintendence and numerous exhibitions.

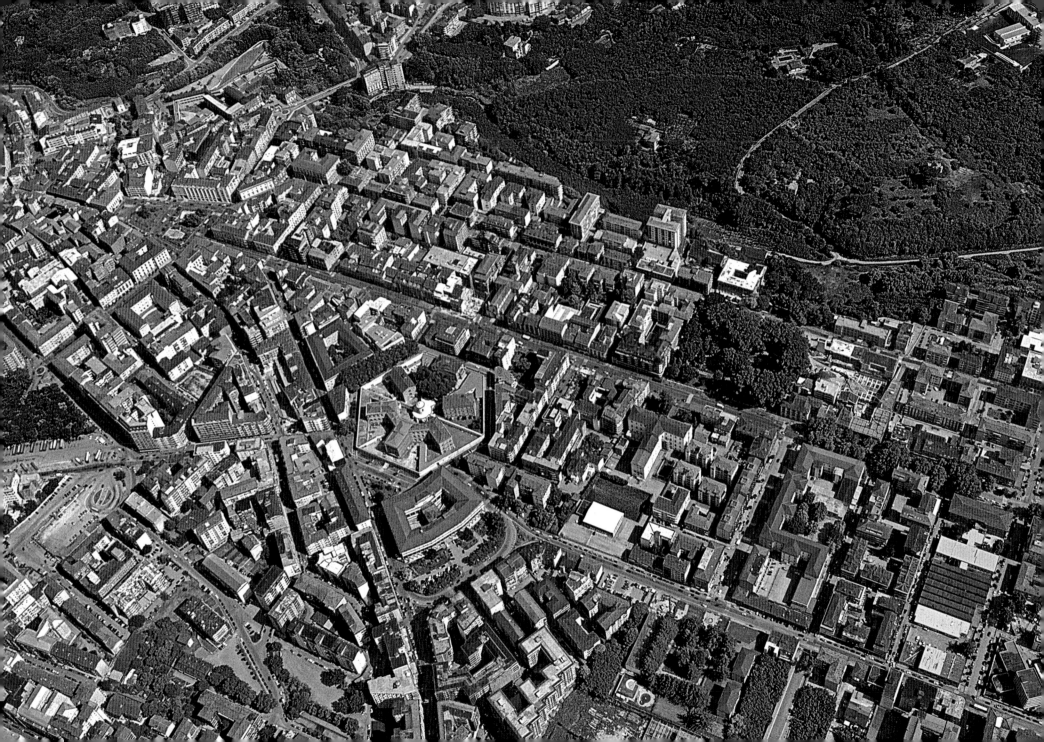

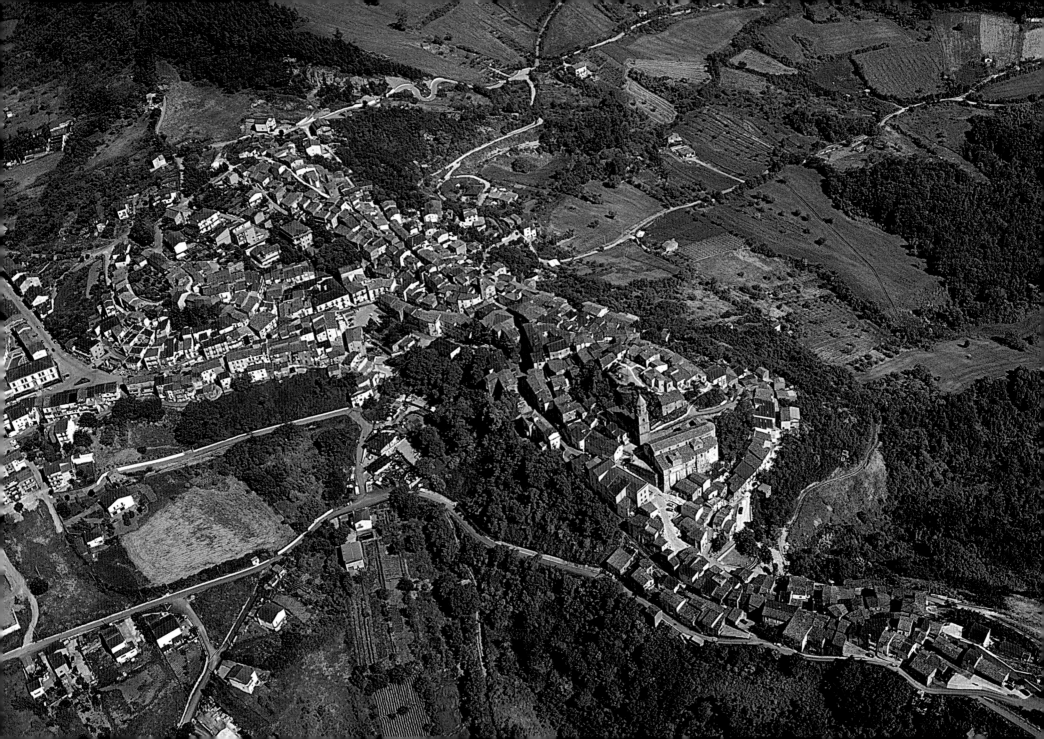

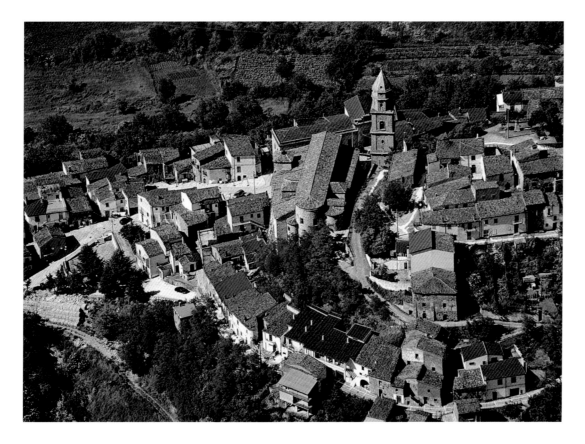

136 Strongly damaged by the 1980 earthquake, Andretta, in the province of Avellino, rises in the high valley of the Ofanto River. A prevalently agricultural country which has seen, thanks to a group of young entrepreneurs, the birth of small industries.

137 At the center of Andretta, in Irpinia, rises the Mother-Church which has undergone numerous reconstructions and remained, until 1830, the only burial place for the entire city.

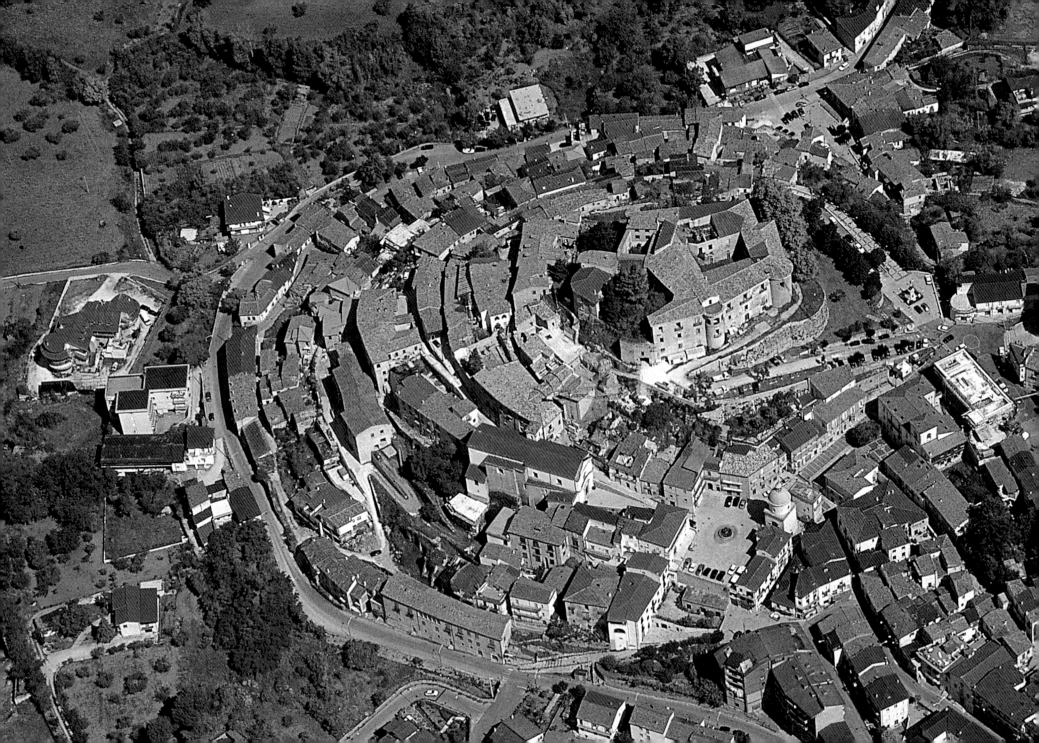

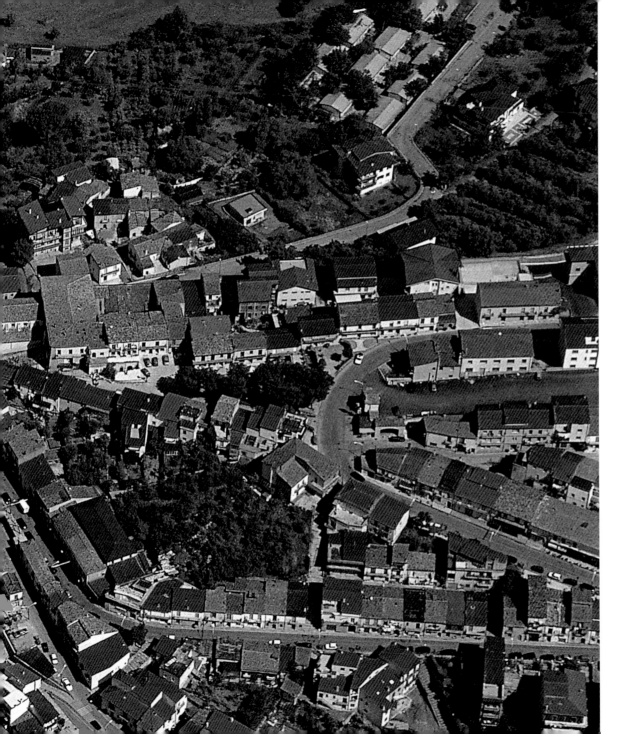

138-139 Irpinia is the land of mountains and harsh reliefs. During the course of the centuries, fortified villages have risen, with difficulty, on the slopes, and often (as pictured here) preserve the vestiges of the past and the medieval urban structure.

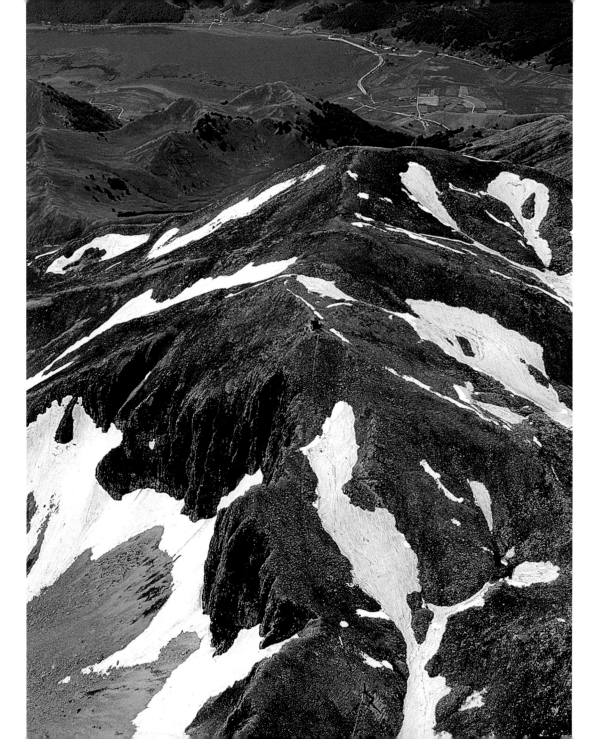

140 The peak of Mount Miletto, midway between Campania and Molise in the mountains of Matese, is 6724 ft (2050 m) high and offers an unspoilt panorama with the total absence of thoroughfares. From here both the Adriatic Sea and the Tyrrenian Sea can be seen.

141 The Alburni Mountains, which form part of the Campanian Apennines, are a karstic massif rich with sinkholes. The caves of Castelcivita and Pertosa are amongst the deepest in Italy and also contain grayish colored, cold-water lakes.

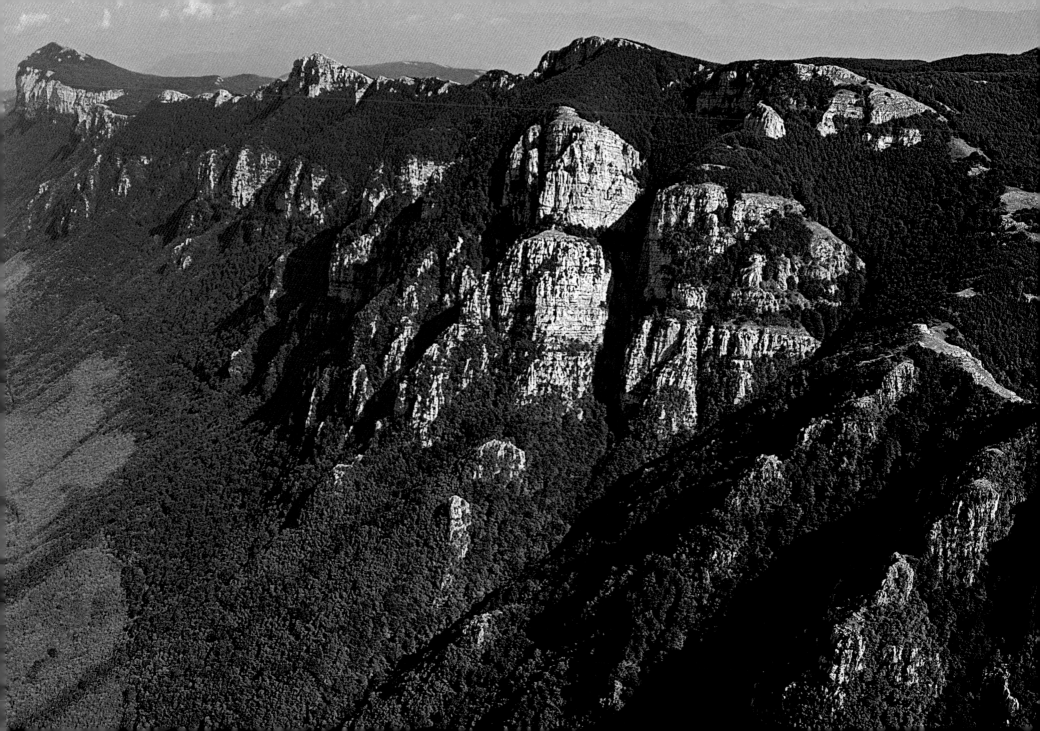

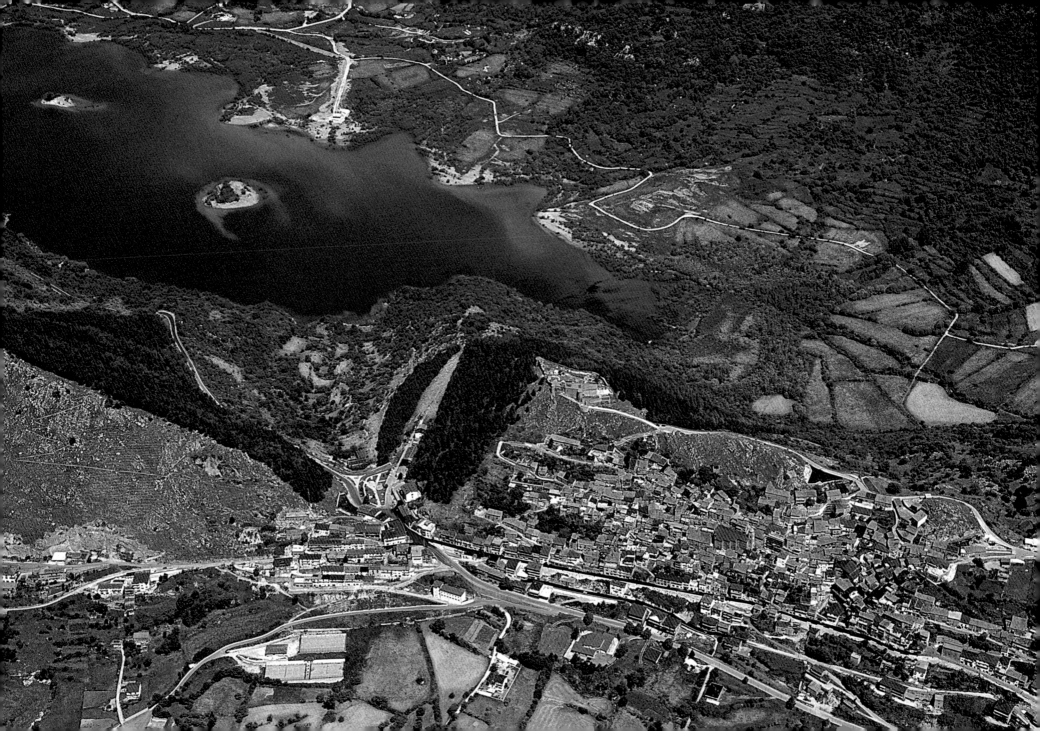

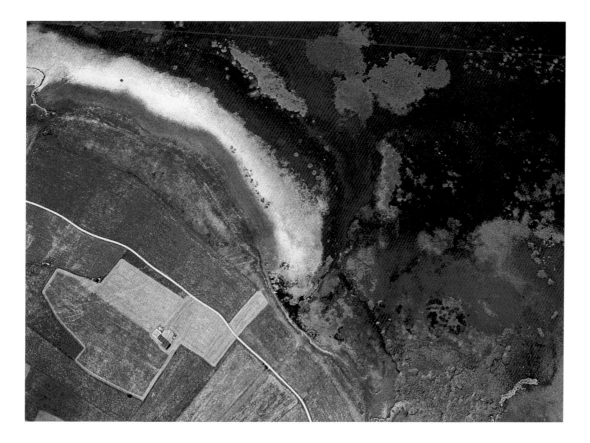

142 Letino (Caserta) rises on the shores of the lake of the same name at over 3200 feet (1000 m). The lake was artificially created in 1911 by the Southern Electricity Society to feed the neighboring power station.

143 The Letino Lake (Caserta) was created by the weir of the mythical hellish river Lethe, which caused forgetfulness. It flows to a height of 3372 ft (1028 m) at 47° F (8° C) and its waters have remarkable therapeutic properties.

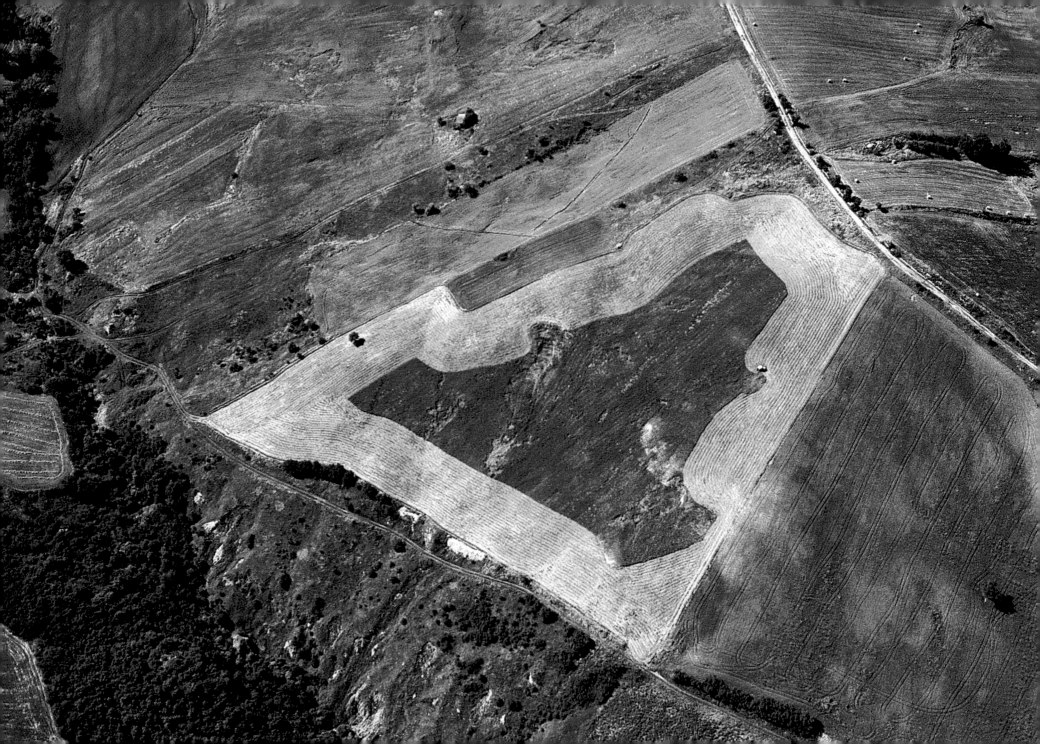

144 and 145 Much of the countryside around Aquilonia (Avellino) was converted back to grain cultivation during the 1500s when the battles between the French and the Spanish on the coast made these areas the "granaries" which sustained the war. There were towns which as much as tripled the number of the grain cultivation areas and several woods disappeared because of this.

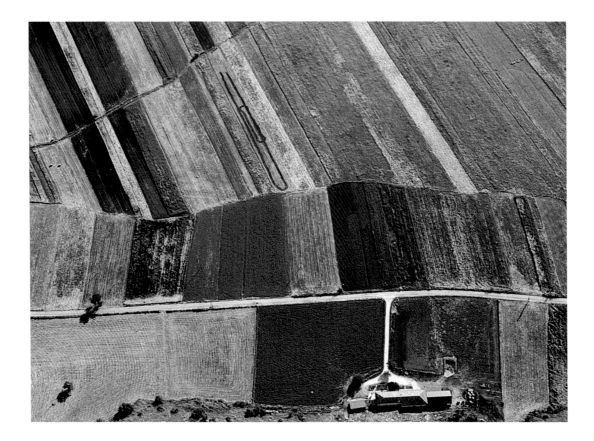

146, 147 and 148-149 It is little known that since 1998, the Cilento and Vallo di Diano's National Park (Salerno) has been listed as a UNESCO World Heritage site and that in the previous year the same park was included in the network of the Biosphere Reserves of the MAB-UNESCO. The program tries to maintain the delicate balance between three important aspects of this area: economic development, biodiversity and respect for cultural traditions.

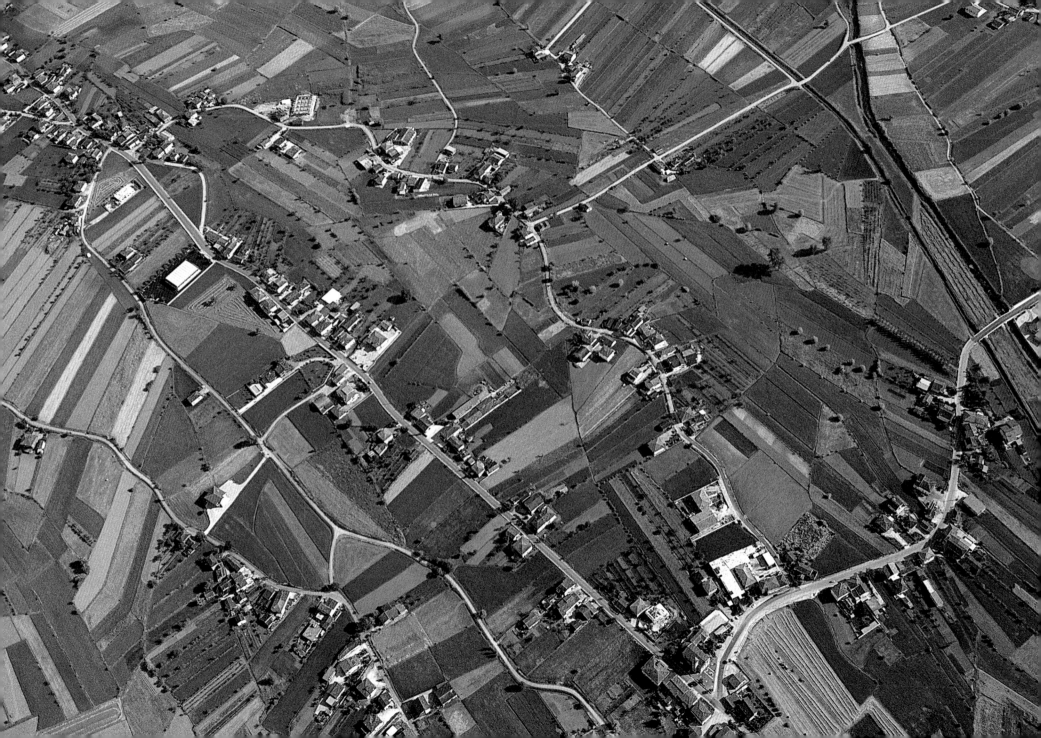

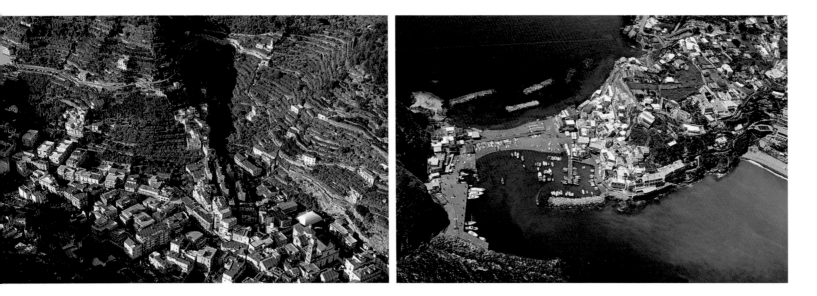

COASTS AND ISLANDS

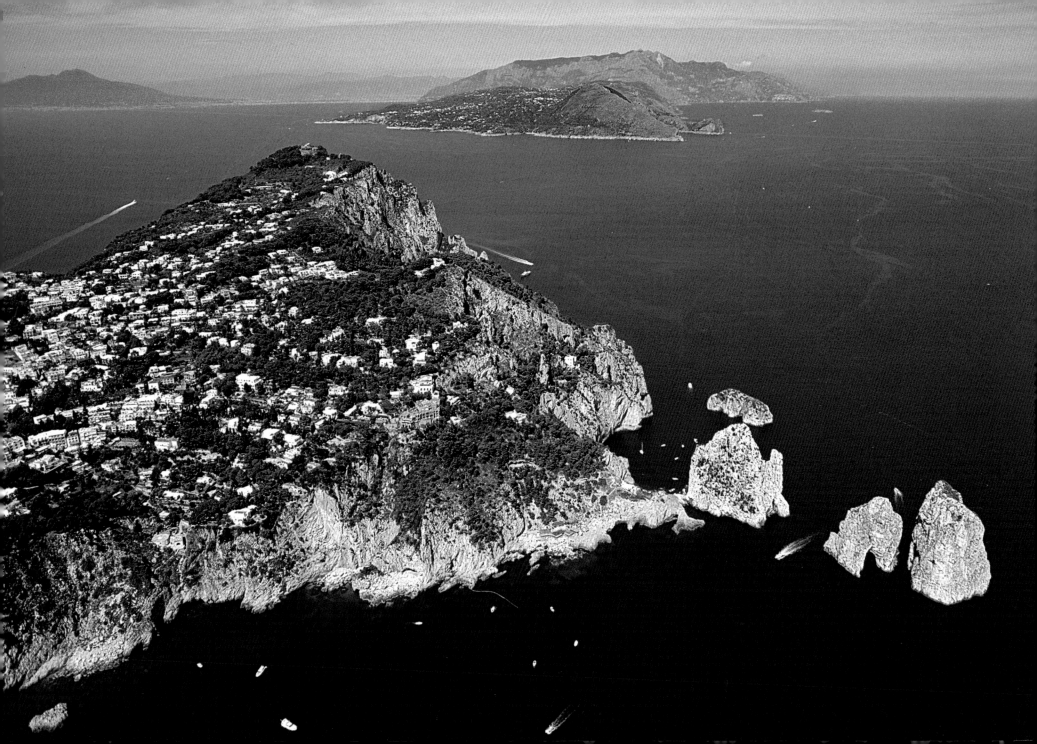

One of the most beautiful places in the world. The Amalfitan coast, that coastal area which extends from Salerno to Sorrento, has a very special appeal and atmosphere. Perhaps it is because of the yellow color and the scent of the lemon orchards, the sun which seems brighter here than anywhere elsewhere, or the sparkle of the sea which brightens a remarkable artistic heritage. The coast is unforgettable. Discovered by travelers on the Grand Tour, in fact, it is a collection of villages atop hills, of endless passages opening between the orchards, of rocky walls covered in green in some parts, colored by blooms and Judas Trees.

Here where a ray of light brightens the majolicas of a distant dome, the legends merge with sacred rites, and craft becomes art of the highest degree. The coral is worked with faithful patience until it is made so perfect that it can be gifted to the Pope for his birthday. The ceramics are colored green, blue, yellow; the colors of gastronomy are "an exquisiteness" and the sweet air brings yearning. Like the song of the sirens which, it is said, enticed seamen as they passed in front of the rocks of Li Galli.

Thus, amidst the Roman vestiges of Minori, the Middle Ages of Maiori, the Norman lands and the Marine Republic of Amalfi's legacy, without forgetting the Baroque of Positano, the coast unrolls curve after curve, in the presence of tourists, painters, sculptors, musicians, celebrities and scholars.

It seems that there were traces of human settlements even when the island of Capri was still joined to the Sorrentine Peninsula, but the first real houses appeared in the 7th–8th centuries BC with the colonization of the Greeks coming from Cumae. In the Greco-Roman period these wild and beautiful seacoasts managed to enchant even the emperors of Urbe. Wealthy Romans had splendid villas built for them and they came here to enjoy the place's splendor and the healthy air. Just like today.

150 left Ravello (Salerno) was termed a "delightful" city by Bocaccio in the fourth novel of the second day of *The Decameron*.

150 right Ischia (Naples), the Greek Pithecusa, seems to be entirely volcanic in origin: the legend of the rebel giant Typhon condemned by Zeus to live beneath the island originated here.

151 Even though Capri (Naples) is very small, it has several attractive walks. One can choose between the historic charm of the coastal village or the sea caves; between paths along the sheer cliffs and the cultivated spreads of lemon orchards, orange groves and olive trees; and between the traditional village center or the remains of the Roman imperial villas.

153 Atrani (Salerno), wedged between rocky walls in the outlet of the Valley of the Dragon, it is the coastal community that has most fully conserved its ancient topographic characteristics.

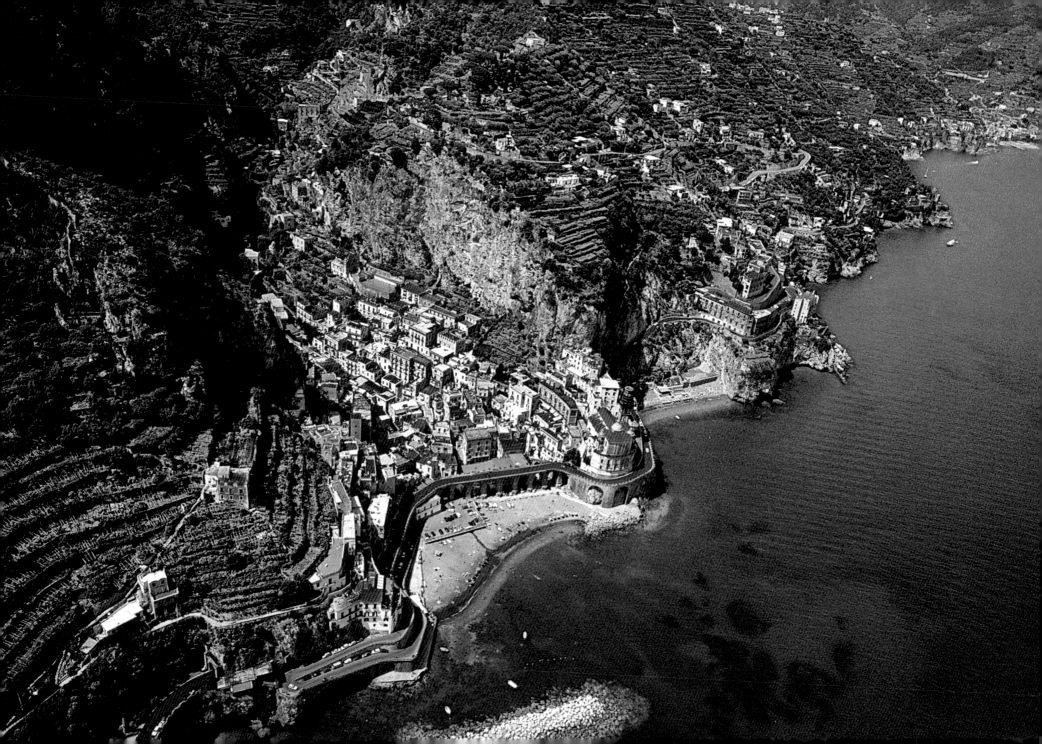

154

Vietri sul Mare (Vietri on the Sea), is the first village going from Salerno and is famous for its colorful majolicas and for the factory of Solimene pottery. Then comes the small Cetara, ancient fishing village, and then beyond the marvelous Capo d'Orso. One arrives at Maiori, with its long beach and pretty shops, and going on to the Roman Villa of Minori. Then, proceeding west, one arrives at Amalfi at nightfall. In this way it is possible to admire the spectacular view which Atrani and the ancient Marine Republic are able to offer, illuminated by the lights at nighttime. During the 10th century, the Amalfitan scenery was very happy: trade, in the eastern part of the Mediterranean, had developed in a remarkable way and the center had become a magnet for

intellectuals and artists. Amalfi's opulence was such that Guglielmo Appulo wrote that no city was richer in gold, silver and fabrics of every type and that one could encounter Arabs, Sicels, Africans and even Indians. The early ideas of a compass were starting to appear and the local men of law drafted the Amalfi Table, a maritime commercial law code. Over the course of the centuries Amalfi has managed to attract a large number of artists who have come here to work. This is where the Norwegian Henrick Ibsen wrote his "A Doll's House" in 1879,. Going inland, after a few miles one finds Ravello, a small center built in the 6th century by several patrician families as a refuge from the massacre of the Goths. They took themselves and

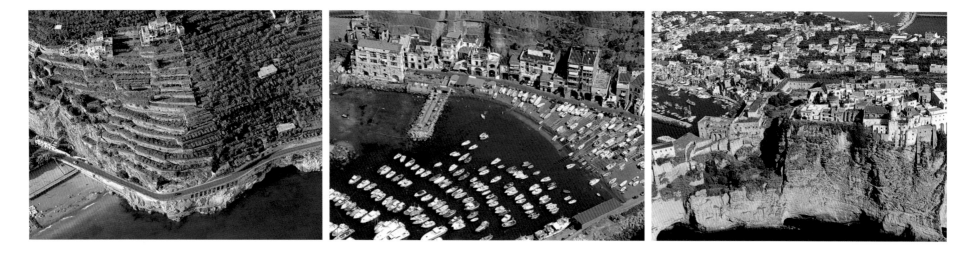

154 left The terraces in the vicinity of Ravello (Salerno) are, for the most part, planted with citrus or vineyards. They integrate perfectly with the nearby cliffs.

their weapons and furnishings through the Valley of the Dragon and the Valley of the Queen, until they happened upon a natural terrace at 1148 ft (350 m), shrouded in woodland and with a beautiful view. This is the residence of poets and celebrities: in Villa Rufolo, the great German musician Richard Wagner composed "Parsifal" and Villa Cimbrone acted as love nest for Garbo and the famous orchestra director Leopold Stokowski.

Then on towards Positano, still on the coast road. Near Conca dei Marini there is the Emerald Grotto, where the boatmen delight the tourists with fantastic stories on these greenest of waters. Going up again to the surface the route continues until we encounter Furore's fjord, a geological oddity which can be admired from above, stopping at the edge of the road, or more closely by walking down a stairway of about 200 steps which takes one up to the few fortified houses bordering the beach.

The deep valley, a deep slit in the mountain behind Praiano, was a refuge for characters like the bandit Ruggeri of Agerola and the heretic Fra' Diavolo (Brother Devil)

And finally, Positano. "It is a dream place that isn't quite real when you are there and becomes beckoningly real after you have gone. Its houses climb a hill so steep it would be a cliff except that stairs are cut in it. I believe that whereas most house foundation are vertical, in Positano they are horizontal." Words by John Steinbeck, which well describe the strange and fascinating sensations provoked by this ancient sea village. Positano's characteristic architectural agglomeration surprised even the Helvetian Paul Klee, master of abstractionism and memorable Bauhaus exponent. Along its streets, one finds gardens and small piazzas, and here illustrious names of Italian and international art have frequently met up for discussion. Art intended as complete, in all its pictorial, literary, musical, choreographic and cinematographic nuances. Some celebrities have bought houses here; others have passed by several times, like Alberto Sordi, Elisabeth Taylor, Liza Minnelli, Richard Burton, Roberto Rossellini and Sergio Leone.

On the tip there is Sant'Agata sui due Golfi (Saint Agatha on the Two Gulfs), whose name contains all that there is to say. Around the semicircle and Sorrento appears – where, in 1544, Torquato Tasso was born, author of "Gerusalemme liberata" (Jerusalem Delivered) – and its coast. Perfumed by the lemon

154 center Piano di Sorrento (The Plain of Sorrento) (Sorrento) achieved its greatest splendor between the late 17th and late 19th centuries. This was when the region's boat-building yards were at their busiest.

154 right On the Torre Murata's promontory in Procida (Naples) stands the castle that the Bourbons adapted as a royal residence in the 1770s. Also visible is the church of St Michael, which has undergone several restorations.

orchards, remembered for "...Oh beautiful the sea, it inspires such sentiment," the city preserves its beauty and authenticity despite tourism.

Before the Sorrentine Peninsula's farthest point lies Capri. A small land of history and memory, a rock four square miles (10 sq. km) long which encloses inside it an inestimable natural-artistic heritage. It is rich with Roman ruins dating back to the 1st century AD, with mysterious caves, sheer hills and precipices over the sea, streets and stairs skillfully carved in the stone, roads and small piazzas hanging on to a scrap of rock and vegetation overlaid on a bed blue water. Capri has been legendary since the time of the emperors Augustus and Tiberius who were so much in love with the island that they built dozens of villas here. On foot or by boat, one meets extraordinary man-made beauties, like the Via Krupp, and scenic beauties, like the stacks: the Blue Grotto stands in Anacapri, already known in the time of the Emperor Tiberius but rediscovered only in 1822. Then, after a calm and reflective wander one reaches the villa and the Byzantine-style church of Saint Michael, together with other churches and basilicas.

Capri is, indeed, the favored location for a stream of people who perennially come to the island to live and devour its myths, a sort of sparkling marketplace of modern times where mundaneness meets and leaves: the destinations are the streets of the center and the Piazzeta, in which an impetuous swarm of people flows frenetically. Important are also the Carthusian Monastery of San Giacomo, today a school, which hosts the paintings of the German painter Karl Wilhelm Diefenbach, who lived in Capri from 1900 to 1913, and Villa Jovis, situated on top of Mount Tiberius, over a frightful precipice above 980 ft (300 m) from which, according to legend, the emperor used to have his enemies thrown.

157 Procida (Naples): Marina Corricella is a evocative, picturesque fisherman's village, which has lost none of its ancient's charm.

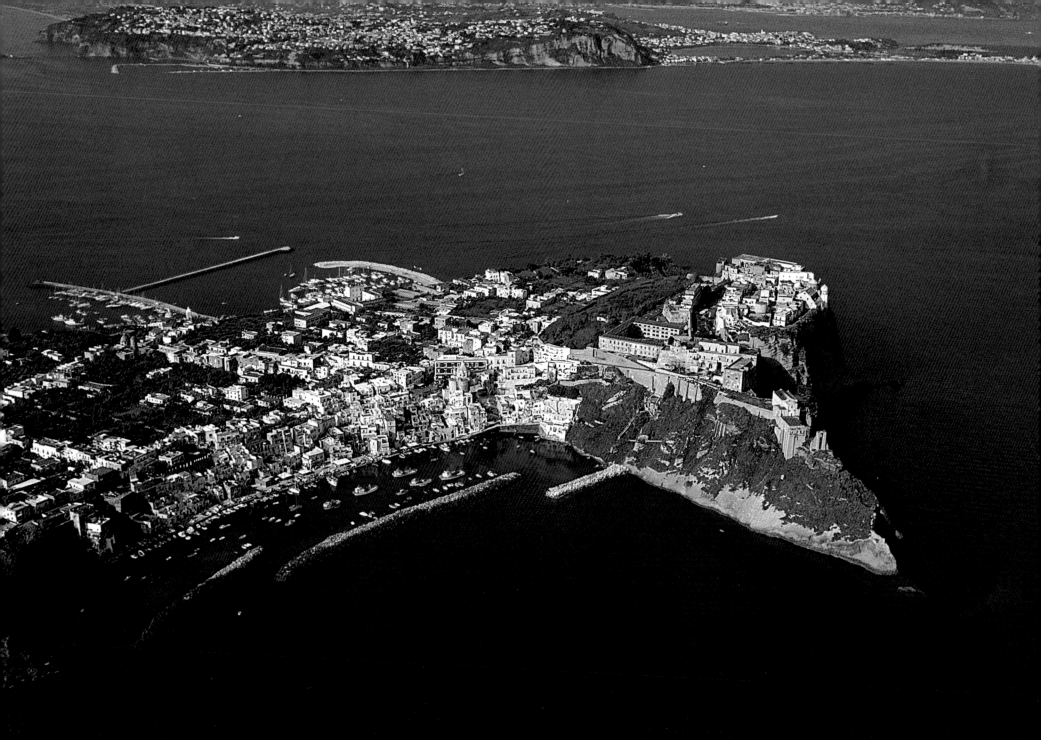

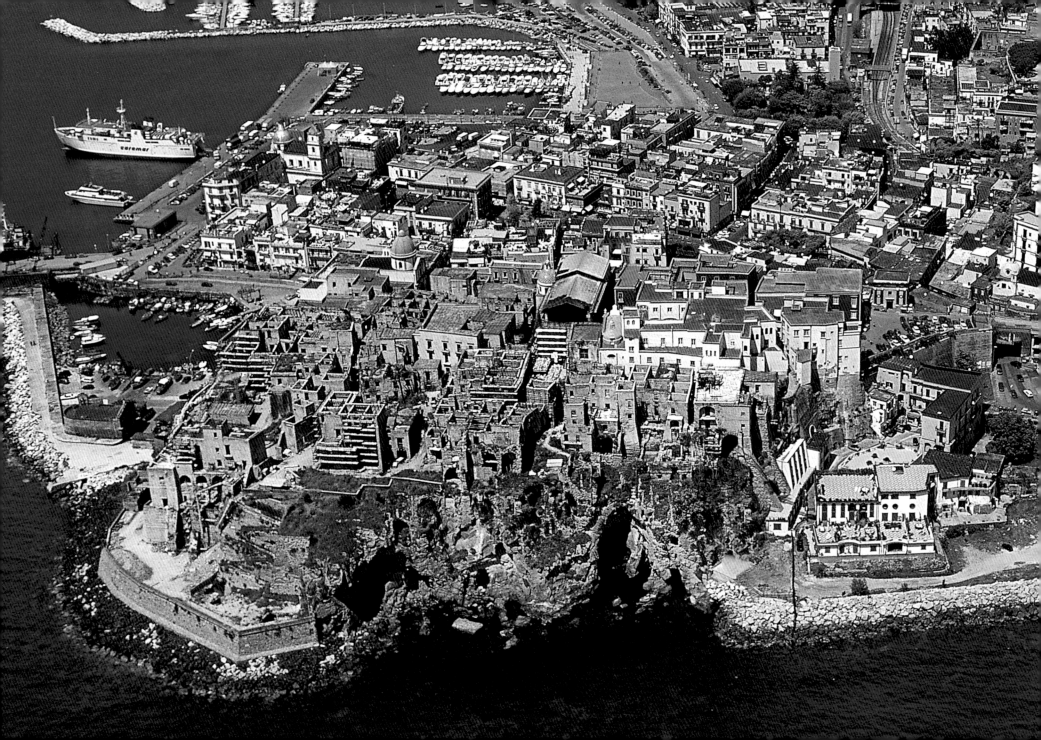

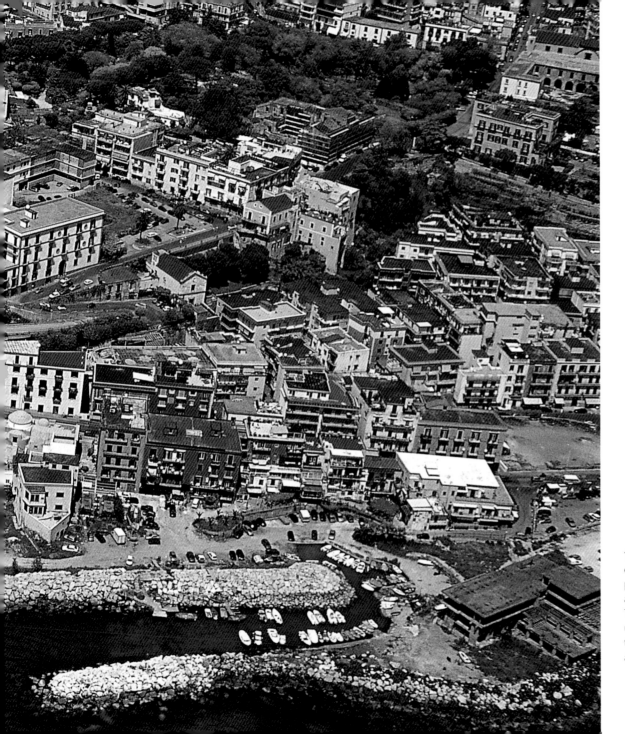

158-159 Pozzuoli (Naples) still possesses extraordinary landscapes with natural phenomena like the Solfataras (volcanic craters) and bradyseism (uplifts in the earth's surface). The ancient underwater city and the underground city are still well preserved, their tunnels intertwining with each other and forming a labyrinth.

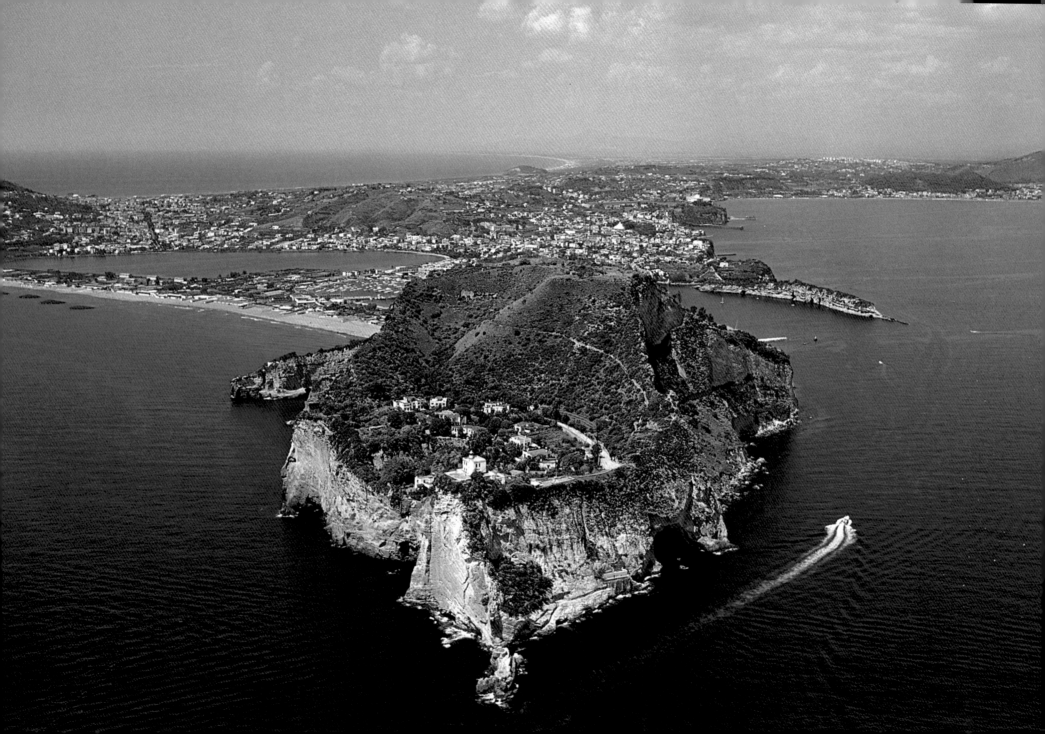

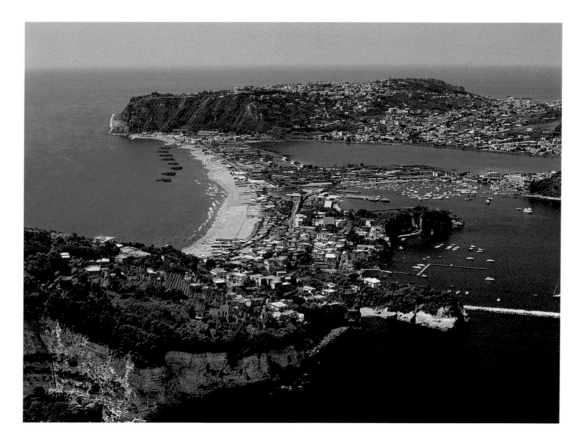

160 Capo Miseno (Naples) is the very well known promontory which, according to Virgil's words in the *Aeneid*, took its name from Aeneas' trumpeter. In 39 BC it was site of the famous pact between the triumvirs Pompey, Antony and Octavian.

161 Miseno is a thriving beach resort. The Miseno promontory forms the northern border of the Gulf of Naples, which was once an enormous crater. The nearby sea is an enormous underwater archeological park, conserving vestiges of the old Roman harbor, and amphorae, anchors and other relics.

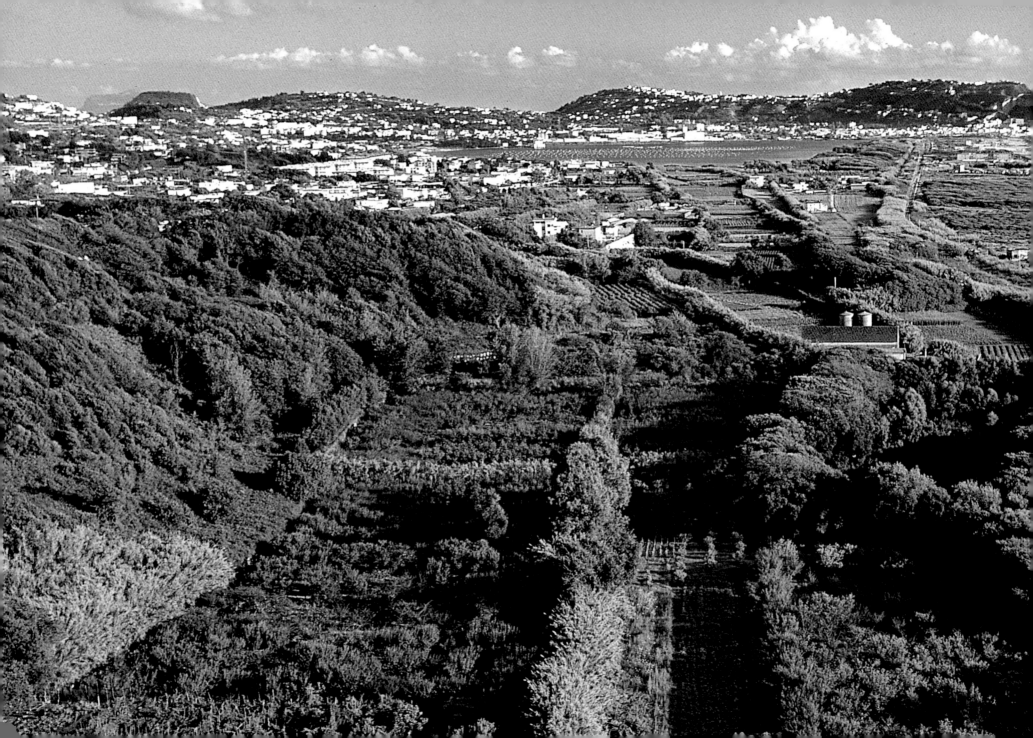

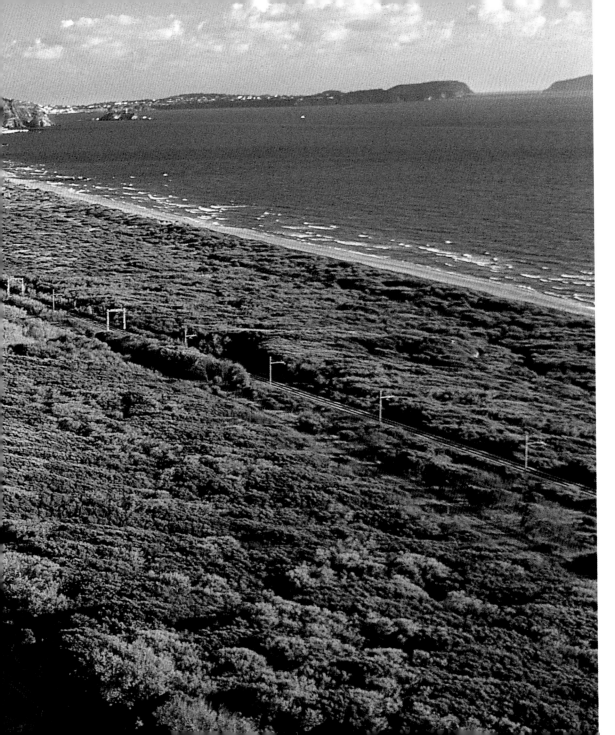

162-163 The plain to the south of Cumae (Naples) forms the Phlegraean Fields, so named because Aegean sailors noted volcanic activity, and applied the Greek word *phlegraios* (burning) to the locality.

164-165 Bacoli (Naples) is located in the Phlegraean Fields vicinity, a territory with many dormant craters, very fertile soil and a mild and sunny climate The coast, with its safe natural harbors, was the site of ancient settlements.

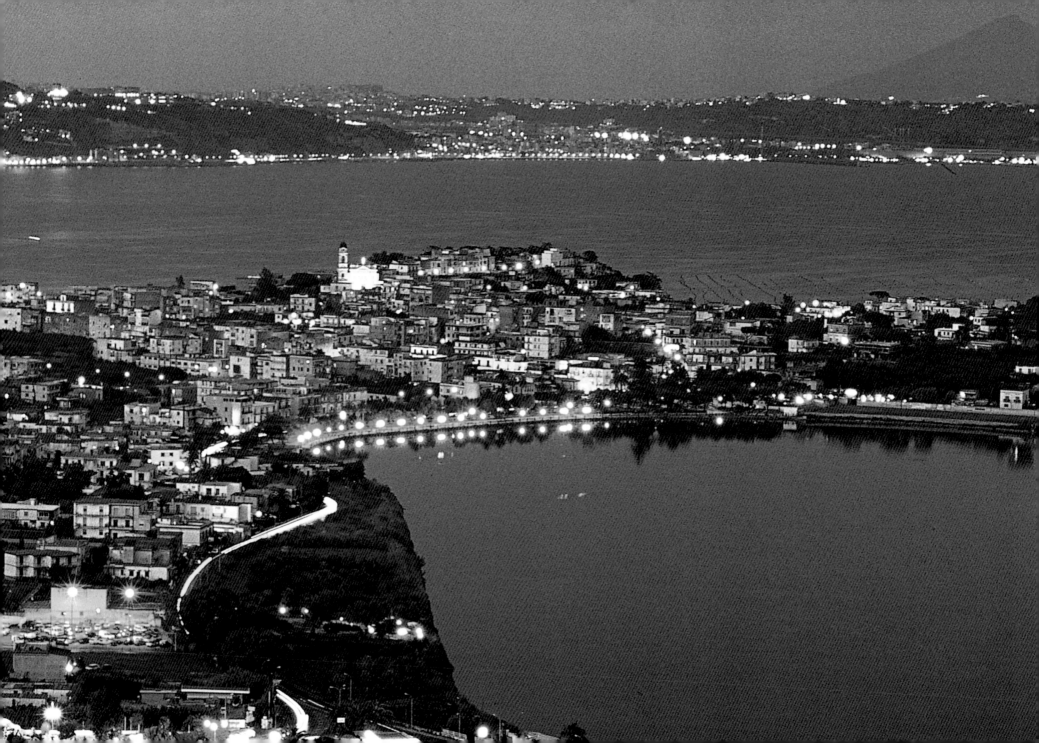

166 On the island of Procida (Naples) even the burial place is beautiful. Overlooking the Pozzo Vecchio's beach, the island's cemetery is adorned, in accordance with an ancient rite, with olive branches or palm branches on Palm Sunday.

167 Procida's new marina offers, besides the traditional connections with mainland, the possibility for thousands of boats to dock and enjoy the beauties of the island. Continuing to the north (on the left in the photograph) one reaches the suggestive Spiagga della Lingua (Tongue's Shore) which is of volcanic origin.

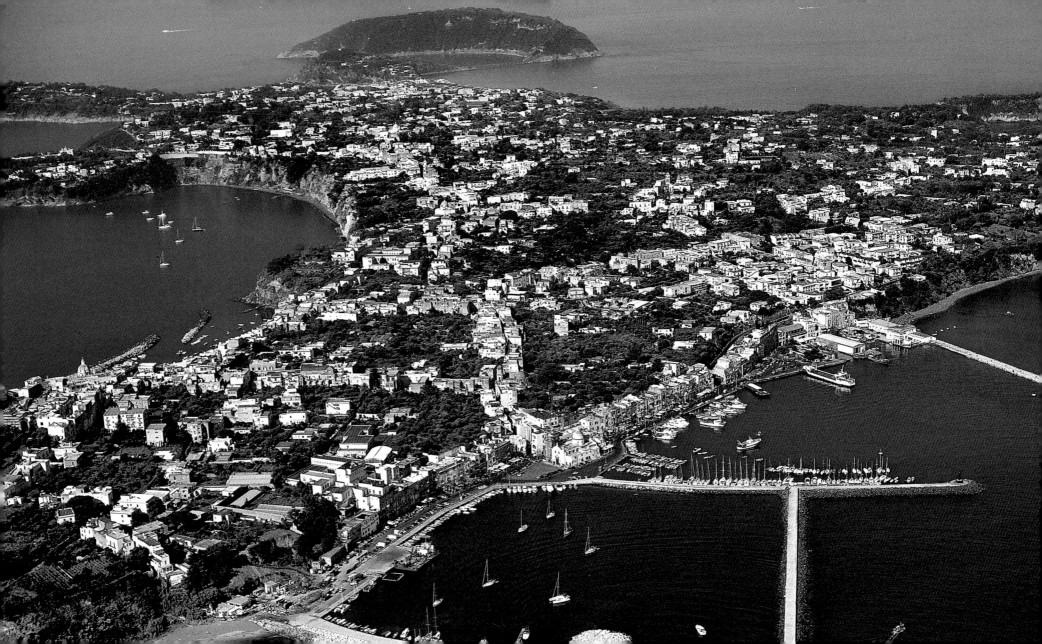

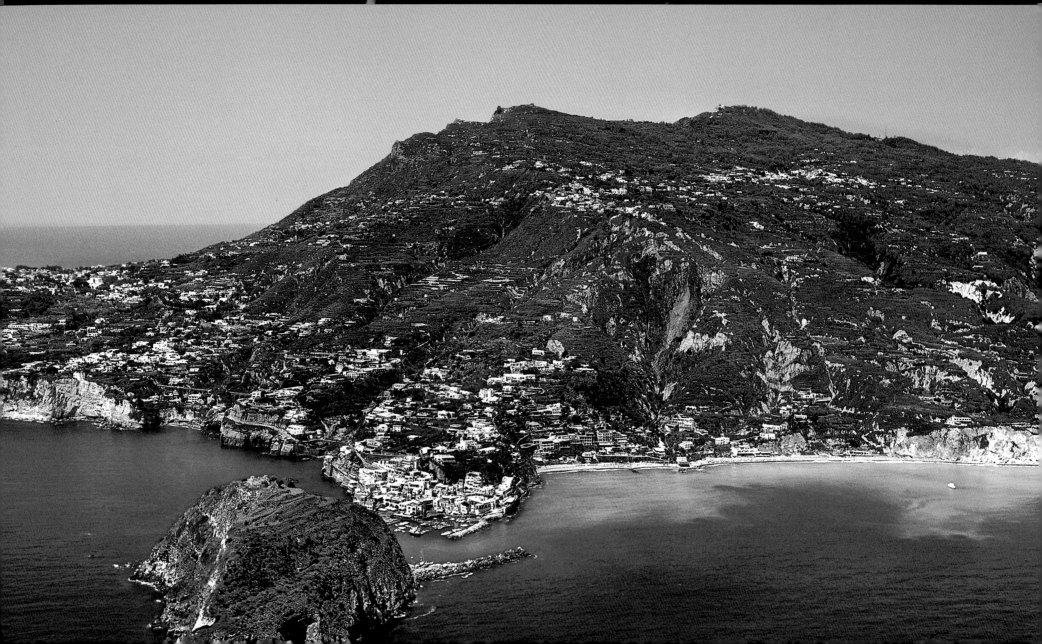

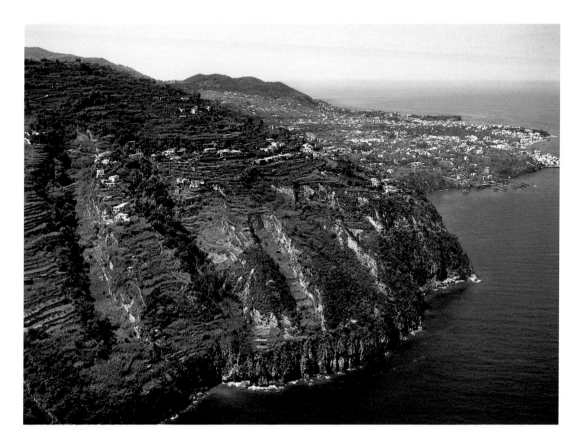

168 Situated on the southern coast of the island of Ischia, the small town of Sant'Angelo is an oasis of greenery and quiet. Ancient fishing village and particularly characterized by the volcanic islet-promontory at 345 ft (105 m). Upon its summit once rose a small church dedicated to Saint Michael Archangel, from which the town takes its name.

169 The island has a surface area of 17.89 sq. miles (46.33 sq. km) and rises from the depths of the sea for 808 miles (1300 km) of which only 490 miles (788 km) emerge to the surface. Mount Epomeo is Ischia's highest point, inactive since 1302.

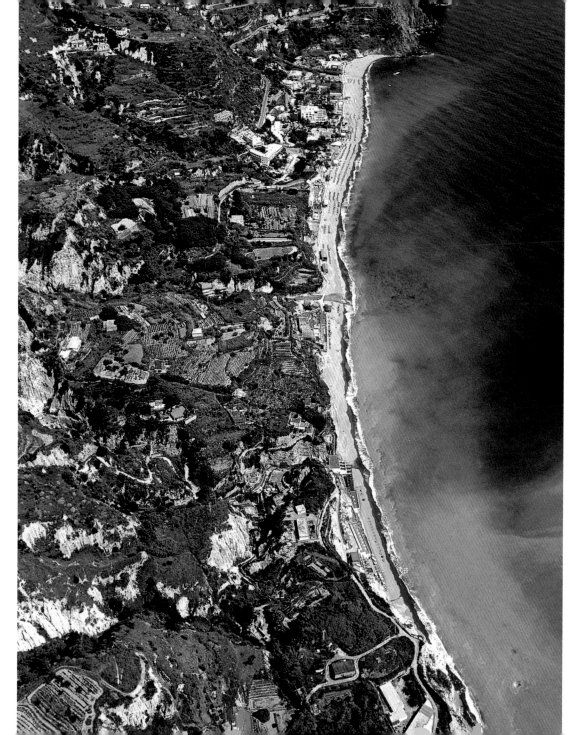

170 The beach between Sant'Angelo and Barano d'Ischia is a wild and unspoilt part of the island.

171 On the tract of coast between Ischia Harbor and Casamicciola there are numerous thermal spas adjoined to splendid hotels. On the promontory, on the right we can see one of the largest, the Thermal Park of Castiglione, with 8 thermal pools between 86° F and 104° F (30° C–40° C).

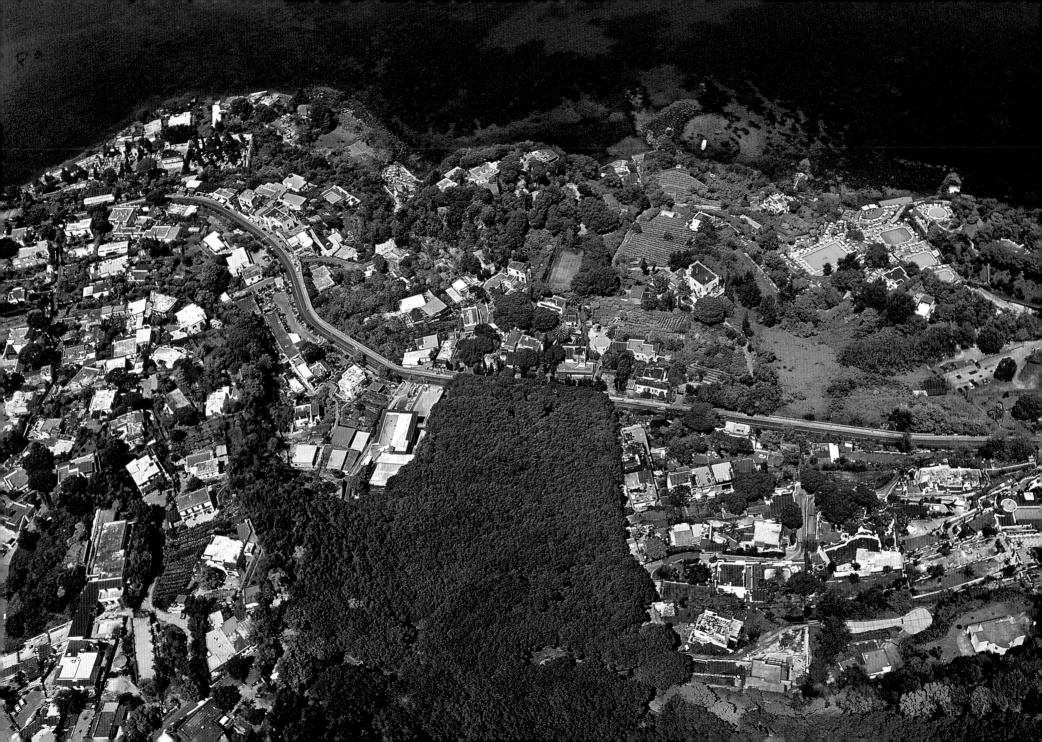

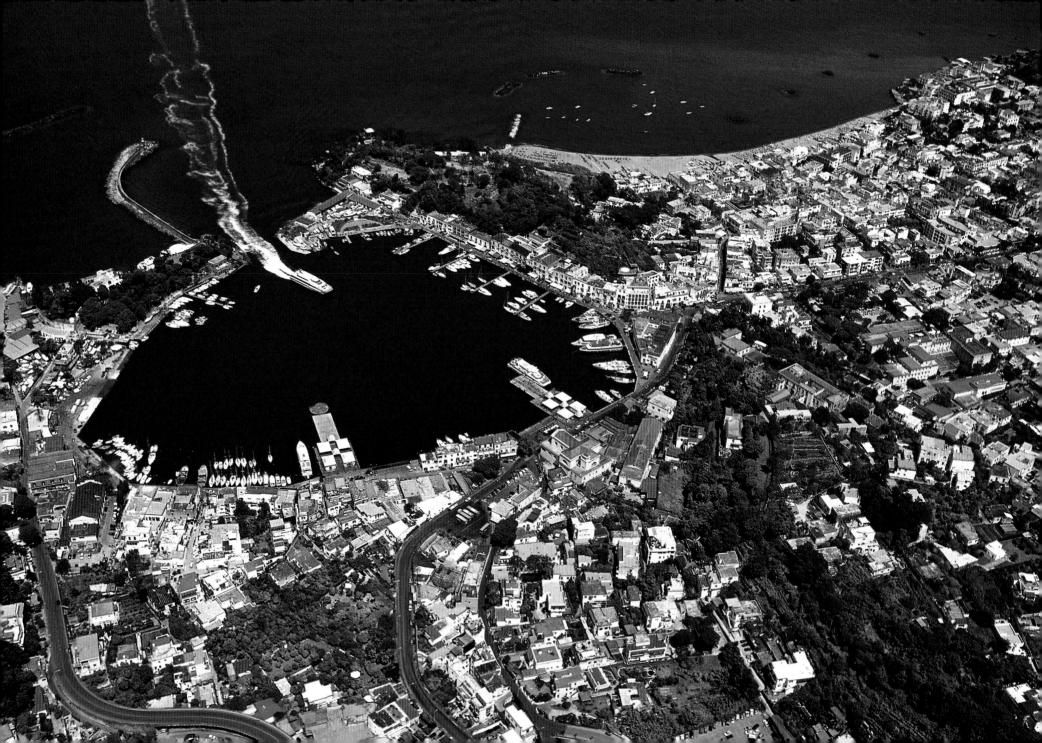

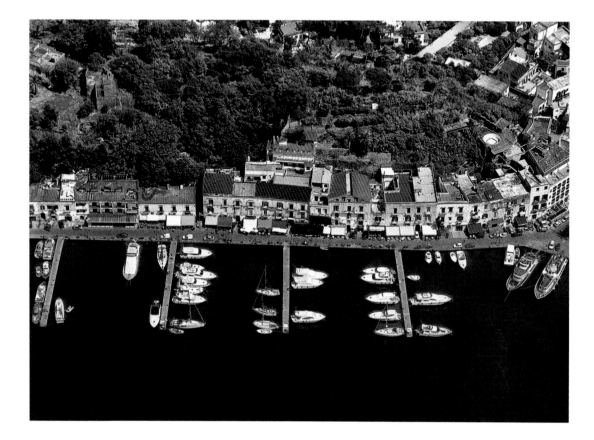

172 and 173 Ischia's port was inaugurated on 17 September 1854 by the king of Naples Ferdinand II of Bourbon. The port was built in a natural lake which lay behind the sea in an old volcano crater. The thermal waters of the area caused the First Medic of the court in 1735 to build a villa, which soon turned into a nursing home for those closest to the king. The construction of the Bourbon port instigated the building of houses and hotels and paved the way for the island to become a prized tourist destination.

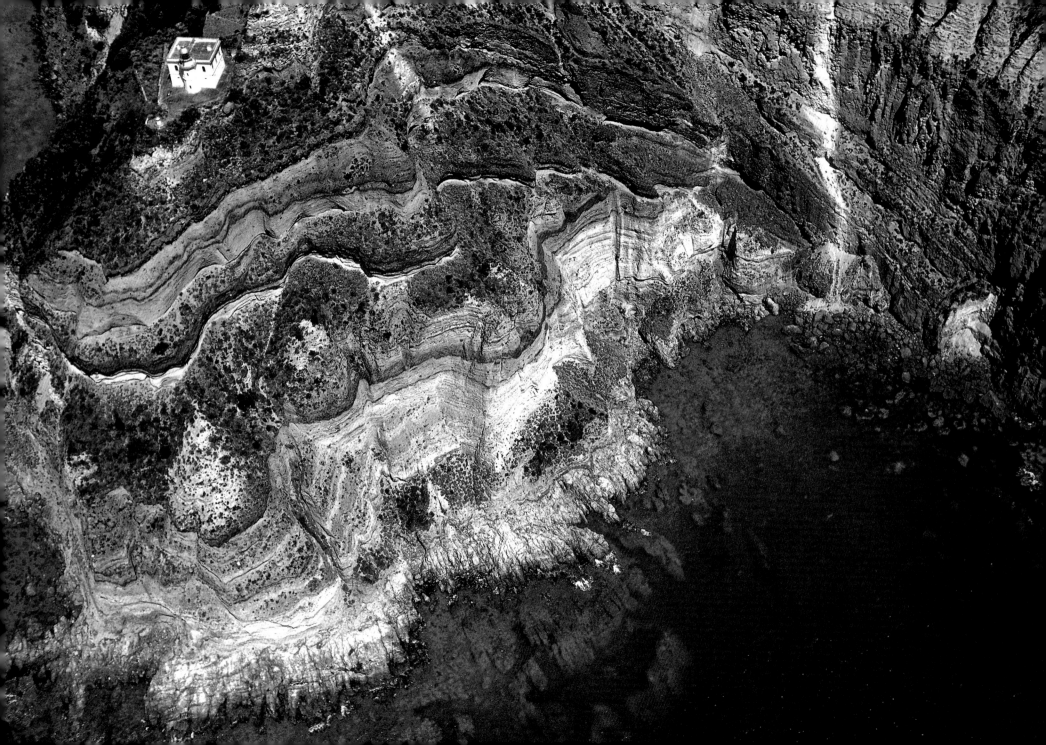

174 Ischia's (Naples) undoubted volcanic origin increases the beauty of its landscapes which are quite changeable. An example of this are the coasts which geology has clearly divided and distinguished. The southern coast is in fact high and wild, formed by the characteristically dark colored rock on a cliff overlooking the sea, whilst the northern coast is low and has allowed the creation and the development, over the centuries, of several small cities. The photograph reveals a view of Punta Imperatore (Emperor's Point), recognizable for its lighthouse which has a range of 35 miles (57 km) and its one of the most beautiful and powerful in Italy.

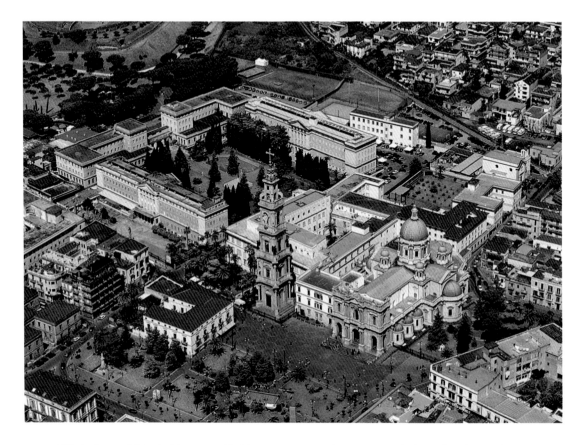

176 In Pompeii (Naples) lies one of Italy's most renowned sanctuaries dedicated to the Madonna of the Rosary. Visitors number about four million per year.

177 Torre Annunziata is set between Vesuvius and the sea in the Gulf of Naples' inlet and borders Pompeii. During the Roman Empire the area was named Oplontis and represented a suburban residential quarter of Pompeii, where marvelous villas rose along the coast and around a large thermal center. The current city hosts the Basilica Pontificia Minore (the Minor Pontifical Basilica) consecrated to the cult of Mary S.S of the Snows, the city's patron saint.

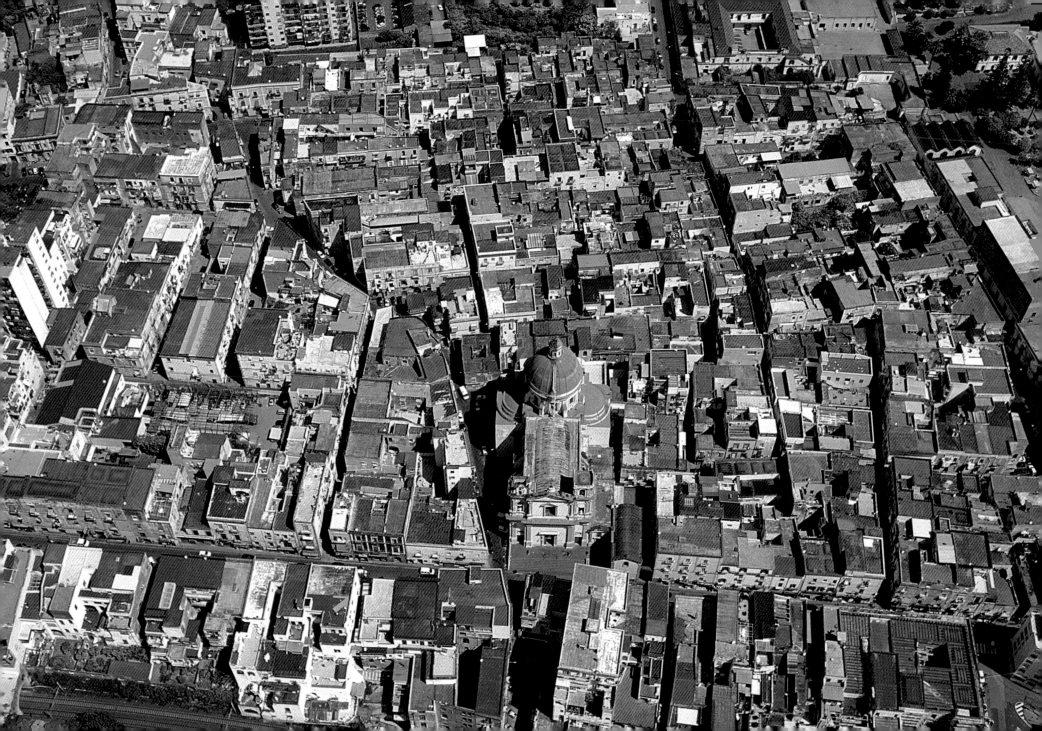

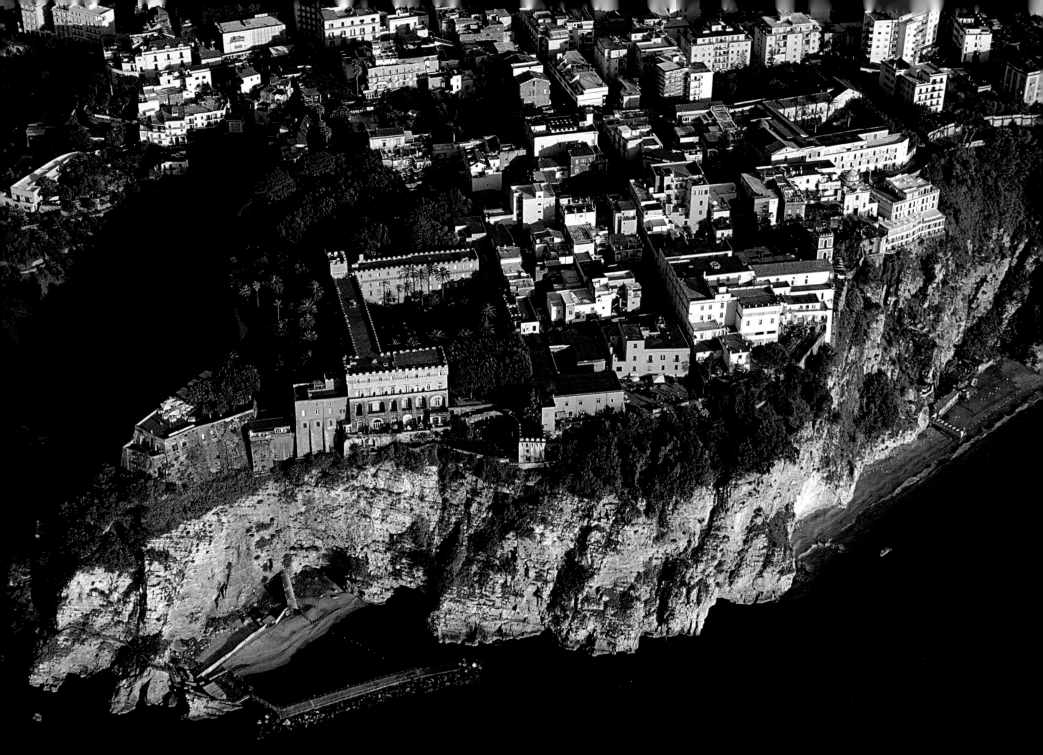

178 The castle of Charles II of Anjou was built in the 14th century on the Vico Equense's promontory upon a hill overhanging the sea. Now the palace is known as Castello Giusso (from the name of the last owner who undertook reconstruction work) and is used for ceremonies and banquets.

179 The Sorrentine Peninsula (Naples) was a very stylish destination during the first Roman imperial age, renowned as a vacation resort for patricians, who chose the entire Gulf of Naples, from the Flegrean Fields to Sorrento, as the ideal place to spend the summer.

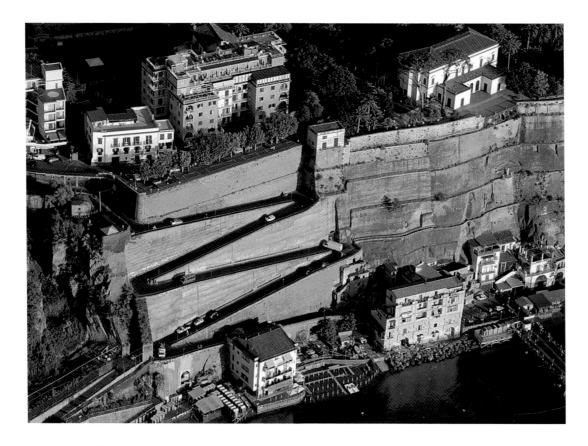

180 and 181 Piano Sorrento (Naples). During the Roman era the city was called Planites, meaning flat, but in the local dialect it is referred to as Caruotte from the Latin caruttum, a term which probably derives from the presence of numerous tuff caves in the area.

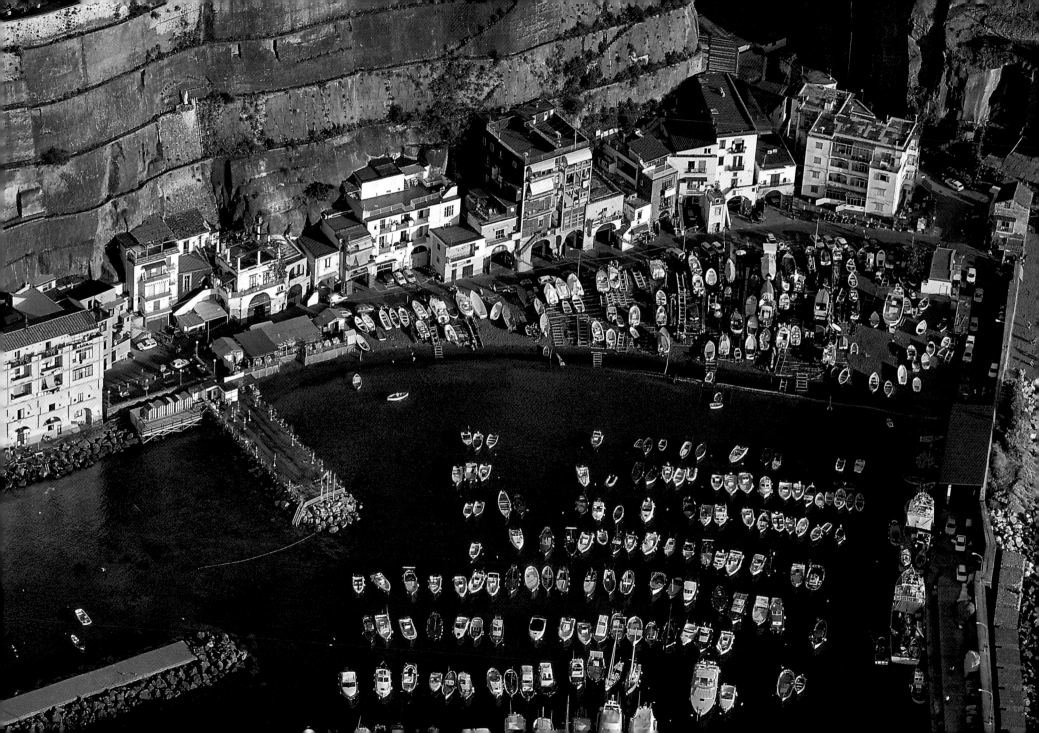

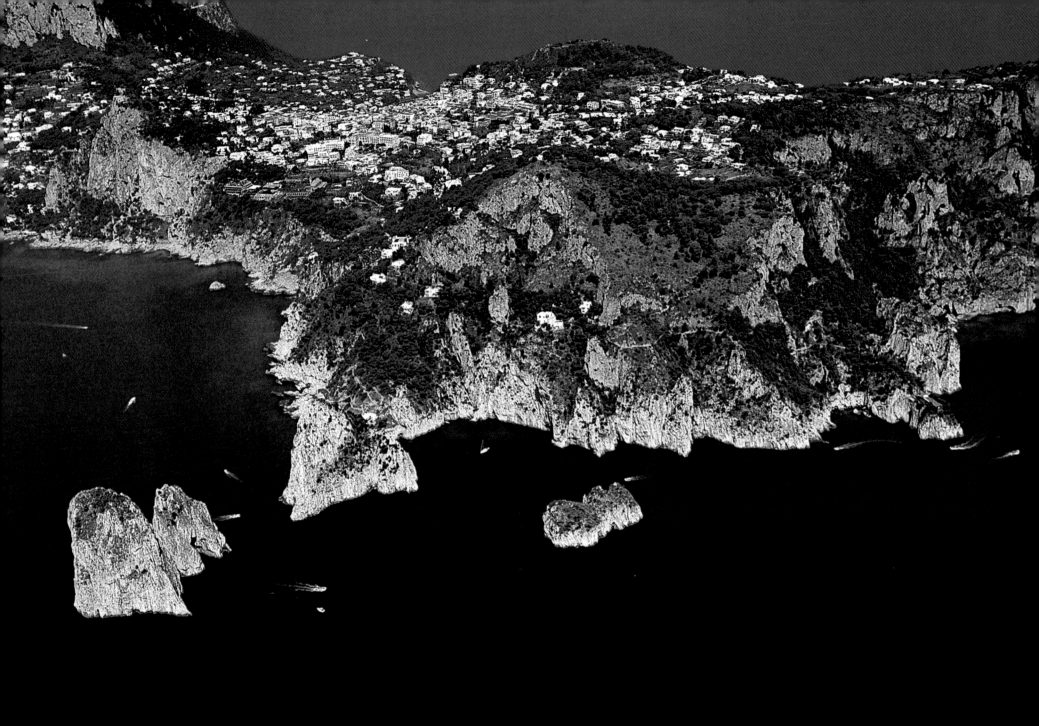

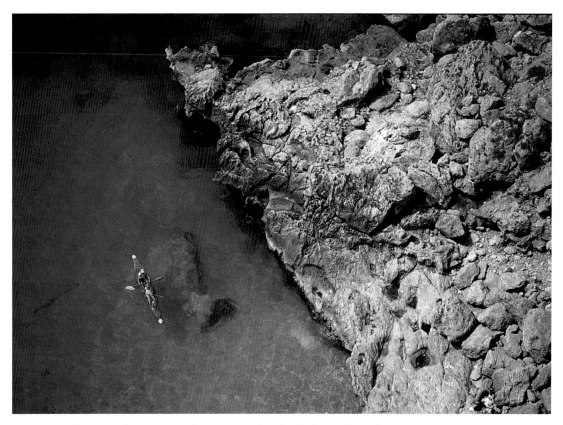

182 The strait of Bocca Piccola separates the island of Capri from the Sorrentine Peninsula, to which it was originally attached. The island is of karstic origin and is marked by medium-sized mountains and uplands.

183 Capri's prestige "exploded" with the Grand Tour of AD 800, when artists, writers, musicians and intellectuals discovered it. Here, amidst the blue of the sea and the green of the island, they gained inspiration for their masterpieces.

184-185 Capri's Stacks (Naples) are three peaks saved from the disintegration of the coast, the erosion of the sea and atmospheric agents. They have various names: the first, joined to land, is called Stella; the second, separated from the former by a tract of sea is called Middle Stack; the third, where the rare blue lizard lives, is called Outer Stack.

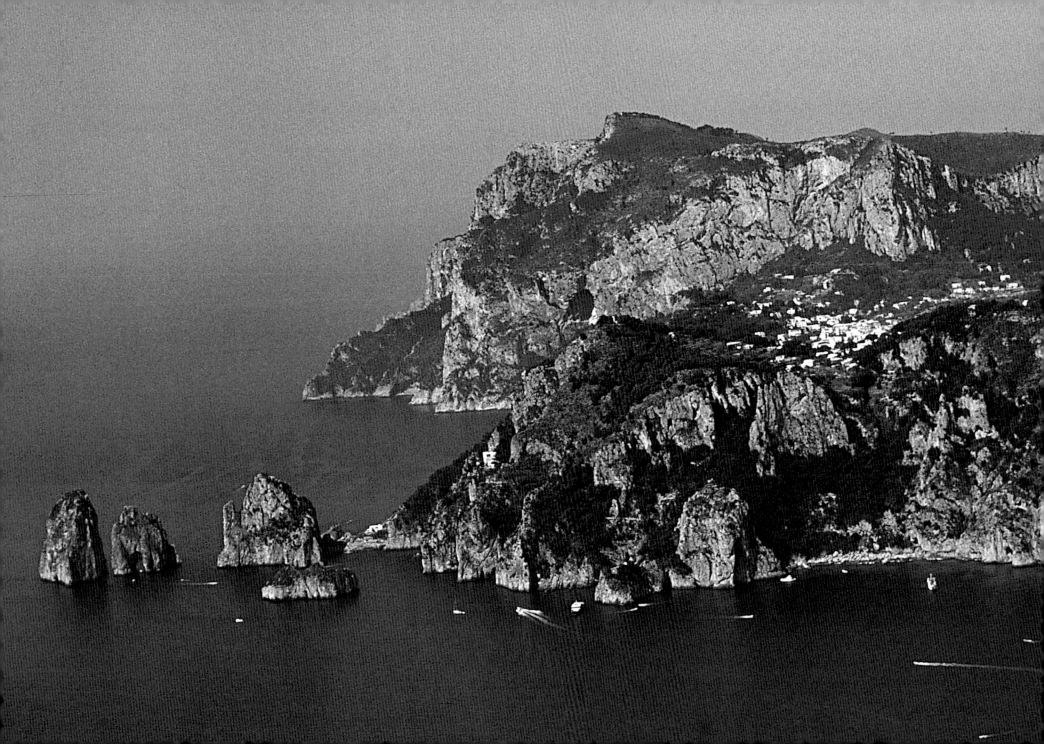

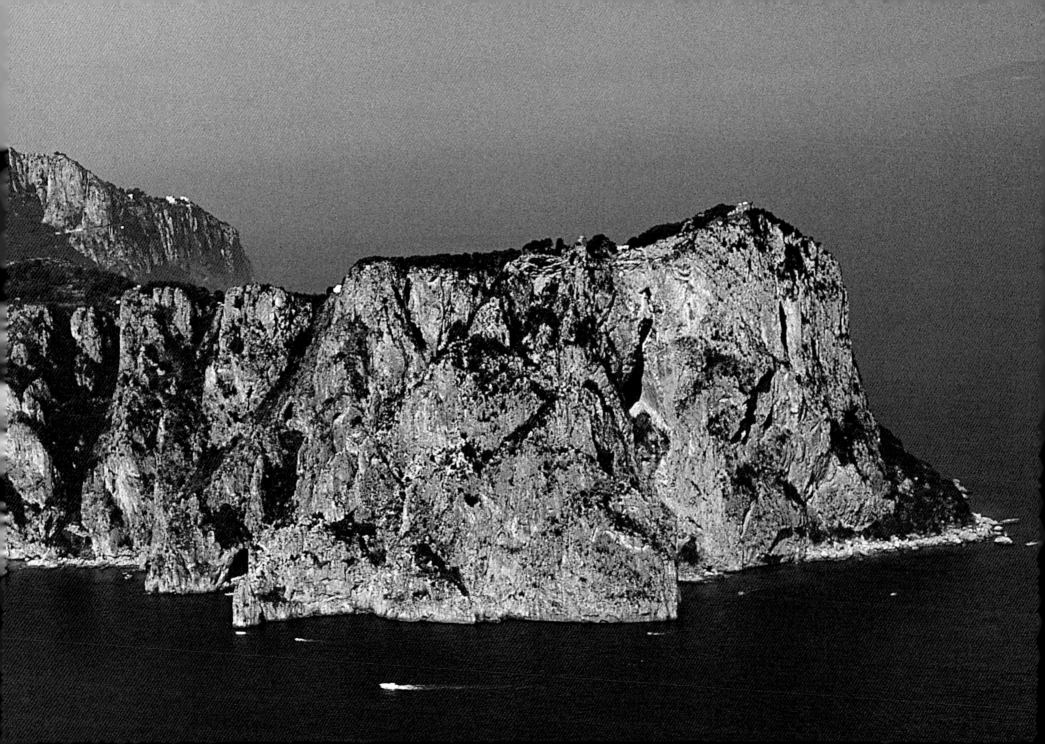

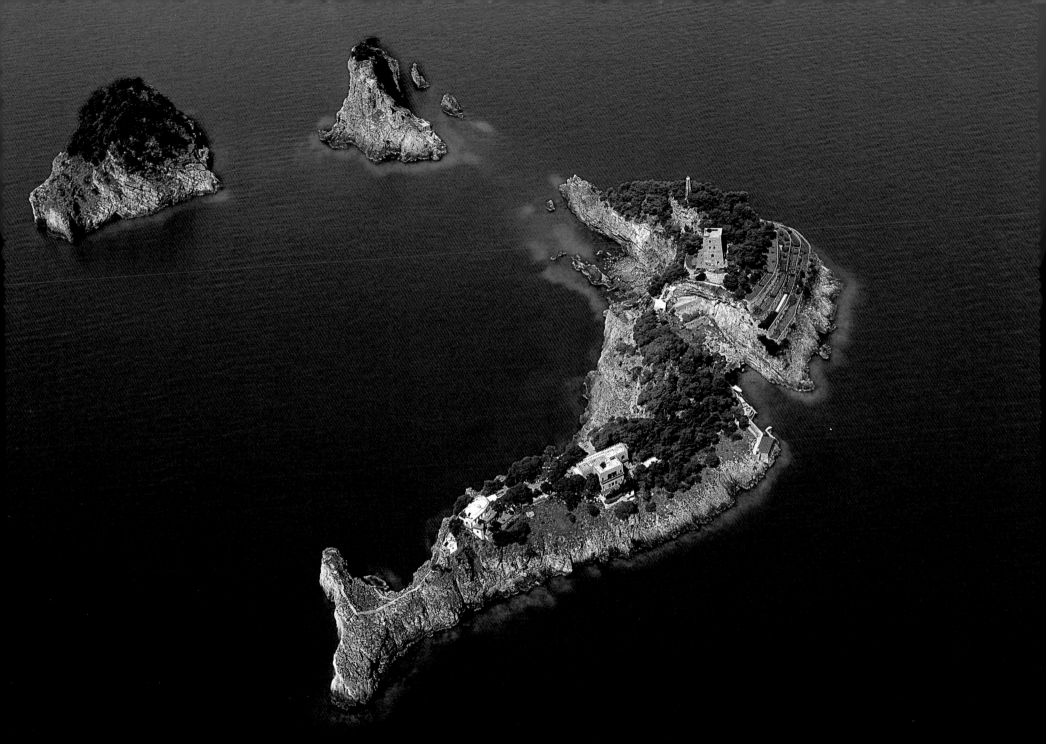

186 The Galli (also called the Sirenuse) are three romantic islets which are found before Positano (Salerno). Homer referred to them as the place in which Ulysses was tempted by the sirens. Today these islets are still drawing people in; for a long time they were the property of the ballet dancer Rudolf Nureyev.

187 In the middle of the Bay of the Infreschi (Salerno) is a beautiful natural site possessing great atmosphere, totally unspoilt. One notes at the center the cave of the same name, which takes its name from the coolness of its interior, due to the presence of a spring. The sea bottom is spectacular.

188-189 Positano (Salerno) is one of the places most loved by the international beau monde, by artists of every type, celebrities and tourists. It is also one of the most popular and well-known vacation resorts in Italy, a location not to be missed during a coastal visit.

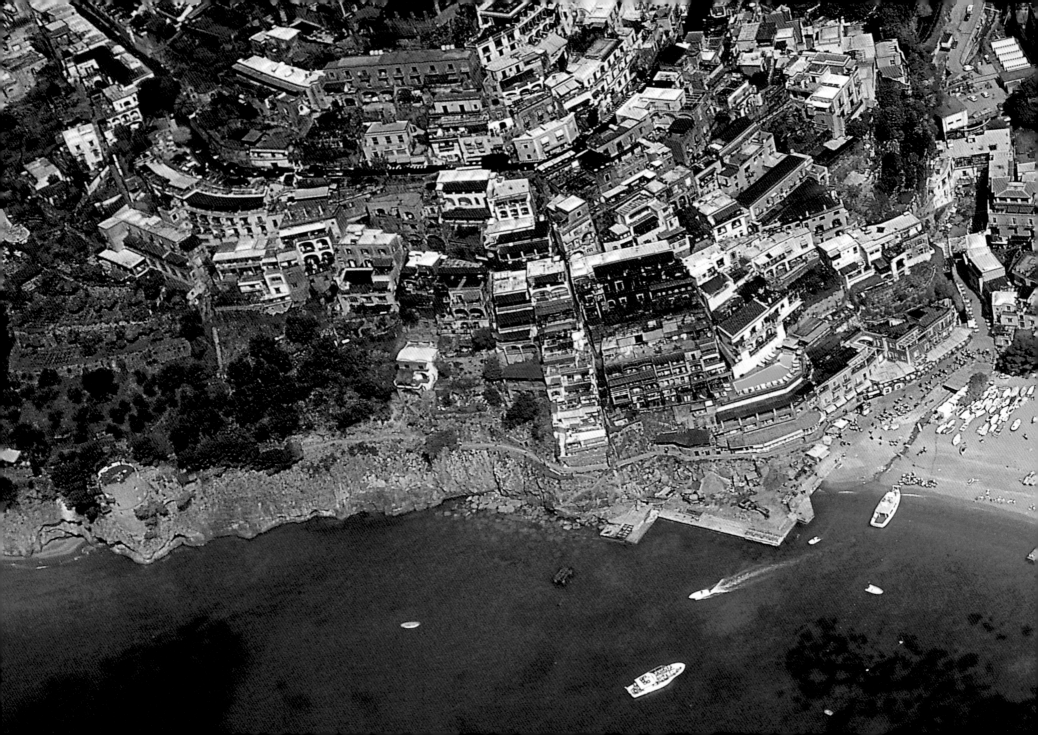

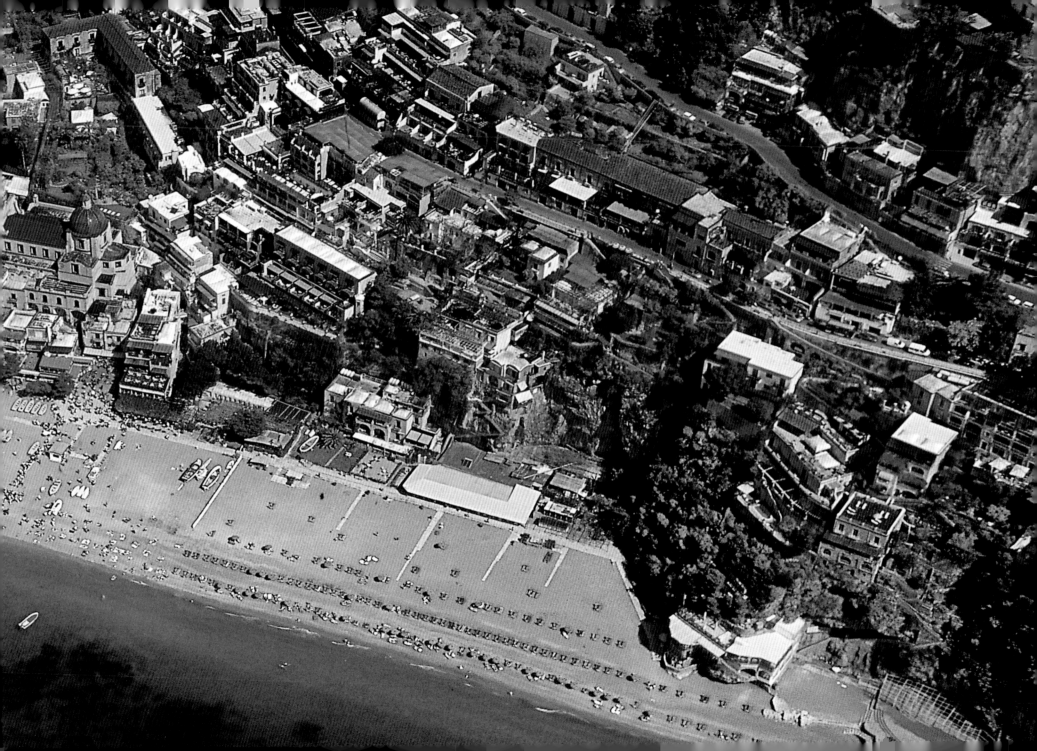

190 Positano (Salerno) is located on the southern slopes of the Lattari Mountains, which shelter it from northern winds. It is found in the center of a small bay formed by Punta Germano and from Capo Sottile.

191 Two, three days, a lifetime. It is impossible to define the time needed to visit the Amalfitan Coast (Salerno) as this is a UNESCO World Heritage site which surprises even the most disenchanted of souls.

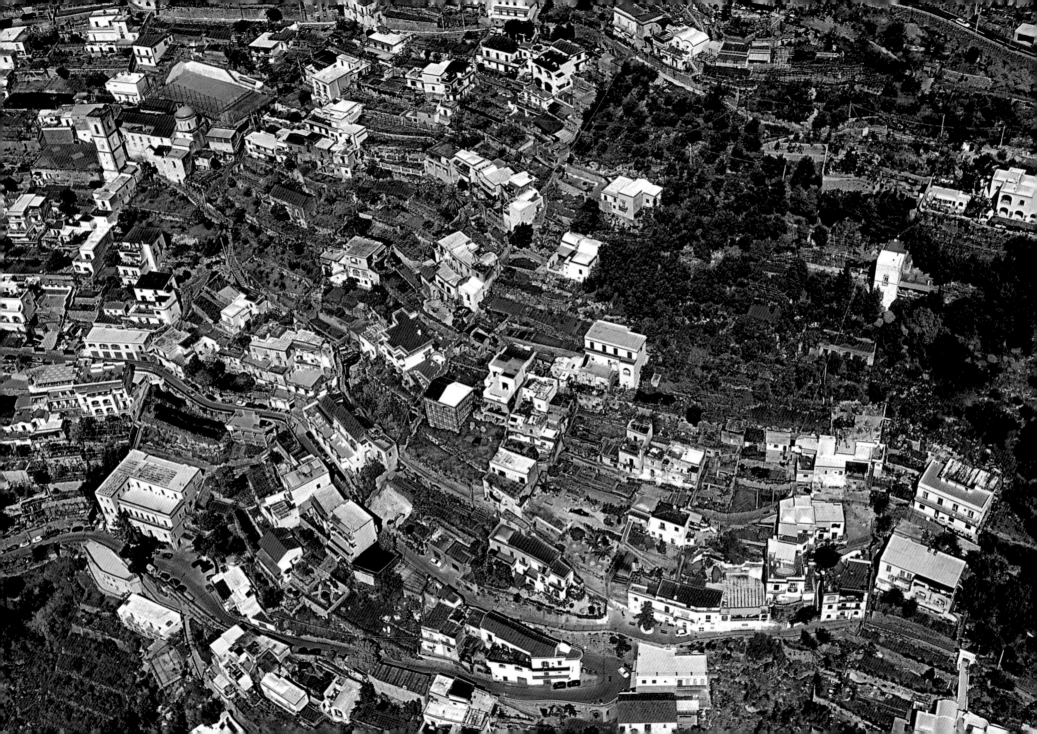

192

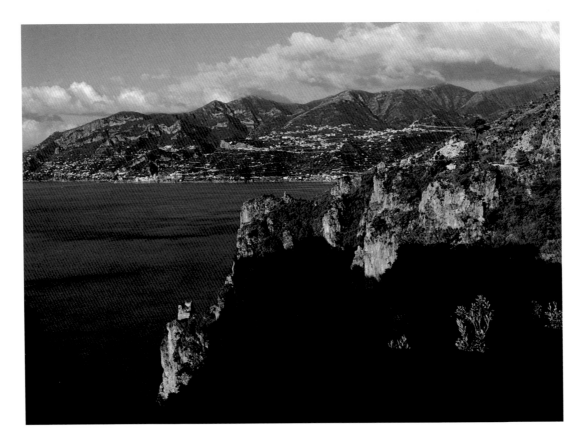

192 In 1817 the poet Stendhal complained that all the hotels on the Amalfitan Coast (Salerno) were occupied by "two or three thousand British," and the situation has little changed. The tourists circle here all year round, with astronomical numbers in summer.

193 During the Middle Ages Praiano (Salerno) was one of the hamlets in the Marine Republic of Amalfi. Ever since that time, the center has been characterized by two residential areas: the hamlet of Praiano, on top, and the Vettica Maggiore, below.

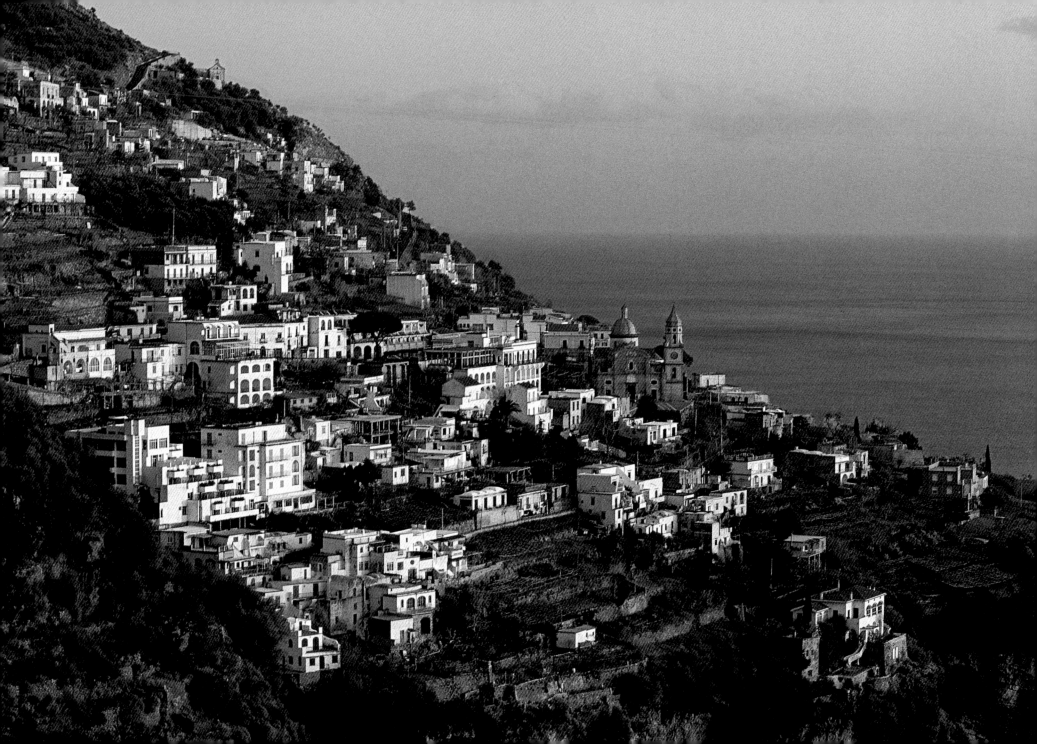

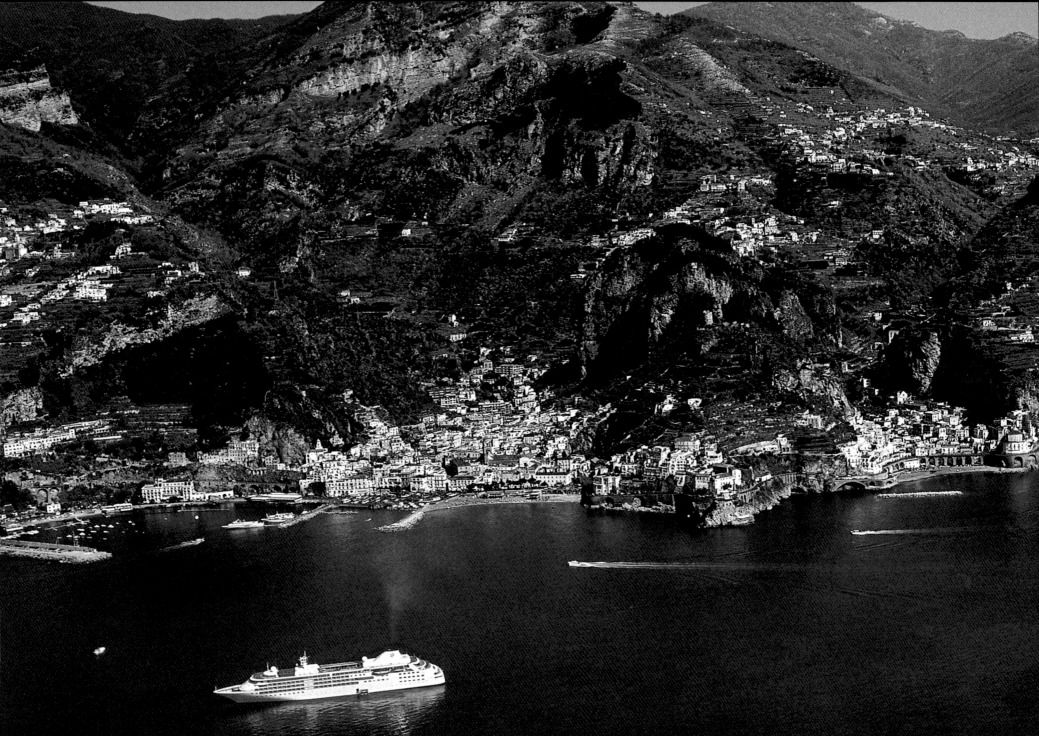

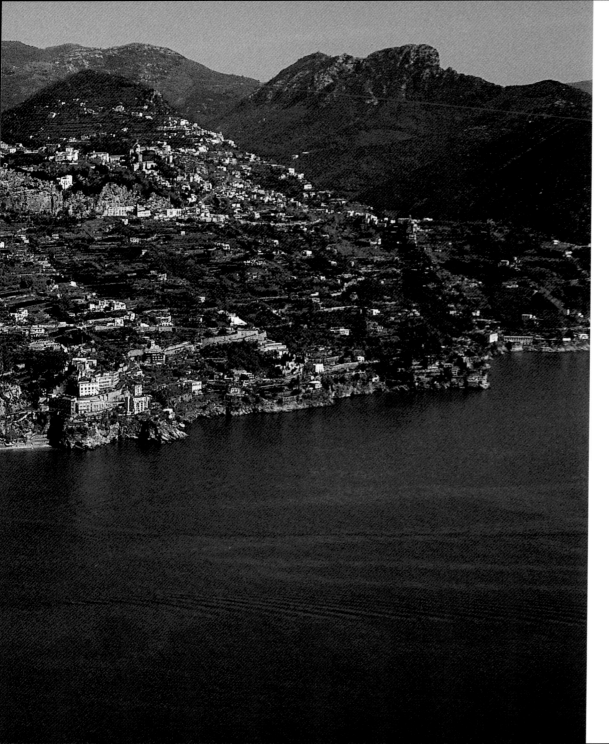

194-195 Amalfi (left) and Atrani (right), immortalized in this image taken from the Amalfitan Coast, cannot be very much different to the sight seen by thousands of traders and merchants who waited to land in these rich Mediterranean localities over the centuries.

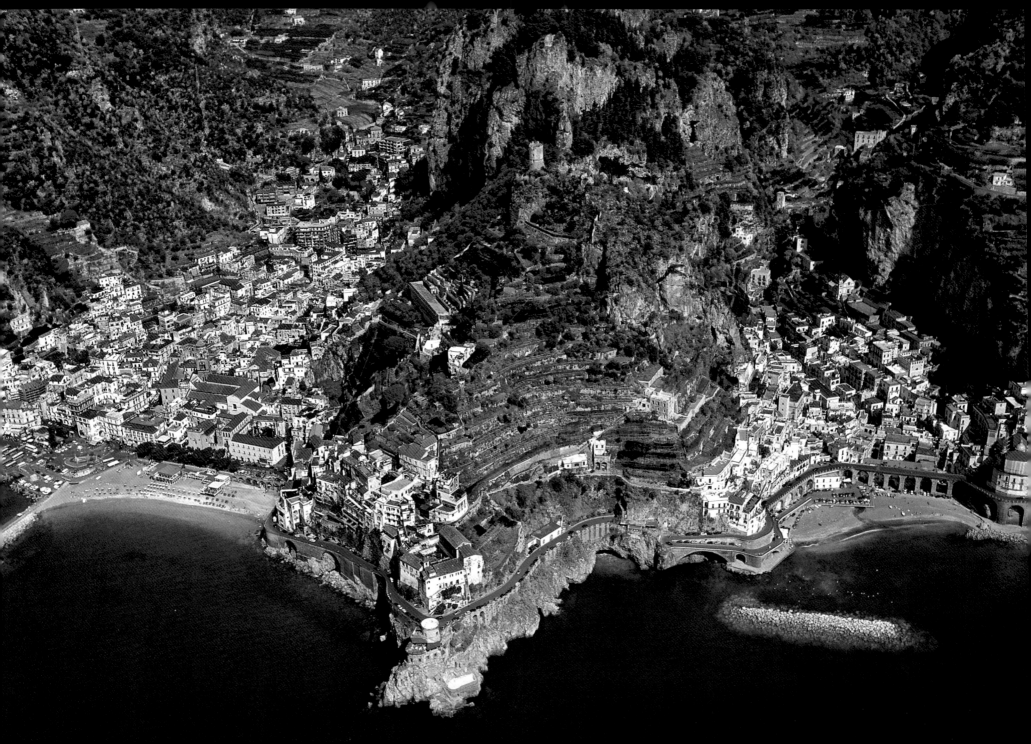

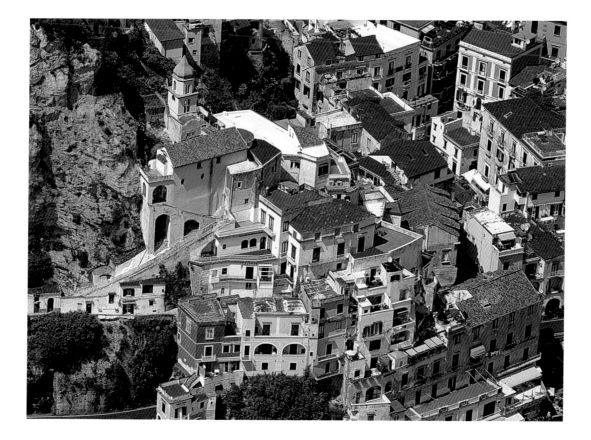

196 The Saracen Tower of Amalfi (the city on the left of the photograph), a watch tower used for defensive purposes, was once called Torre San Francesco (Saint Francis Tower) and defended the convent which the saint had built in 1222 just behind. The tower and the convent are now home to a prestigious hotel.

197 On 13 June of every year the statue of Saint Anthony is taken in a procession from the Amalfi's convent of Saint Francis to the beach of the nearby Atrani where a boat takes it up to the church dedicated to the same saint which lies upon the rocks.

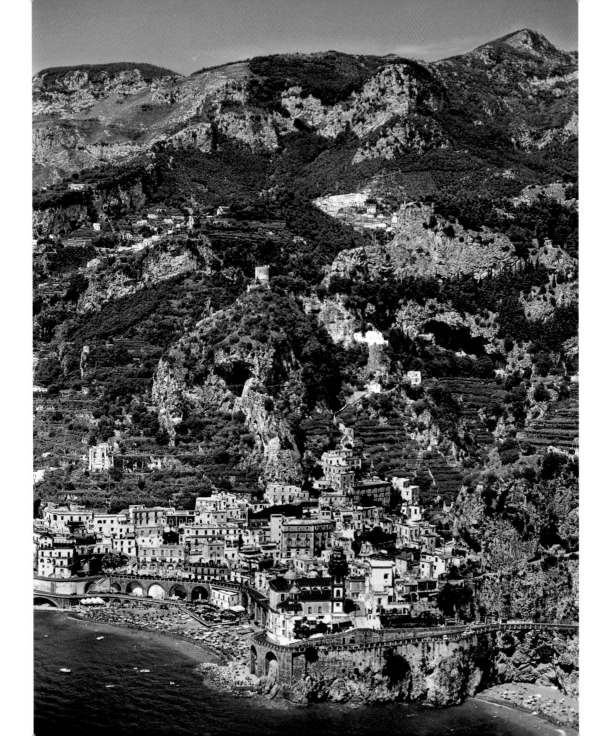

198 Set in a tiny, picturesque inlet on the Amalfi Coast, Atrani (Salerno) is the smallest municipality in Southern Italy. Its name may be derived from the Etruscan term *atru* ("black" or "hidden"), referring to the rocky cove in which the village was built.

199 The church of Saint Mary Magdalen of Atrani, built in the 13th century as thanksgiving for the defeat of the Saracen plunderers, has become one of the symbols of the small city, previously devastated by the Pisani army in 1135.

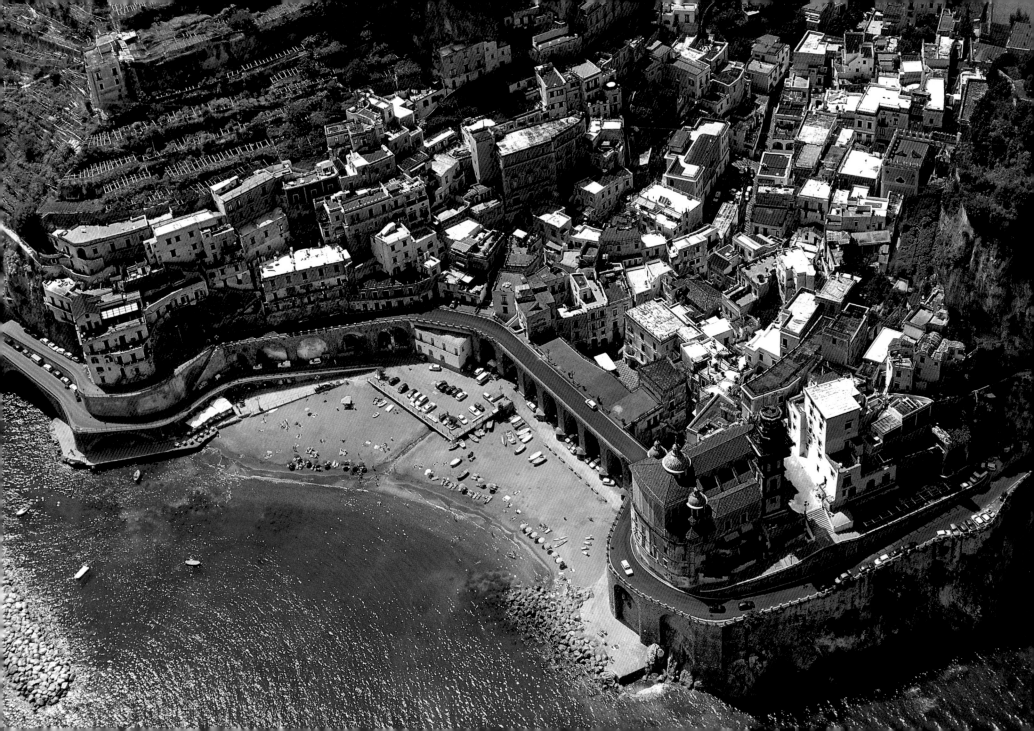

200 The convent of Saint Francis of Assisi rises in the locality of Ponticeto and it is said that it was founded by the saint in 1222 when he traveled to Ravello while on his way to Amalfi for the veneration of the remains of Saint Andrew the apostle.

201 Built in a Romanesque style, the Duomo of Ravello was built around the 10th century by the city's first bishop and was subsequently restructured in a Byzantine style. It preserves in its interior a precious marble and mosaic ambo in an Arabic-Byzantine style from 1272.

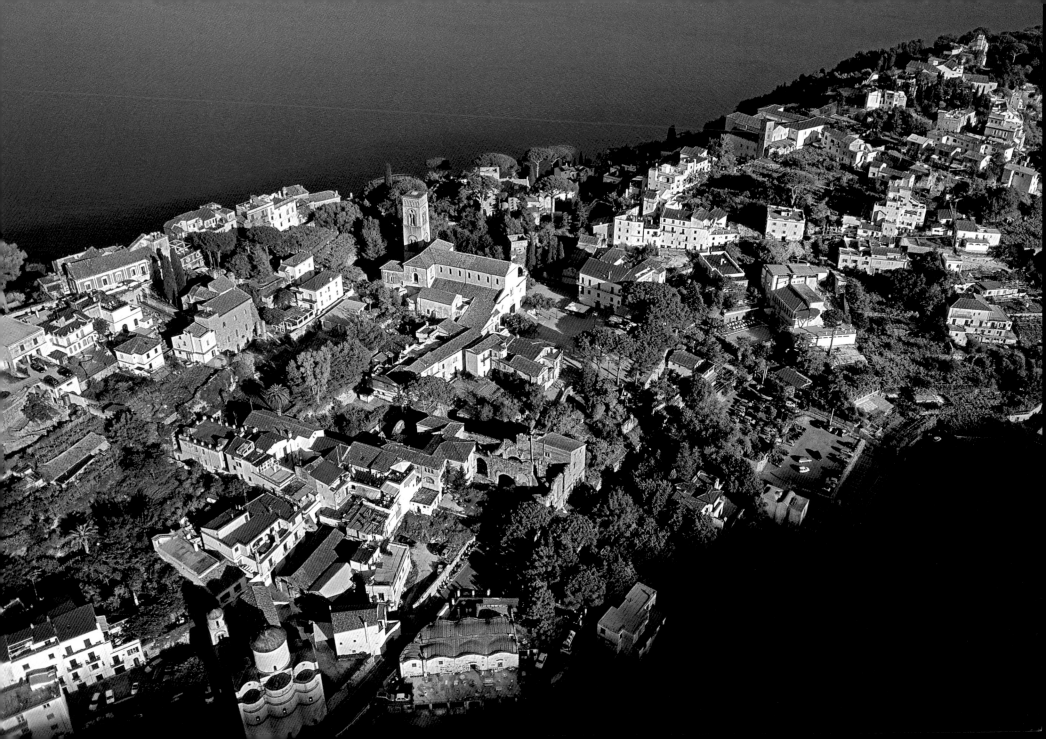

202

202-203 Superior grapes are grown in the terraced vineyards of Ravello, Scala, Minori and Atrani (Salerno). The local Costa d'Amalfi wines were granted DOC status in 1995.

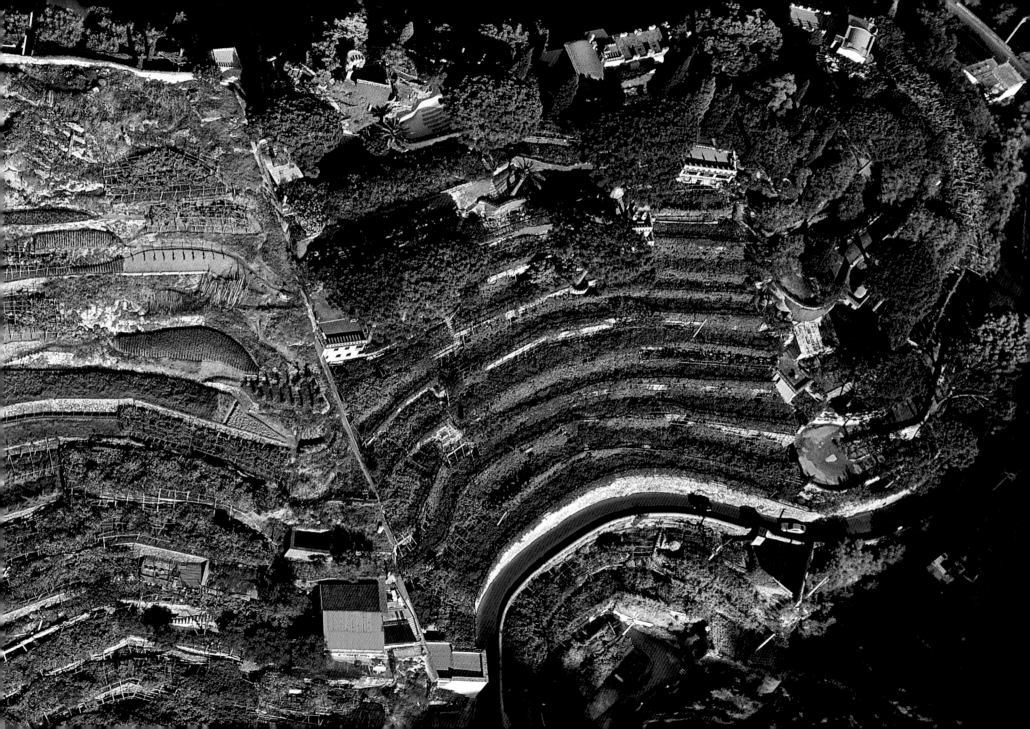

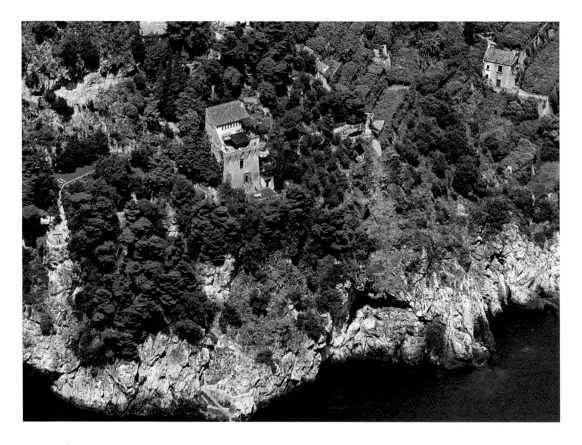

204 and 205 Driving along the Amalfitan Coast (Salerno) on the road edge overhanging the sea is almost like flying. On one side the mountain, and on the other the precipice above the enchanting waves. Numerous villas are set in the rocks where, due to the difficulty of access one can enjoy absolute and wondrous privacy.

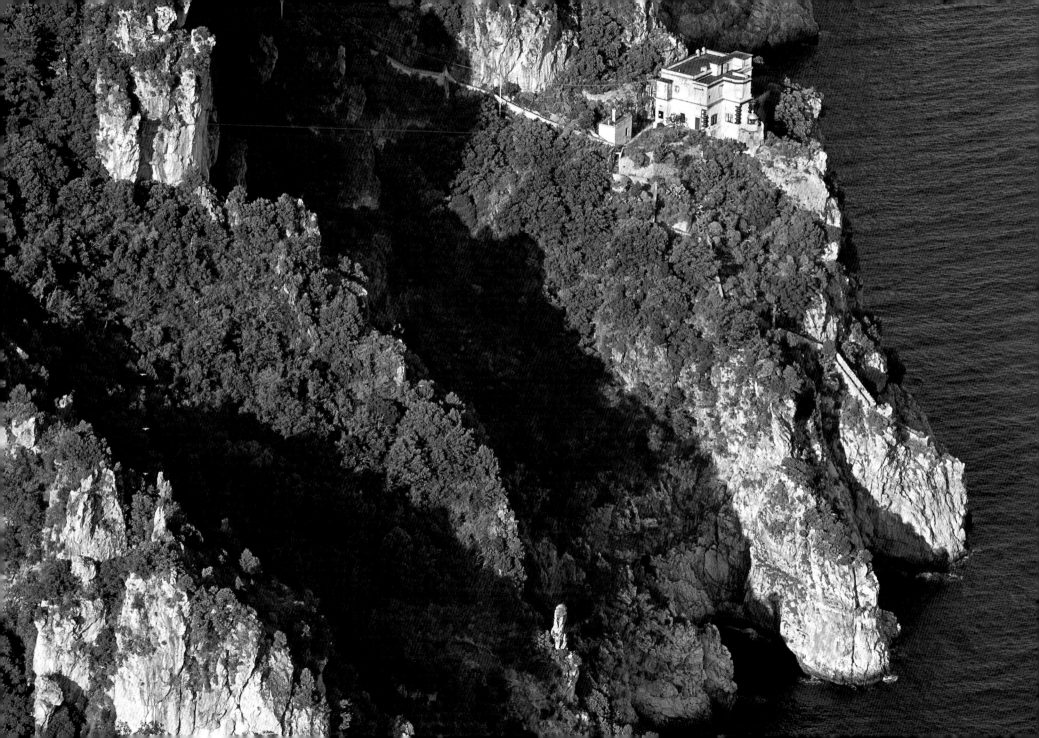

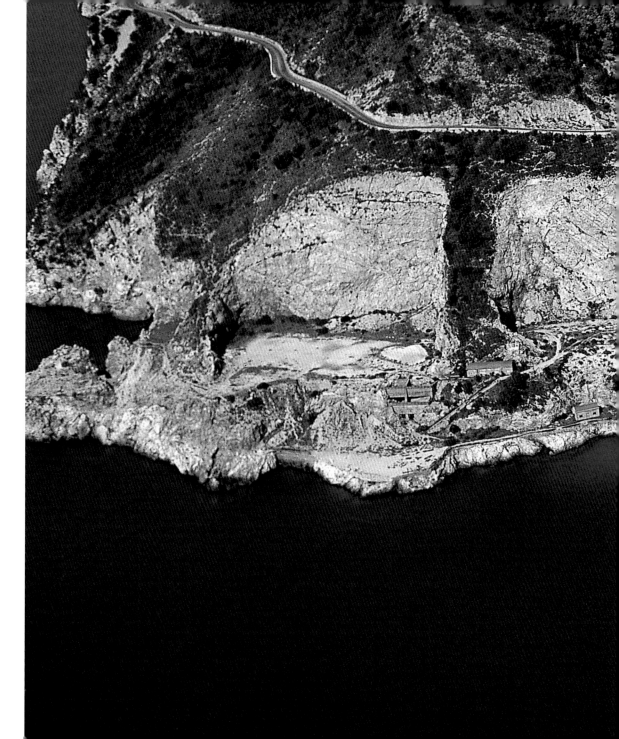

206-207 The small village of Erchie (Salerno) first began life as a Greek colony and according to legend the first visitor to this strip of coast was Hercules. The beautiful beach is dominated to the east by the medieval tower built in 1278 by Charles I of Anjou, today private property.

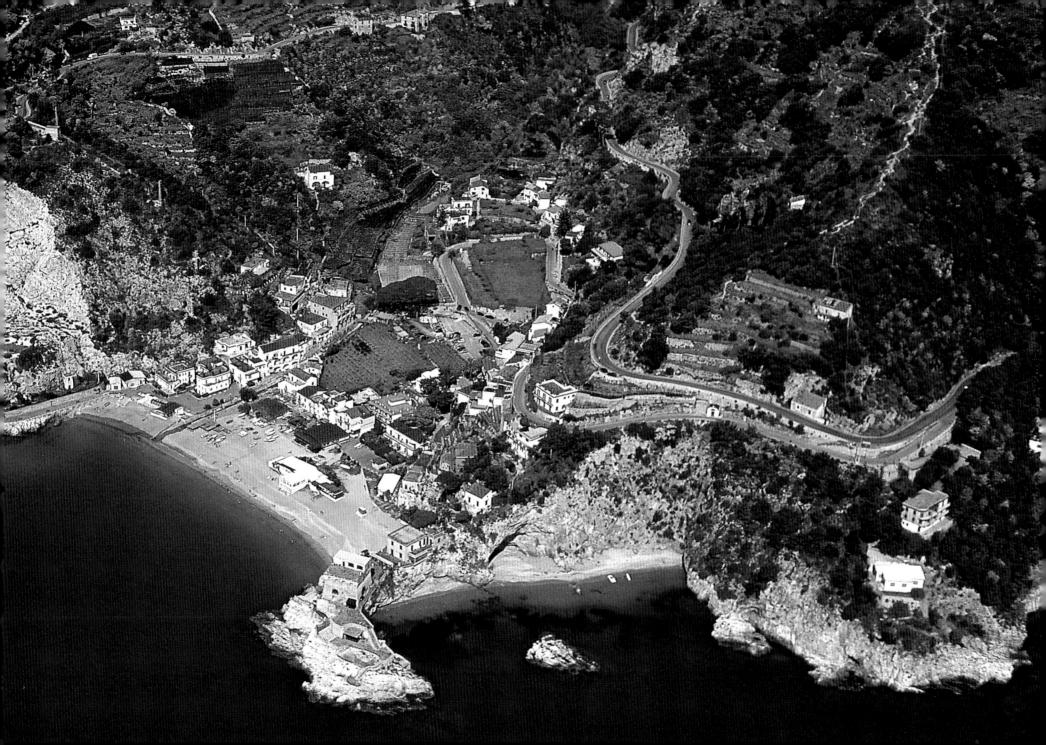

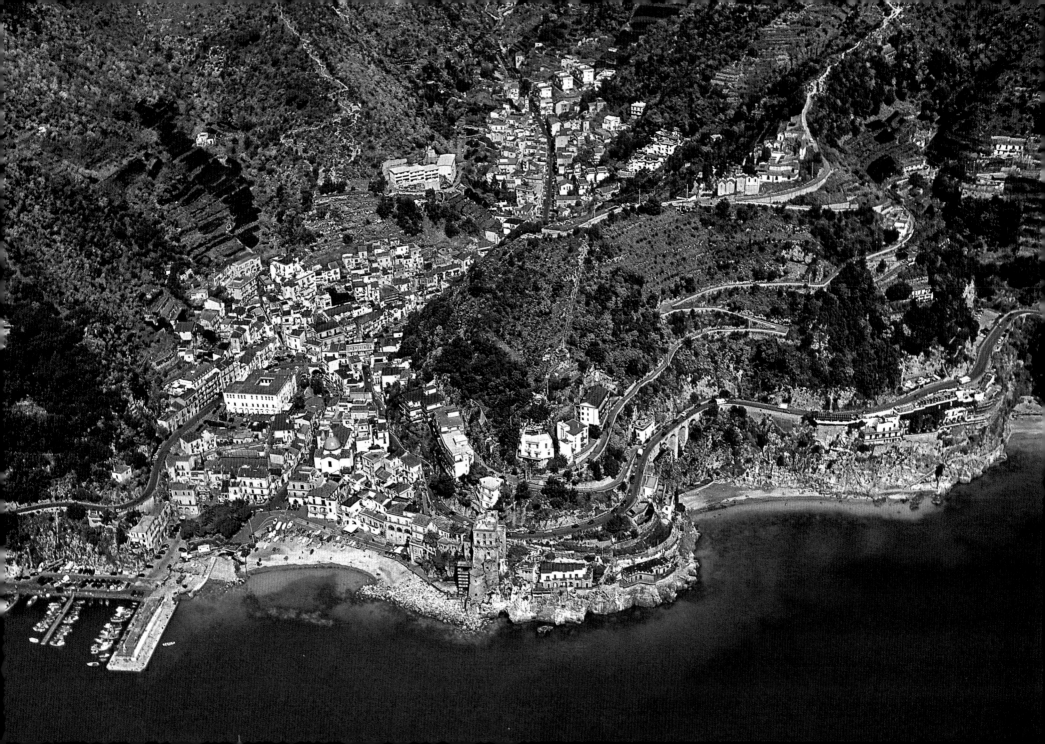

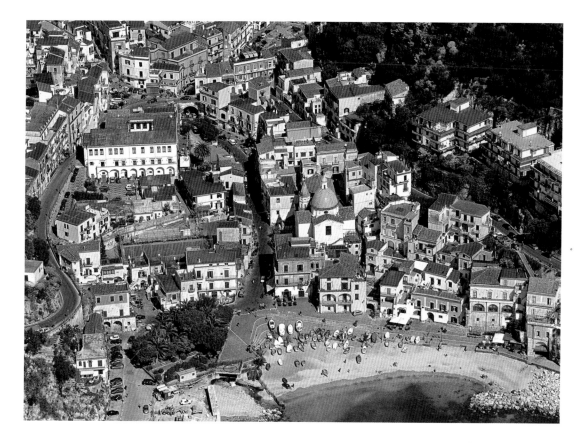

208 A Saracen stronghold in 842 and in 879 at the time of Salerno's siege, Cetara (Salerno) owes its name to fish, deriving from cetaria (fish ponds) or cetari (vendors of large fish). It was ransacked in 1534 by the Turks headed by Sinan Pascia and the Vicireale (viceroy) Tower was built immediately afterwards to defend itself from similar attacks and is now privately owned.

209 Cetara's most important church, restored in the 13th century, is that of Saint Peter, the patron saint. Built in a Romanesque style, it has a beautiful 13th century steeple and an octagonally shaped belfry. One feature is the earthenware cupola, typical of many churches which overlooks the Amalfitan Coast.

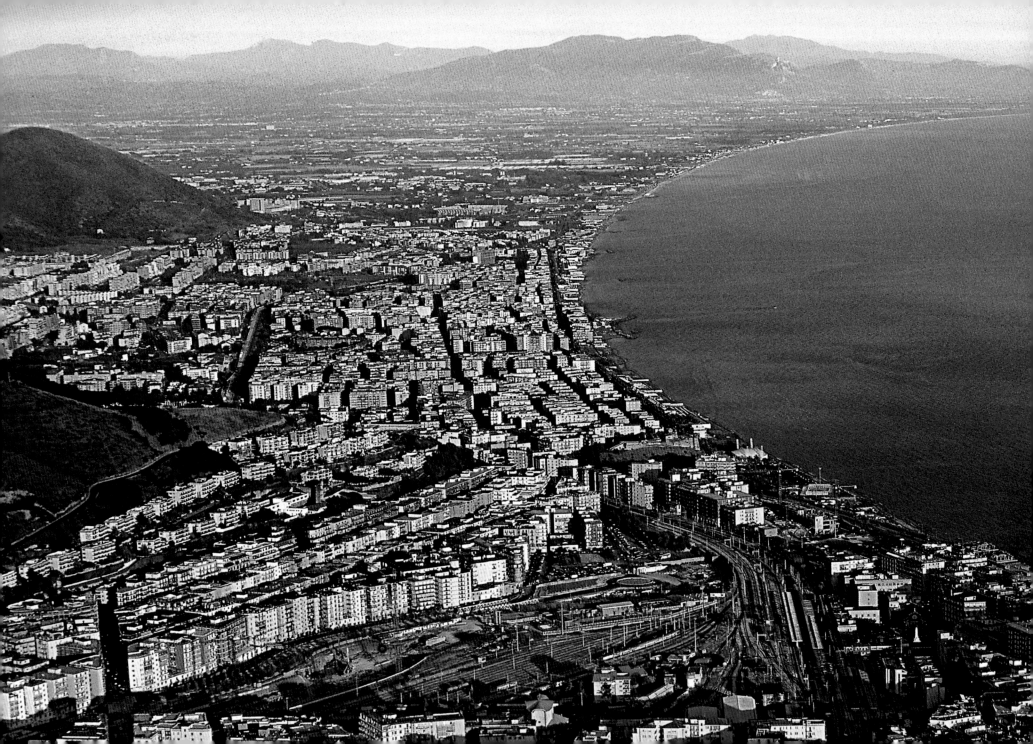

210-211 Salerno's seafront is one of the longest in Italy, entirely used as a pedestrian island and in continuous expansion because of the desire to extend the car-free area up to the city's southern coast.

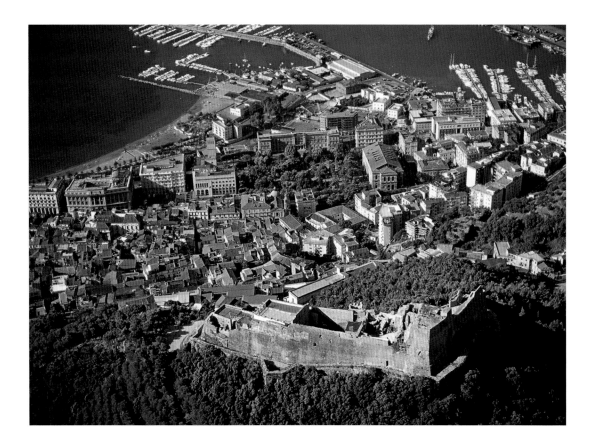

212 Arechi Castle in Salerno is found around 9850 ft (300 m) above sea level. It had a moment of splendor around the 8th century thanks to the Lombard prince who had given it its name who restored the previous Roman or Byzantine center.

213 On 9 September 1943, the day after yet another bombardment, Salerno was the scene of the landing of the Allies during Operation Avalanche. From 12 February to 17 July 1944 it became the headquarters of the Badoglio Government.

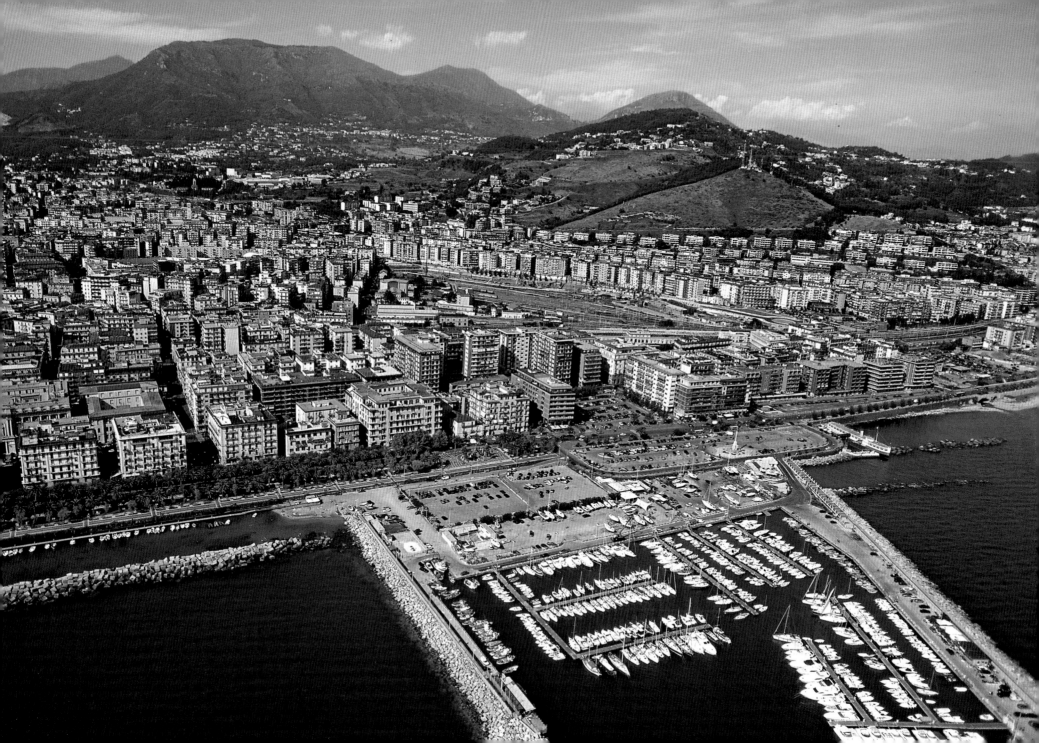

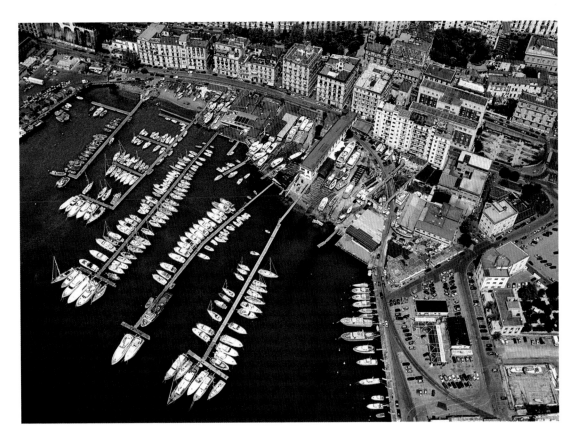

214 Despite the lack of reliable information about Salerno's origins it is known that it was influenced by the Etruscans and Greeks and that between 197 BC and 194 BC it was a Roman colony with the name of Salernum.

215 The Duomo of Salerno (at the center of the photograph) was inaugurated in March 1084 and consecrated by Pope Gregory VII. The current building is the one restored after the earthquake on 5 June 1688, with the atrium surrounded by a portico held up by 28 columns with round arches. On the southern part stands the belfry of the mid 1100s.

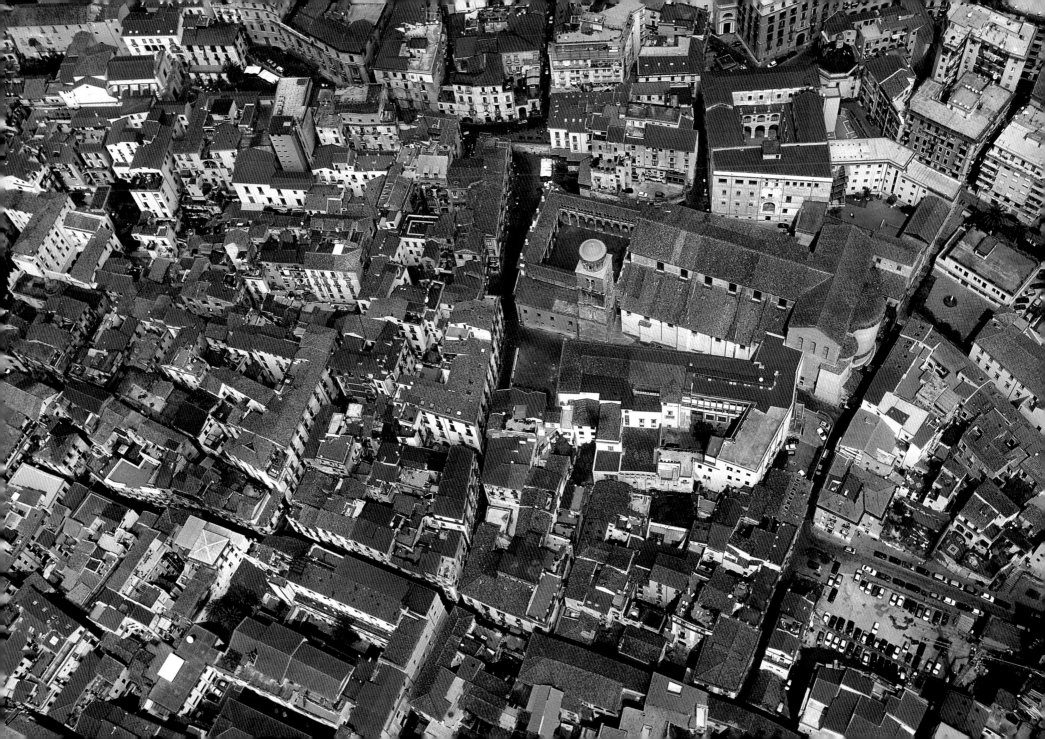

216 and 217 The waterfront between Salerno and Paestum (Salerno) is beautiful with long fine sandy beaches, a limpid sea and a land rich in woodland.

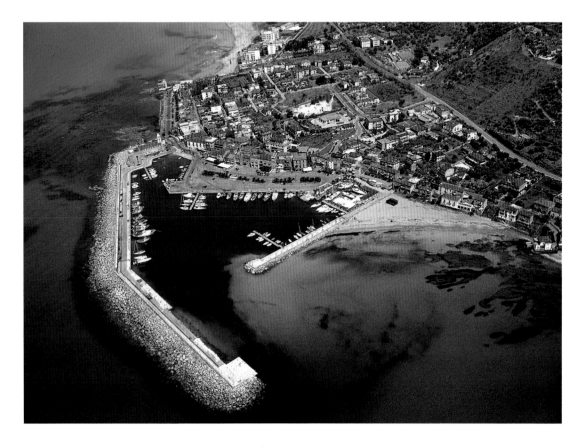

218 The small hamlet of Acciaroli (Salerno) is located in the National Park of Cilento. A beach locality renowned for the cleanliness of its waters, it still offers unspoilt natural surroundings which sees the blooming of water lilies on its coasts.

219 Marina di Camerota (Salerno) was probably founded by the Greeks between the 8th and the 7th century BC. This can also be seen by its name which derives from the Greek Kamaroton which means "done in vaults." The name probably alluded to the natural grottos in the region.

220-221 Just outside Salerno there are maritime pines which almost reach to the sea. Native to the western Mediterranean basin. These pines are planted in coastal areas because they are resistant to the wind and stabilize sandy terrain.

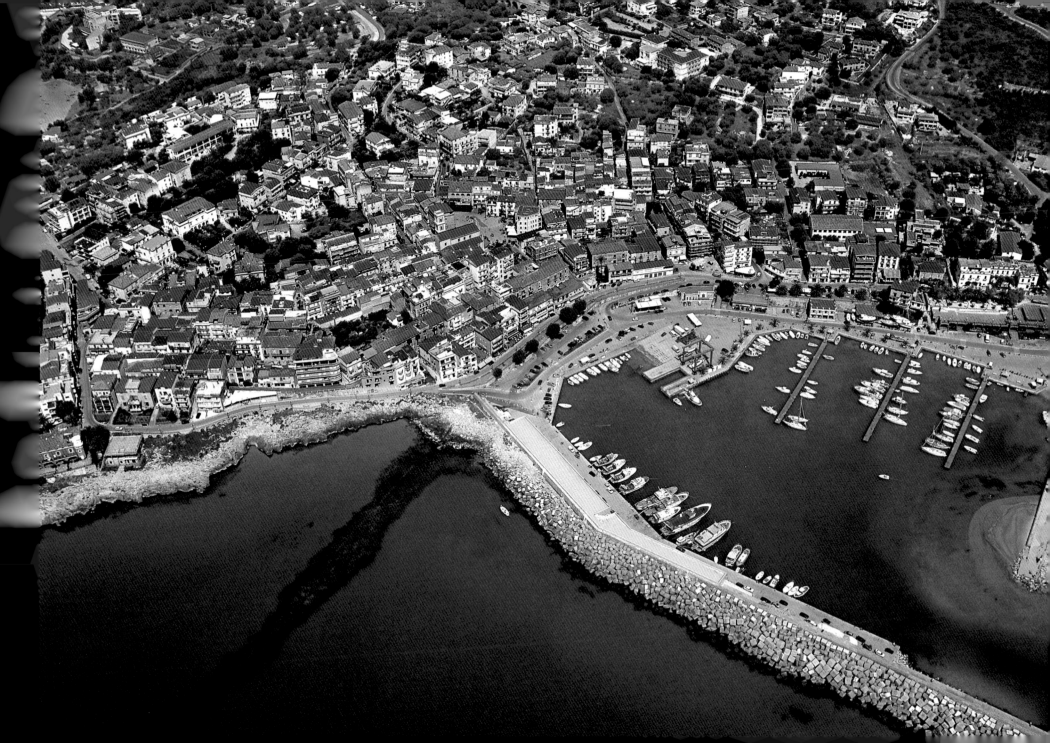

Index

Index

Credits:

Antonio Attini/Archivio White Star: pages 4-5, 24 right, 27, 28 center, 31, 42, 43, 45, 52-53, 54, 55, 56-57, 58, 59 left and right, 60-61, 63, 66 left, center and right, 69, 73, 74, 76, 77, 78-79, 80, 81, 82, 83, 86-87, 88, 89 left and right, 90, 91, 92, 94 left and right, 95, 96 right, 100 right, 103, 104-105, 106, 107, 114-115, 116, 117, 118, 119 left and right, 120, 122-123, 125 left, 126 left and right, 127, 128 left and right, 129, 130, 131, 132-133, 134 left and right, 135, 137 right, 146, 147, 150 left and right, 151, 152, 153, 154-155, 156 left and right, 157, 158, 159, 160, 161 left and right, 162 left and right, 163, 164-165, 166, 167 left and right, 168 left and right, 169, 170, 172 left and right, 173, 175, 176 in centro and right, 180, 183, 184-185, 186, 187 left and right, 188, 189, 190-191, 192, 193, 194-195, 196, 197, 198, 199 left and right, 200-201, 202, 203, 204, 205, 206-207, 208, 209, 210, 211, 212, 214, 215, 216, 217, 218, 219 left and right, 220, 221 left and right

Marcello Bertinetti/Archivio White Star: pages 2-3, 8, 10, 12 left, 15, 20-21, 22-23, 40, 41, 75

Anne Conway/Archivio White Star: pages. 9, 12 center, 18-19

Marcello Libra/Archivio White Star: pages 24 left, 25, 28 left, 34, 35, 36 left and right, 37, 38-39, 44, 62 left and right, 65, 70-71, 72, 97, 99, 109, 110 left and right, 111, 112, 113

Giulio Veggi/Archivio White Star: pages 6-7, 12 right, 28 right, 32-33, 46-47, 48-49, 50-51, 84, 85, 96 left, 100 left and center, 121, 124, 125 right, 136, 137 left, 139, 140, 141, 142, 143 left and right, 144-145, 148-149, 176 left, 178, 182 left and right

Worldsat International Inc.: page 16

Photographs
Antonio Attini
Marcello Bertinetti

Text
Raffaella Piovan

Editor
Valeria Manferto De Fabianis

Editorial coordination
Alberto Bertolazzi
Maria Valeria Urbani Grecchi

The publisher would like to thank:
Francesco Orrico and Elio Rullo

© 2008 White Star S.p.A.
Via Candido Sassone, 22/24
13100 Vercelli, Italy
www.whitestar.it

TRANSLATION: GLENN DEBATTISTA

ISBN 978-88-544-0369-7

REPRINTS:
1 2 3 4 5 6 12 11 10 09 08

Color separation: areagroup media, Milan
Printed in Thailand